wanderlust

46 MODERN KNITS FOR BOHEMIAN STYLE

—

Tanis Gray

INTERWEAVE
interweave.com

For Barbara King and Abby, who
taught me to be a fearless knitter.

EDITOR
Ann Budd

TECHNICAL EDITOR
Therese Chynoweth

ASSOCIATE ART DIRECTOR
Charlene Tiedemann

COVER + INTERIOR DESIGN
Pamela Norman

LAYOUT DESIGN
Laura Spencer

PHOTOGRAPHER
Joe Hancock

PHOTO STYLIST
Allie Liebgott

HAIR AND MAKEUP
Kathy MacKay

PRODUCTION
Katherine Jackson

© 2014 Tanis Gray
Photography © 2014 Joe Hancock
Illustrations © 2014 Interweave,
a division of F+W Media, Inc.
All rights reserved.

Interweave
A division of F+W Media, Inc.
4868 Innovation Drive
Fort Collins, CO 80525
interweave.com

Manufactured in China by RR Donnelley Shenzhen

Library of Congress Cataloging-in-Publication Data

Wanderlust : 46 modern knits for bohemian style /
[compiled by] Tanis Gray.
 pages cm
Includes index.
ISBN 978-1-62033-831-5 (pbk.)
ISBN 978-1-62033-832-2 (PDF)
1. Knitting. 2. Dress accessories. I. Gray, Tanis.
TT825.W357 2014
746.43'2--dc23

2014028514

10 9 8 7 6 5 4 3 2 1

To locate retailers of Cascade Longwood, go to
cascadeyarns.com.

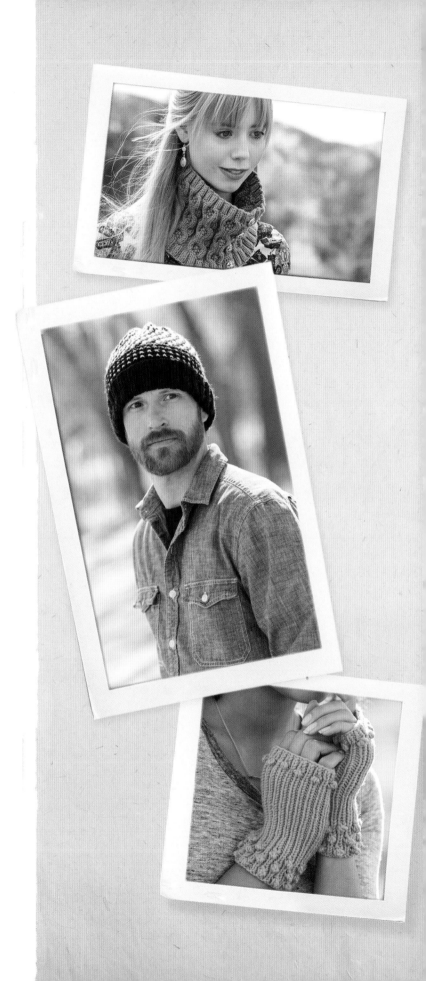

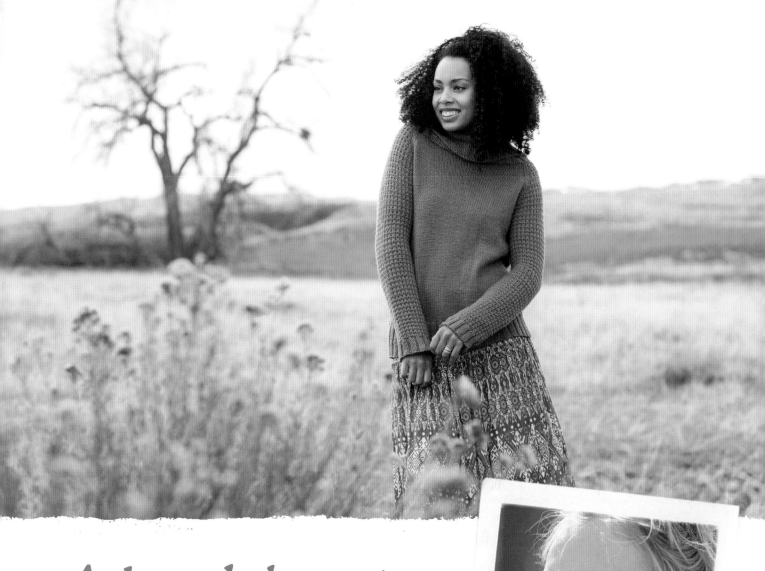

Acknowledgments

Making a book is not a solo journey. Many, many thanks to Allison Korleski, my remarkable editorial director and the Slash to my Axl; Therese Chynoweth, my eagle-eyed technical editor; Joe Hancock for his inspiring photography and talent; Charlene Tiedemann for her marvelous art directing and skill; and to Ann Budd for taking a good book and making it great and for her suggestions, support, and expertise. My deepest thanks go to each and every designer included in this book—it's a privilege to work with such an accomplished and global group. And to you, dear readers. Grab your knitting and bring it with you as you tame your wanderlust!

contents

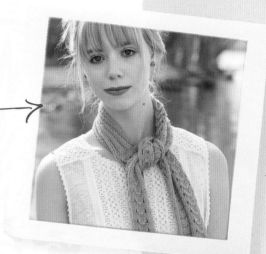

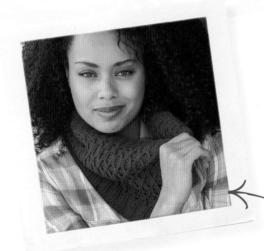

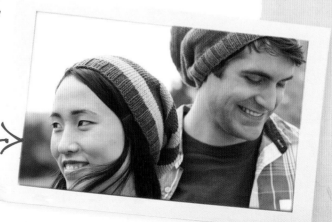

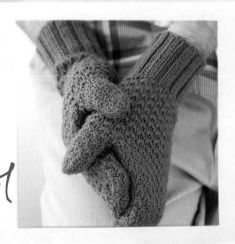

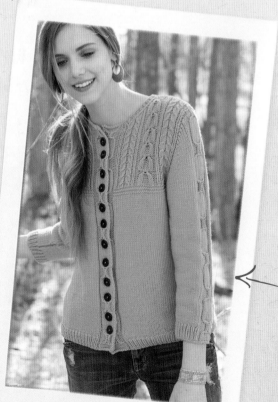

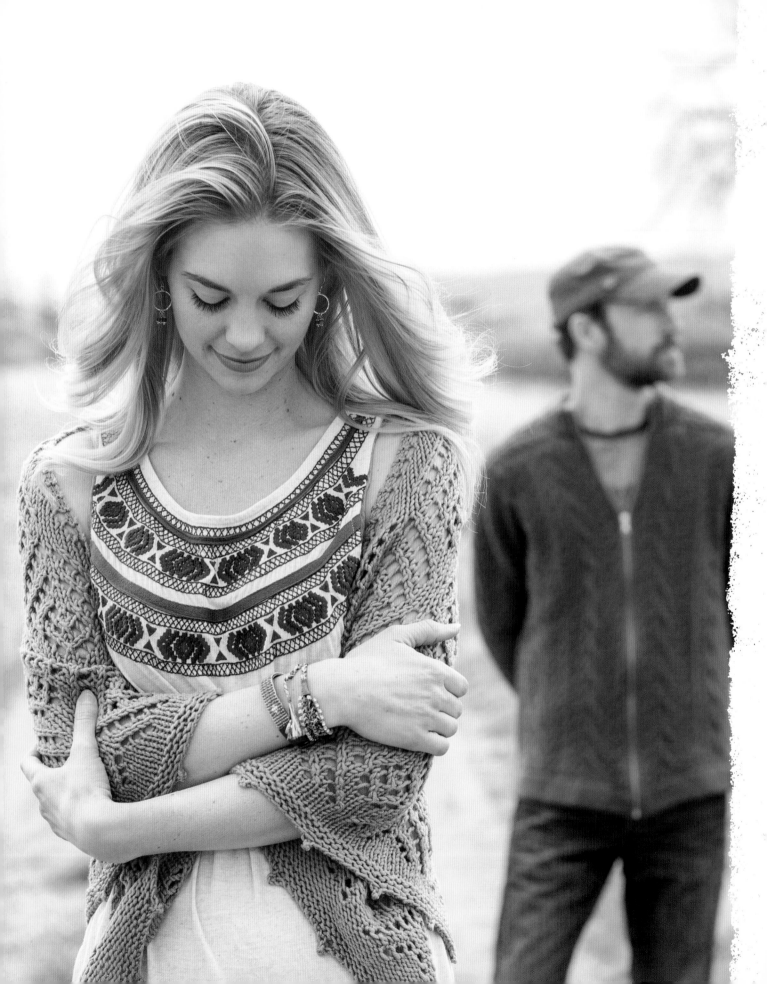

Introduction

Most of us carry a sense of wanderlust.

Whether I'm hiking through the wilderness like the models in this book or walking through the "urban jungle" of the city, I appreciate the effortlessness of caring for a garment knitted in superwash yarn. Wanderlust means having an urge to travel, explore, and see what this world has to offer. Why not do this while wearing garments that are not only quick to make, but portable enough to bring along and work on while doing that traveling?

We modern knitters are spoiled, whether or not we realize it. The ease of caring for our knits that we enjoy would make our grandmothers shake their heads. Being able to throw a garment into the washer and dryer and having it come out clean and looking like new makes me turn to machine washable yarn again and again. While handknits are indeed precious, we can live our busy lives and quell that wanderlust while wearing something both lovely and easy to care for.

There's a common misconception about the simplicity of superwash yarn and how it's meant only for baby garments. Filled with projects for modern knitters, such as Todd Groken's classy cabled men's zippered jacket, Elena Nodel's feminine pullover with lace sleeves and dramatic collar, Paulina Popiolek's charming unisex cabled hat and scarf set, Karen Joan Raz's elegant duotone rectangular lace shawl, and Robin Melanson's cozy shawlette, this book proves that's not the case. Among the nearly fifty garments for both men and women, including seven glorious sweaters (and not one of them for a baby!), you'll find something for everyone on your knitting list, and more importantly, for you.

Extrafine merino superwash wool is also ideal when it comes to knitting gifts—it has the lovely properties of wool without the itch and without the possibility of accidental felting. Cascade's plied Longwood, which was used for all the projects in this collection, has an impressive bounce factor, comes in dozens of colors, and has superb stitch definition. If you think superwash is just for babies, think again!

Happy wanderlusting,

Tanis

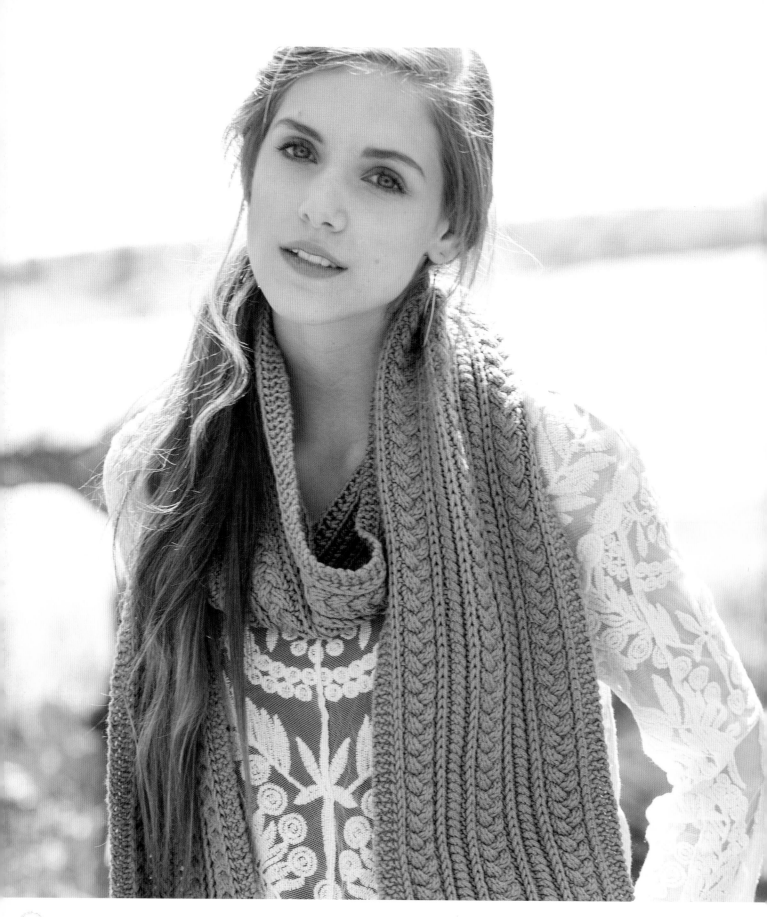

scarves + wraps

[FOR THE NECK AND SHOULDERS]

Bedeck your neck with cables, stranded colorwork, or simple lace. Scarves and wraps are ideal projects to learn new techniques or tuck into your bag for knitting on-the-go.

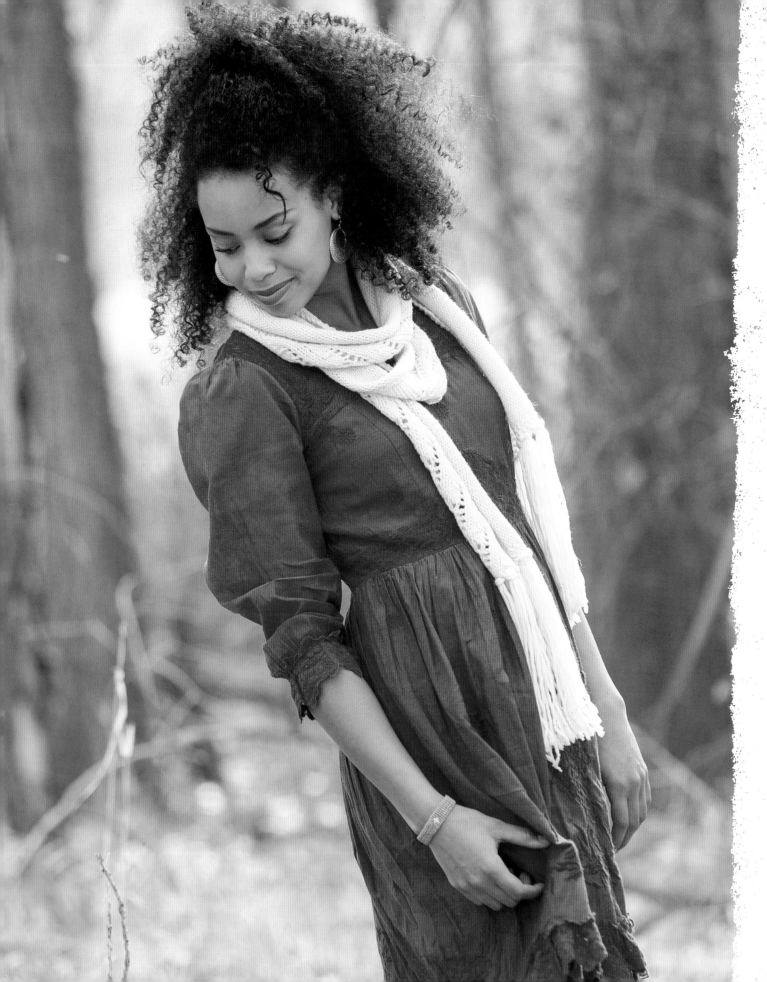

aleut
SCARF

designed by JOAN FORGIONE

Named for Cyrillic script, this two-directional scarf begins with a short, but wide, stockinette strip. Stitches are then picked up along one long edge for the edging, which is worked perpendicular to the strip. Fringe finishes off each end of the scarf for a long, warm, and cozy touch of elegance.

FINISHED SIZE
86" (218.5 cm) long and 5½" (14 cm) wide (see Notes for adjusting the size).

YARN
Worsted weight (#4 Medium).

Shown here: Cascade Yarns Longwood (100% superwash extrafine merino wool; 191 yd [175 m]/100 g): #12 Dew, 2 balls.

NEEDLES
Size U.S. 9 (5.5 mm): 40" (100 cm) circular (cir).

Adjust needle size if necessary to obtain the correct gauge.

NOTIONS
Tapestry needle; size H/8 (5 mm) crochet hook; T-pins for blocking (optional).

GAUGE
14 sts and 31 rows = 4" (10 cm) in St st.

STITCH GUIDE

SEED STITCH
(odd number of sts)

All rows: *K1, p1; rep from * to last st, k1.

CRESTED LACE EDGING
(worked over 13 sts)

Row 1 and all WS rows: K2, purl to last 2 sts, k1, k2tog (last edging st and first st of scarf body).

Row 2: (RS) Sl 1 purlwise with yarn in back (pwise wyb), k3, yo, k5, yo, k2tog, yo, k2—15 edging sts.

Row 4: Sl 1 pwise wyb, k4, sl 1, k2tog, psso, k2, [yo, k2tog] 2 times, k1—13 edging sts rem.

Row 6: Sl 1 pwise wyb, k3, ssk, k2, [yo, k2tog] 2 times, k1—12 edging sts rem.

Row 8: Sl 1 pwise wyb, k2, ssk, k2, [yo, k2tog] 2 times, k1—11 edging sts rem.

Row 10: Sl 1 pwise wyb, k1, ssk, k2, [yo, k2tog] 2 times, k1—10 edging sts rem.

Row 12: Sl 1 pwise wyb, ssk, k2, yo, k1, yo, k2tog, yo, k2—11 edging sts.

Row 14: Sl 1 pwise wyb, [k3, yo] 2 times, k2tog, yo, k2—13 edging sts.

Rep Rows 1–14 for patt.

NOTES:
The lace edging is worked perpendicular to the direction of the scarf body and is attached with k2tog decreases.

The stitch count of the lace edging pattern varies by row.

To work slipped stitches on right-side (RS) rows of lace edging, pull the yarn behind the stitch to be slipped, then slip the stitch purlwise.

You can make the scarf wider by working more rows of the body section of the pattern; however, yardage may vary.

scarf

BODY
CO 281 sts.

Rows 1 and 2: *K1, p1; rep from * to last st, k1.

Next row: (RS) K1, p1, k1, knit to last 3 sts, k1, p1, k1.

Next row: (WS) K1, p1, k1, purl to last 3 sts, k1, p1, k1.

Rep the last 2 rows until piece measures 3" (7.5 cm) from CO, ending with a RS row.

LACE EDGING
With RS still facing, use the backward-loop method (see Glossary) to CO 13 more sts for edging.

Set-up row: (WS) K2, purl to last 2 sts, k1, k2tog (last edging st and first body st).

Working from chart or row-by-row instructions (see Stitch Guide), work Rows 2–14 of Crested Lace Edging patt, then rep Rows 1–14 until all scarf body sts have been used, ending with Row 14 of patt.

Loosely BO rem 13 sts.

finishing

Weave in loose ends.

Soak in cool water with wool soap until completely saturated. Wrap in towel to remove excess water. Stretch and pin lace to form points. Allow to dry thoroughly before unpinning.

FRINGE
Cut twenty-seven 24" (61 cm) lengths of yarn for fringe. Holding three lengths tog, fold the yarn in half, insert crochet from WS to RS along short end of scarf, pull loop through WS, then pull cut ends through loop to secure. Rep 8 more times for a total of 9 fringes evenly spaced along one short end. Tie overhand knot ¾" (2 cm) from both ends of each strand.

Rep for other short end.

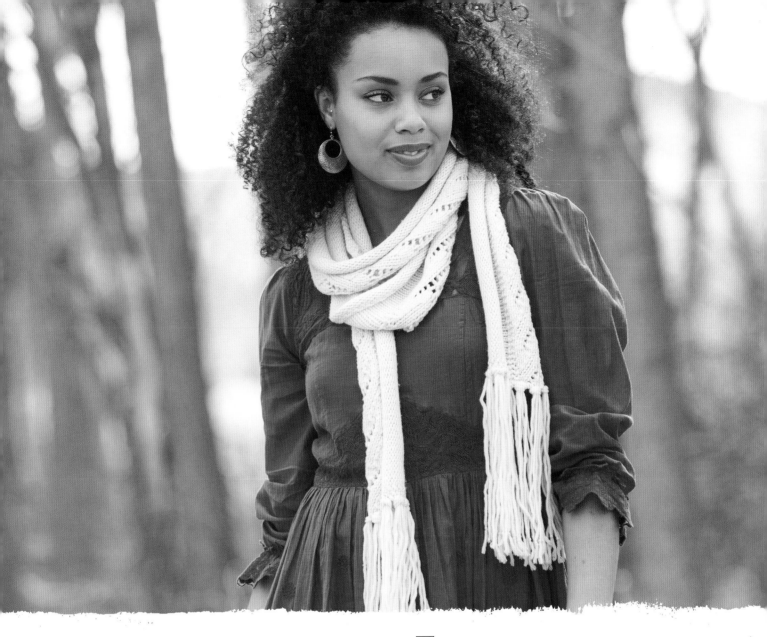

LACE EDGING

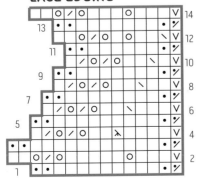

	k on RS, p on WS
•	p on RS, k on WS
O	yo
/	k2tog
\	ssk
V	sl 1 pwise wyb
⅄	sl 1, k2tog, psso
⁄	p2tog
	pattern repeat

snoqualmie
WRAP

designed by BETH KLING

This simple asymmetrical wrap marries garter stitch with a lacy vine pattern to create a generously sized rectangle with just the right balance between snuggle-up warmth and casual elegance.

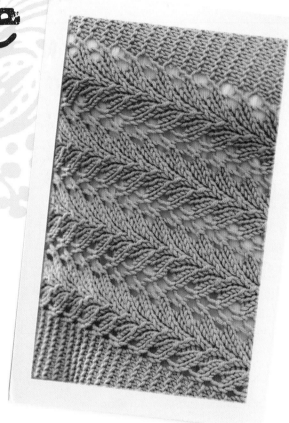

FINISHED SIZE
About 74" (188 cm) long and 17" (43 cm) wide.

YARN
Worsted weight (#4 Medium).

Shown here: Cascade Yarns Longwood (100% superwash extrafine merino wool; 191 yd [175 m]/100 g): #23 Stonewash, 5 balls.

NEEDLES
Size U.S. 9 (5.5 mm): 24" or 32" (60 or 80 cm) circular (cir).

Adjust needle size if necessary to obtain the correct gauge.

NOTIONS
Markers (m); tapestry needle.

GAUGE
18 sts and 20 rows = 4" (10 cm) in garter st, blocked.

wrap

Using the long-tail method (see Glossary), CO 72 sts.

Set-up row: (WS) K24, place marker (pm), p36, pm, k12.

Follow the chart or row-by-row instructions below.

Row 1: (RS) K12, slip marker (sl m), [k1, yo, k2, ssk, k2tog, k2, yo] 4 times, sl m, knit to end.

Row 2: K24, sl m, p36, sl m, knit to end.

Row 3: K12, sl m, [yo, k2, ssk, k2tog, k2, yo, k1] 4 times, sl m, knit to end.

Row 4: Rep Row 2.

Rep Rows 1–4 until piece measures desired length, ending with Row 4.

BO all sts knitwise.

finishing

Weave in loose ends, but do not trim tails.

Wet-block to finished measurements; allow to dry completely.

Trim tails.

☐	k on RS, p on WS
▪	p on RS, k on WS
○	yo
╱	k2tog
╲	ssk
▢	pattern repeat

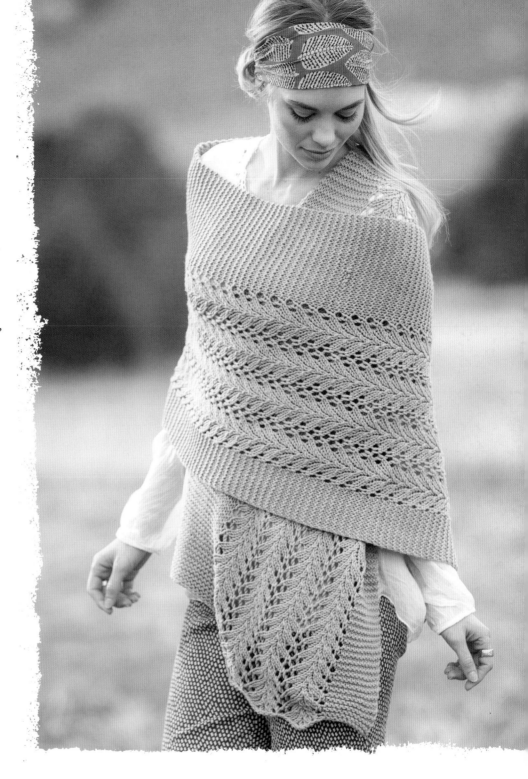

SNOQUALMIE

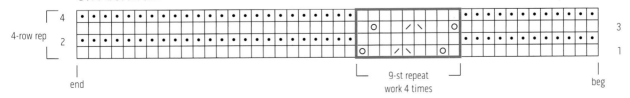

4-row rep

9-st repeat
work 4 times

end

beg

fitted lacy
SCARF

designed by LINDA MEDINA

The center portion of this pretty little scarf is ribbed for a comfortable fit under a jacket or coat. The two tails are worked separately in a lace pattern from ruffles at the cast-on edges. One tail continues through the ribbed center section, then the two are grafted together for a symmetrical look.

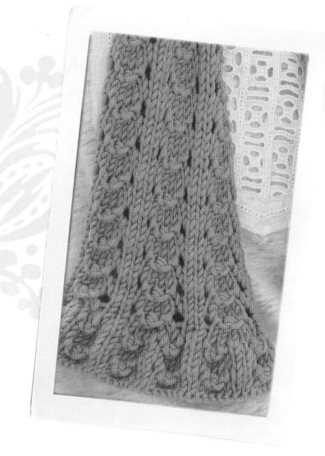

FINISHED SIZE
About 4¾" (12 cm) wide and 42" (106.5 cm) long.

YARN
Worsted weight (#4 Medium).

Shown here: Cascade Yarns Longwood (100% superwash extrafine merino wool; 191 yd [175 m]/100 g): #07 Nectarine, 1 ball.

NEEDLES
Size U.S. 8 (5 mm): straight.

Adjust needle size if necessary to obtain the correct gauge.

NOTIONS
Stitch holder; tapestry needle.

GAUGE
20 sts and 24 rows = 4" (10 cm) in little shell patt.

STITCH GUIDE

LITTLE SHELL PATTERN
(mult of 7 sts + 4)

Row 1: (RS) Knit.

Row 2: K1, purl to last st, k1.

Row 3: K3, *yo, p1, p3tog, p1, yo, k2; rep from * to last 3 sts, k3.

Row 4: Rep Row 2.

Rep Rows 1–4 for patt.

scarf

CO 46 sts.

FIRST TAIL

Work Rows 1–4 of little shell patt (see Stitch Guide or chart) 2 times for ruffle.

Dec Row 1: (RS; Row 1 of patt) K2, *k2tog; rep from * to last 2 sts, k2—25 sts rem.

Work Rows 2–4 of patt, then rep Rows 1–4 twenty times, then rep Rows 1 and 2 once more—piece measures about 16" (40.5 cm) from CO.

Change to ribbing as foll.

Dec Row 2: (RS) K2tog, k1, p2, *k2, p2; rep from *—24 sts rem.

Work in k2, p2 rib for 60 rows, ending with a RS row—ribbed section measures about 10" (25.5 cm).

Inc row: (WS) K1, purl to last 2 sts, p1f&b (see Glossary), k1—25 sts.

Cut yarn, leaving a 6" (15 cm) tail. Place sts onto holder.

SECOND TAIL

CO 46 sts and work as first tail to beg of k2, p2 of ribbing—25 sts.

Cut yarn, leaving a 30" (76 cm) tail. Thread tail on a tapestry needle and use the Kitchener st (see Glossary) to graft the two tails tog.

finishing

Weave in loose ends.

Block lightly.

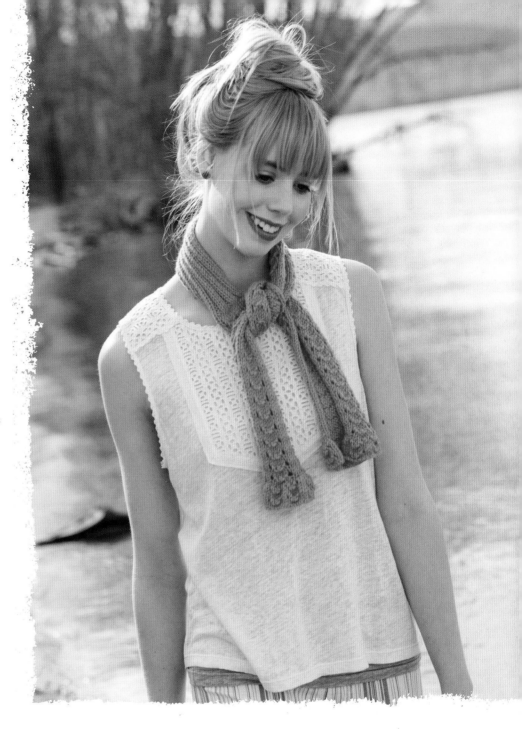

LITTLE SHELL

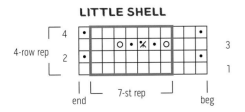

4-row rep

7-st rep

end beg

 k on RS, p on WS

 p on RS, k on WS

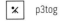 yo

 p3tog

pattern repeat

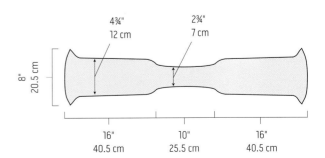

4¾"
12 cm

2¾"
7 cm

8"
20.5 cm

16"
40.5 cm

10"
25.5 cm

16"
40.5 cm

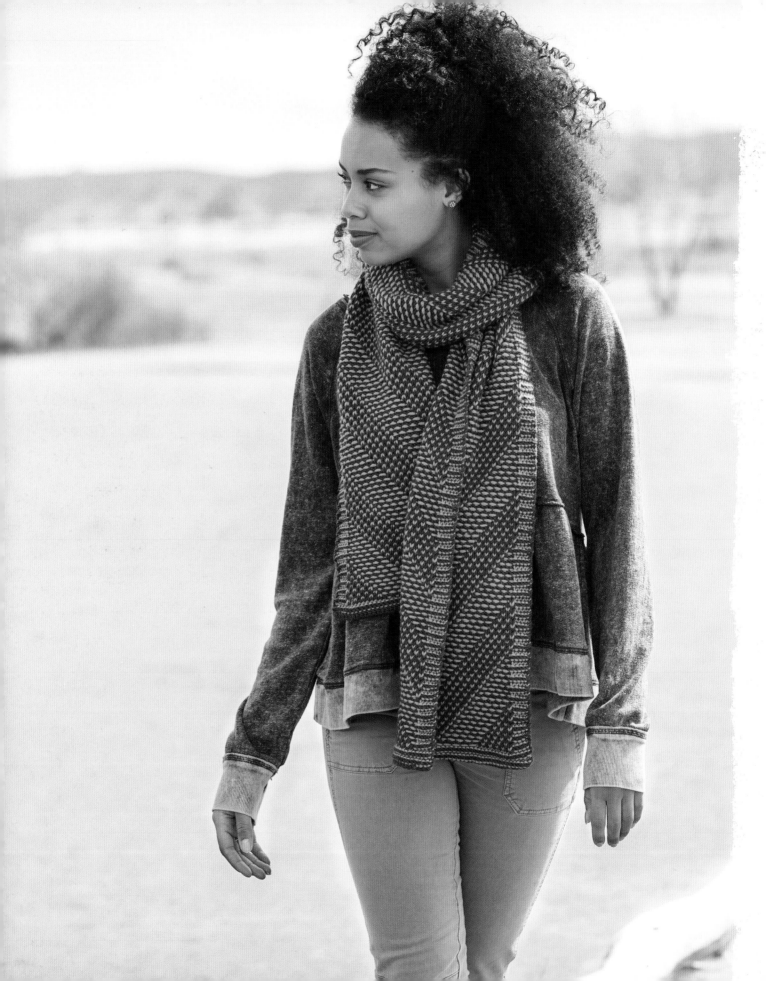

slip-stitch
SCARF

designed by NATALIYA GALIFIANAKIS

This reversible scarf is knitted in a slip-stitch pattern with two contrasting colors. The intriguing pattern is achieved by working two right-side rows followed by two wrong-side rows; therefore, a circular or double-pointed needles are required. The consecutive right- and wrong-side rows are worked in alternating colors for a most interesting "Fair Isle" effect.

FINISHED SIZE
About 10" (25.5 cm) wide and 72" (183 cm) long.

YARN
Worsted weight (#4 Medium).

Shown here: Cascade Yarns Longwood (100% superwash extrafine merino wool; 191 yd [175 m]/100 g): #10 Dark Brown (A) and #05 Peach (B), 2 balls each.

NEEDLES
Size U.S. 7 (4.5 mm): circular (cir) or double-pointed (dpn).

Adjust needle size if necessary to obtain the correct gauge.

GAUGE
20 sts and 32 rows = 4" (10 cm) in slip-st patt.

STITCH GUIDE

SLIP-STITCH PATTERN
(mult of 20 sts + 10)

Row 1: (RS) With B, k5, *[k1, sl 1 purlwise with yarn in back (pwise wyb)] 5 times, [p1, sl 1 purlwise with yarn in front (pwise wyf)] 5 times; rep from * once, k5; slide all sts to other end of needle.

Row 2: (RS) With A, k5, [p1, k10, p9] 2 times, k5.

Row 3: (WS) With B, k5; *[k1, sl 1 pwise wyb] 4 times, k1, [sl 1 pwise wyf, p1] 5 times, sl 1 pwise wyb; rep from * once, k5, slide all sts to other end of needle.

Row 4: (WS) With A, k5, [k8, p10, k2] 2 times, k5.

Row 5: (RS) With B, k5; *p1, sl 1 pwise wyf, [k1, sl 1 pwise wyb] 5 times, [p1, sl 1 pwise wyf] 4 times; rep from * once, k5, slide all sts to other end of needle.

Row 6: (RS) With A, k5, [p3, k10, p7] 2 times, k5.

Row 7: (WS) With B, k5, *[k1, sl 1 pwise wyb] 3 times, k1, [sl 1 pwise wyf, p1] 5 times, sl 1 pwise wyb, k1, sl 1 pwise wyb; rep from * once, k5, slide all sts to other end of needle.

Row 8: (WS) With A, k5, [k6, p10, k4] 2 times, k5.

Row 9: (RS) With B, k5, *[p1, sl 1 pwise wyf] 2 times, [k1, sl 1 pwise wyb] 5 times, [p1, sl 1 pwise wyf] 3 times; rep from * once, k5, slide all sts to other end of needle.

Row 10: (RS) With A, k5, [p5, k10, p5] 2 times, k5.

Row 11: (WS) With B, k5, *[k1, sl 1 pwise wyb] 2 times, k1, [sl 1 pwise wyf, p1] 5 times, [sl 1 pwise wyb, k1] 2 times, sl 1 pwise wyb; rep from * once, k5, slide all sts to other end of needle.

Row 12: (WS) With A, k5, [k4, p10, k6] 2 times, k5.

Row 13: (RS) With B, k5, *[p1, sl 1 pwise wyf] 3 times, [k1, sl 1 pwise wyb] 5 times, [p1, sl 1 pwise wyf] 2 times; rep from * once, k5, slide all sts to other end of needle.

Row 14: (RS) With A, k5, [p7, k10, p3] 2 times, k5.

Row 15: (WS) With B, k5, *k1, sl 1 pwise wyb, k1, [sl 1 pwise wyf, p1] 5 times, [sl 1 pwise wyb, k1] 3 times, sl 1 pwise wyb; rep from * once, k5, slide all sts to other end of needle.

Row 16: (WS) With A, k5, [k2, p10, k8] 2 times, k5.

Row 17: (RS) With B, k5, *[p1, sl 1 pwise wyf] 4 times, [k1, sl 1 pwise wyb] 5 times, p1, sl 1 pwise wyf; rep from * once, k5, slide all sts to other end of needle.

Row 18: (RS) With A, k5, [p9, k10, p1] 2 times, k5.

Row 19: (WS) With B, k5, *k1, [sl 1 pwise wyf, p1] 5 times, [sl 1 pwise wyb, k1] 4 times, sl 1 pwise wyb; rep from * once, k5, slide all sts to other end of needle.

Row 20: (WS) With A, k5, [p10, k10] 2 times, k5.

Row 21: (RS) With B, k5, *[p1, sl 1 pwise wyf] 5 times, [k1, sl 1 pwise wyb] 5 times; rep from * once, k5, slide all sts to other end of needle.

Row 22: (RS) With A, k5, [k1, p10, k9] 2 times, k5.

Row 23: (WS) With B, k5, *[p1, sl 1 pwise wyf] 4 times, p1, [sl 1 pwise wyb, k1] 5 times, sl 1 wyf; rep from * once, k5, slide all sts to other end of needle.

Row 24: (WS) With A, k5, [p8, k10, p2] 2 times, k5.

Row 25: (RS) With B, k5, *k1, sl 1 pwise wyb, [p1, sl 1 pwise wyf] 5 times, [k1, sl 1 pwise wyb] 4 times; rep from * once, k5, slide all sts to other end of needle.

Row 26: (RS) With A, k5, [k3, p10, k7] 2 times, k5.

Row 27: (WS) With B, k5, *[p1, sl 1 pwise wyf] 3 times, p1, [sl 1 pwise wyb, k1] 5 times, sl 1 pwise wyf, p1, sl 1 pwise wyf; rep from * once, k5, slide all sts to other end of needle.

Row 28: (WS) With A, k5, [p6, k10, p4] 2 times, k5.

Row 29: (RS) With B, k5, *[k1, sl 1 pwise wyb] 2 times, [p1, sl 1 pwise wyf] 5 times, [k1, sl 1 pwise wyb] 3 times; rep from * once, k5, slide all sts to other end of needle.

Row 30: (RS) With A, k5, [k5, p10, k5] 2 times, k5.

Row 31: (WS) With B, k5, *[p1, sl 1 pwise wyf] 2 times, p1, [sl 1 pwise wyb, k1] 5 times, [sl 1 pwise wyf, p1] 2 times, sl 1 pwise wyf; rep from * once, k5, slide all sts to other end of needle.

Row 32: (WS) With A, k5, [p4, k10, p6] 2 times, k5.

Row 33: (RS) With B, k5, *[k1, sl 1 pwise wyb] 3 times, [p1, sl 1 pwise wyf] 5 times, [k1, sl 1 pwise wyb] 2 times; rep from * once, k5, slide all sts to other end of needle.

Row 34: (RS) With A, k5, [k7, p10, k3] 2 times, k5.

Row 35: (WS) With B, k5; *p1, sl 1 pwise wyf, p1, [sl 1 pwise wyb, k1] 5 times, [sl 1 pwise wyf, p1] 3 times, sl 1 pwise wyf; rep from * once, k5, slide all sts to other end of needle.

Row 36: (WS) With A, k5, [p2, k10, p8] 2 times, k5.

Row 37: (RS) With B, k5, *[k1, sl 1 pwise wyb] 4 times, [p1, sl 1 pwise wyf] 5 times, k1, sl 1 pwise wyb; rep from * once, k5, slide all sts to other end of needle.

Row 38: (RS) With A, k5, [k9, p10, k1] 2 times, k5.

Row 39: (WS) With B, k5, *p1, [sl 1 pwise wyb, k1] 5 times, [sl 1 pwise wyf, p1] 4 times, sl 1 pwise wyf; rep from * once, k5, slide all sts to other end of needle.

Row 40: (WS) With A, k5, [k10, p10] 2 times, k5.

Rep Rows 1–40 for patt.

- ■ A
- ■ B
- □ k on RS, p on WS
- ⊡ p on RS, k on WS
- ⊻ sl wyb on RS, sl wyf on WS
- ⊻ sl wyf on RS sl wyb on WS
- □ pattern repeat

NOTE:
The slip-stitch pattern is worked in a sequence of two right-side rows followed by two wrong-side rows.

scarf

With A and using the long-tail method (see Glossary), CO 50 sts.

LOWER GARTER BORDER

Join B.

Row 1: (RS) With B, knit; slide all sts to other end of needle.

Row 2: (RS) With A, knit.

Row 3: (WS) With B, knit; slide all sts to other end of needle.

Row 4: (WS) With A, knit.

Rep Rows 1–4 once more—8 rows total.

CENTER SECTION

Rep Rows 1–40 of slip-st patt (see Stitch Guide or chart) until piece measures 71" (180.5 cm) from CO, ending with an even-numbered row.

UPPER GARTER BORDER

Work Rows 1–4 of lower garter border, then work Row 1–3 once more—7 rows total.

With A, loosely BO all sts.

finishing

Weave in loose ends.

Block lightly.

SLIP-STITCH PATTERN

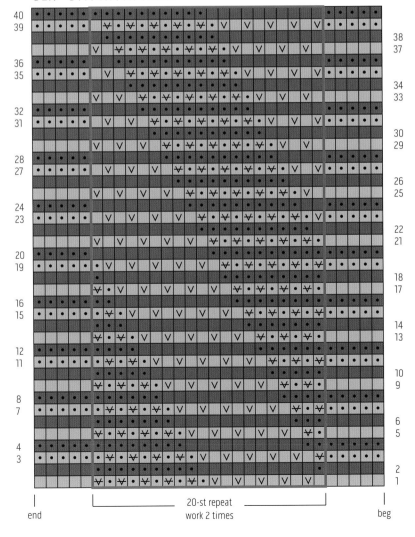

20-st repeat
work 2 times

end beg

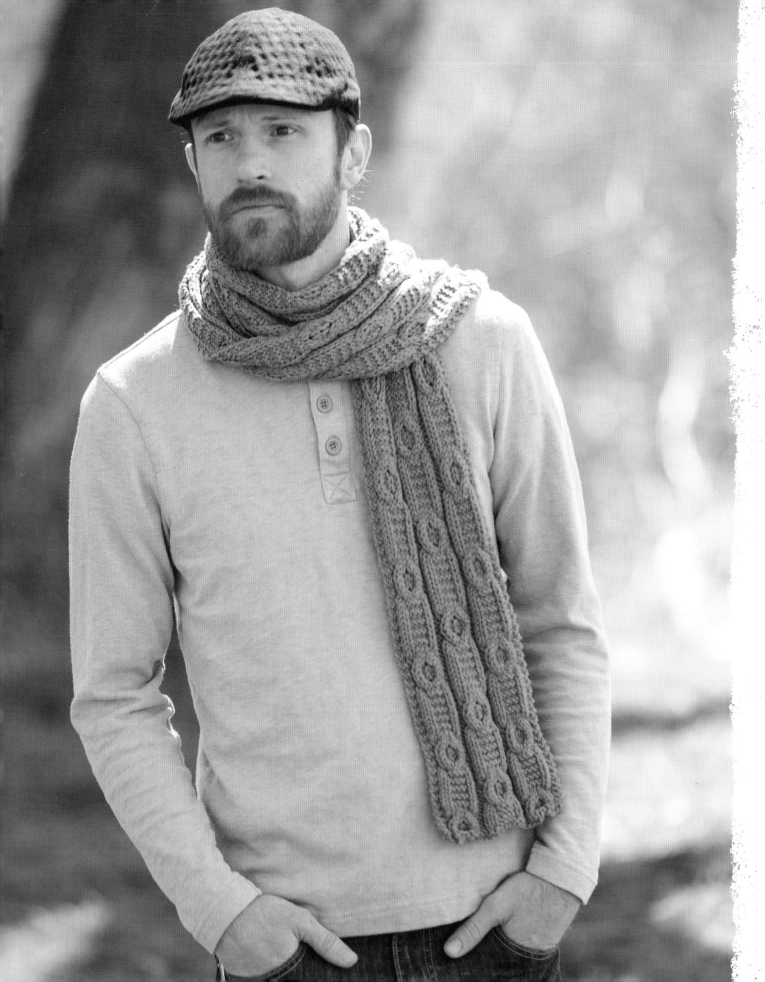

drop-in-the-bucket
SCARF

designed by TANIS GRAY

Get your cable on with this offset cable scarf! An ideal knit if you're new to cabling or chart reading, this unisex scarf will make you an expert in no time at all.

FINISHED SIZE
72½" (184 cm) long and 5¼" (13.5 cm) wide.

YARN
Worsted weight (#4 Medium).

Shown here: Cascade Yarns Longwood (100% superwash extrafine merino wool; 191 yd [175 m]/100 g): #18 Green Spruce, 2 balls (3 balls if fringe is included).

NEEDLES
Size U.S. 8 (4 mm): straight or 16" (40 cm) circular (cir).

Adjust needle size if necessary to obtain the correct gauge.

NOTIONS
Cable needle (cn); tapestry needle; size H/8 (5 mm) crochet hook (optional).

GAUGE
27½ sts and 21 rows = 4" (10 cm) in cable patt.

STITCH GUIDE

2/2RC: Sl 2 sts onto cn and hold in back of work, k2, then k2 from cn.

2/2LC: Sl 2 sts onto cn and hold in front of work, k2, then k2 from cn.

TEXTURED CABLES
(panel of 36 sts)

Row 1: (RS) K2, p1, 2/2RC (see above), 2/2LC (see above), p3, k8, p3, 2/2RC, 2/2LC, p1, k2.

Rows 2, 4, and 6: (WS) K3, p8, k3, p2, k4, p2, k3, p8, k3.

Rows 3, 7, 11, and 15: K2, p1, [k8, p3] 2 times, k8, p1, k2.

Row 5: K2, p1, 2/2LC, 2/2RC, p3, k8, p3, 2/2LC, 2/2RC, p1, k2.

Rows 8, 10, 12, and 14: K3, p2, k4, p2, k3, p8, k3, p2, k4, p2, k3.

Row 9: K2, p1, k8, p3, 2/2RC, 2/2LC, p3, k8, p1, k2.

Row 13: K2, p1, k8, p3, 2/2LC, 2/2RC, p3, k8, p1, k2.

Row 16: [K3, p2, k4, p2] 3 times, k3.

Row 17: K2, p1, [k8, p3] 2 times, k8, p1, k2.

Row 18: K3, p8, k3, p2, k4, p2, k3, p8, k3.

Rep Rnds 1–18 for patt.

scarf

CO 36 sts.

Knit 2 rows.

Work Rows 1–18 of textured cables from chart or row-by-row instructions (see Stitch Guide) a total of 21 times—piece measures 72¼" (183.5 cm) from CO.

Knit 2 rows.

Loosely BO all sts knitwise.

finishing

Weave in loose ends.

Block lightly.

OPTIONAL FRINGE

Cut twenty-seven lengths of yarn twice the desired length for fringe. Holding three lengths tog, fold the yarn in half, insert crochet from WS to RS along short end of scarf, pull loop through WS, then pull cut ends through loop to secure. Rep 8 more times for a total of 9 fringes evenly spaced along one short end.

Rep for other short end.

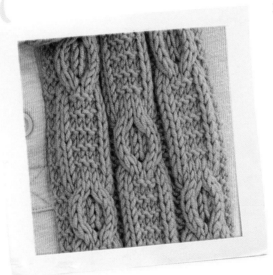

	k on RS, p on WS
•	p on RS, k on WS
	2/2RC (see Stitch Guide)
	2/2LC (see Stitch Guide)
	pattern repeat

TEXTURED CABLES

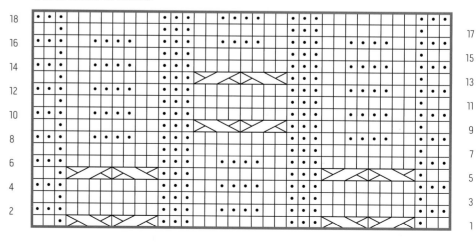

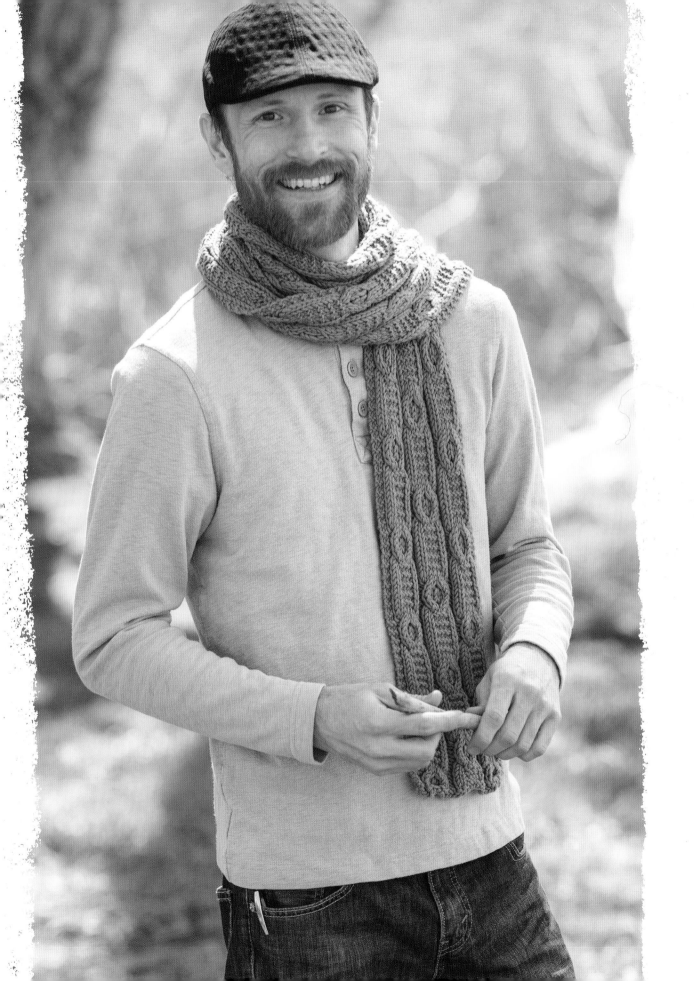

color-block
SCARF

designed by TERRI KRUSE

This fun scarf blends interesting elements to create a cozy winter staple. Two colors are combined in wide color blocks and narrow stripes. One of the colors is worked in reverse stockinette to create an interesting texture. Knitted in the round, there is no wrong side to this cozy scarf.

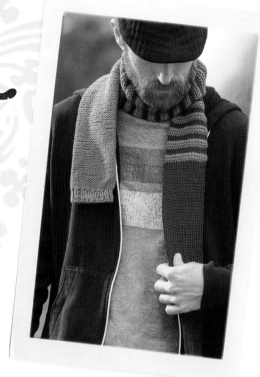

FINISHED SIZE
About 7½" (19 cm) in circumference and 58½" (148.5 cm) long.

YARN
Worsted weight (#4 Medium).

Shown here: Cascade Yarns Longwood (100% superwash extrafine merino wool; 191 yd [175 m]/100 g): #21 Blue (MC) and #09 Mustard (CC), 1 ball each.

NEEDLES
Ribbing: size U.S. 7 (4.5 mm): set of 4 or 5 double-pointed (dpn) or long circular (cir) for magic-loop method (see Glossary).

Scarf body: size U.S. 8 (5 mm): set of 4 or 5 dpn or long cir for magic-loop method.

Adjust needle size if necessary to obtain the correct gauge.

NOTIONS
Marker (m); tapestry needle.

GAUGE
18 and 22 rows = 4" (10 cm) in St st worked in rnds on larger needles.

STITCH GUIDE

STRIPE PATTERN

Rnd 1: Knit with CC.

Rnds 2 and 3: Purl with CC.

Rnds 4 and 5: Knit with MC.

Rep Rnds 1–5 for patt.

scarf

With MC and smaller needles, CO 34 sts. Place marker (pm) and join for working in rnds, being careful not to twist sts.

Work in k1, p1 rib for 5 rnds.

Change to larger needles.

Work in St st (knit every rnd) for 78 rnds—piece measures 15" (38 cm) from CO.

Join CC and work Rnds 1–5 of stripes patt (see Stitch Guide) 30 times.

Cut MC. With CC, work in Rev St st (purl every rnd) for 78 rnds—piece measures 57½" (146 cm) from CO.

Change to smaller needles.

Work in k1, p1 rib for 5 rnds.

Loosely BO all sts in patt.

finishing

Weave in loose ends.

Block to measurements.

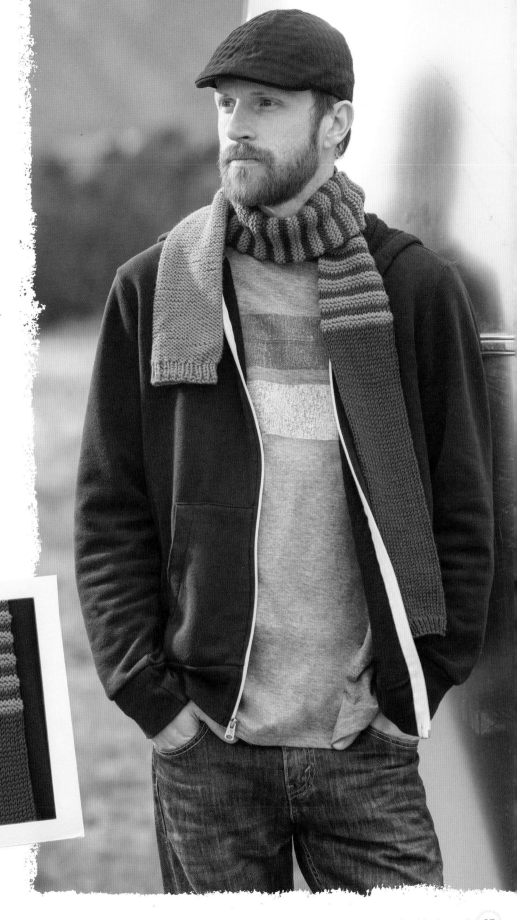

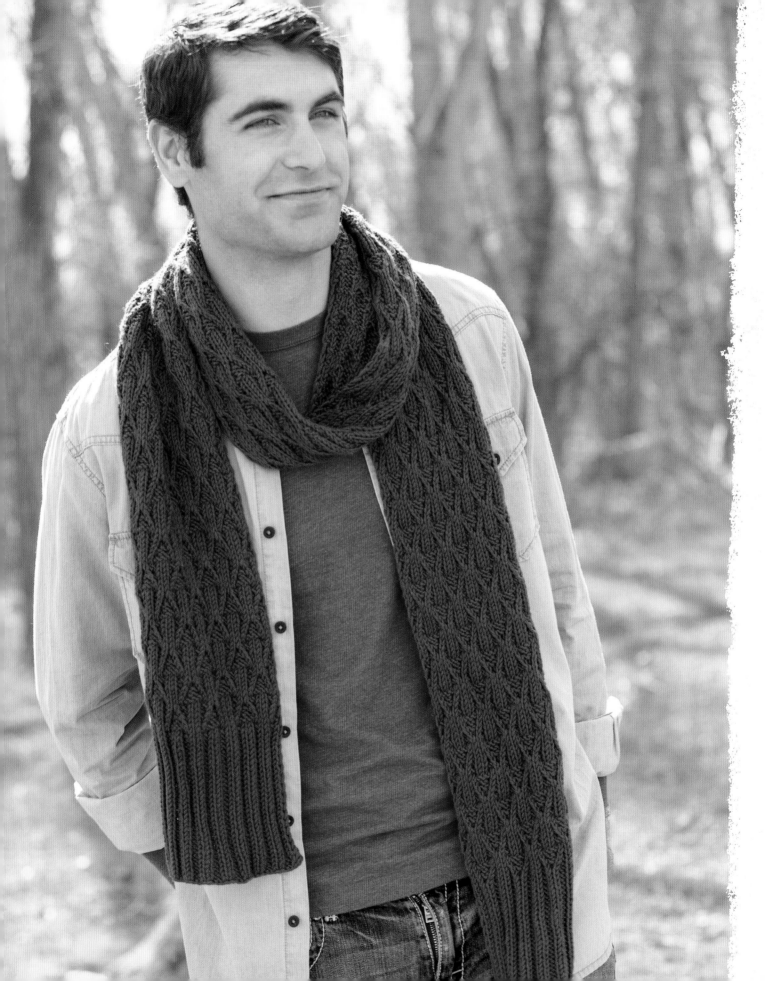

jermyn street
SCARF

designed by BETH KLING

This scarf features a cozy and highly textured stitch pattern paired with deep ribbing at each end. With a finished length of about 85½" (217 cm), it's perfect for wrapping around the neck multiple times to create a warm and stylish barrier against the chilliest of winter days.

FINISHED SIZE
About 85½" (217 cm) long and 7¼" (18.5 cm) wide.

YARN
Worsted weight (#4 Medium).

Shown here: Cascade Yarns Longwood (100% superwash extrafine merino wool; 191 yd [175 m]/100 g): #17 Deep Green, 3 balls.

NEEDLES
Size U.S. 8 (5 mm): 16" (40 cm) circular (cir).

Adjust needle size if necessary to obtain the correct gauge.

NOTIONS
Tapestry needle.

GAUGE
21 sts and 24 rows = 4" (10 cm) in wickerwork patt.

STITCH GUIDE

RIGHT TWIST (RT): Knit the next 2 stitches together but do not remove from left needle, knit just the first stitch again, then slide both stitches from needle.

LEFT TWIST (LT): Skip the first stitch and knit the second stitch through the back loop but do not remove from left needle, knit both the first and second stitches together through the back loop, then slide both stitches from needle.

NOTE:
Throughout the pattern (including ribbing rows) each RS row begins by slipping the first stitch knitwise with yarn in back; each WS row begins by slipping the first stitch purlwise with yarn in front.

scarf

Using the long-tail method (see Glossary), CO 42 sts.

Follow the chart on page 31 or row-by-row instructions below.

Row 1: (WS) Sl 1 purlwise with yarn in front (pwise wyf), p1, *k2, p2; rep from *.

Row 2: (RS) Sl 1 knitwise with yarn in back (kwise wyb), k1, *p2, k2; rep from *.

Rep these 2 rows 16 more times, ending with a RS row—34 rows total.

Row 3: (WS) Sl 1 pwise wyf, p1, *k2, p2; rep from *.

Row 4: (RS) Sl 1 kwise wyb, *k1, p1, RT (see Stitch Guide), LT (see Stitch Guide), p1, k1; rep from * to last st, k1.

Row 5: Sl 1 pwise wyf, *[p1, k1] 2 times, [k1, p1] 2 times; rep from * to last st, p1.

Row 6: Sl 1 kwise wyb, *k1, RT, p2, LT, k1; rep from * to last st, k1.

Row 7: Sl 1 pwise wyf, *p2, k4, p2; rep from * to last st, p1.

Row 8: Sl 1 kwise wyb, knit to end.

Row 9: Sl 1 pwise wyf, p1, *k2, p2; rep from *.

Row 10: Sl 1 kwise wyb, *LT, p1, k2, p1, RT; rep from * to last st, k1.

Row 11: Sl 1 pwise wyf, *[k1, p1] 2 times, [p1, k1] 2 times; rep from * to last st, p1.

Row 12: Sl 1 kwise wyb, *p1, LT, k2, RT, p1; rep from * to last st, k1.

Row 13: Sl 1 pwise wyf, *k2, p4, k2; rep from * to last st, p1.

Row 14: Sl 1 kwise wyb, knit to end.

Rep Rows 3–14 thirty-six more times, ending with a RS row—piece measures 74" (188 cm) from beg of wickerwork patt.

Next Row: (WS) Sl 1 pwise wyf, p1, *k2, p2; rep from *.

Next Row: (RS) Sl 1 kwise wyb, k1, *p2, k2; rep from *.

Rep the last 2 rows 16 more times, ending with a RS row—34 rows total of ribbing.

BO all sts in patt.

finishing

Weave in loose ends but do not trim the tails.

Wet-block to measurements; allow to dry completely.

Trim tails.

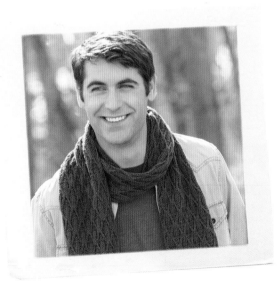

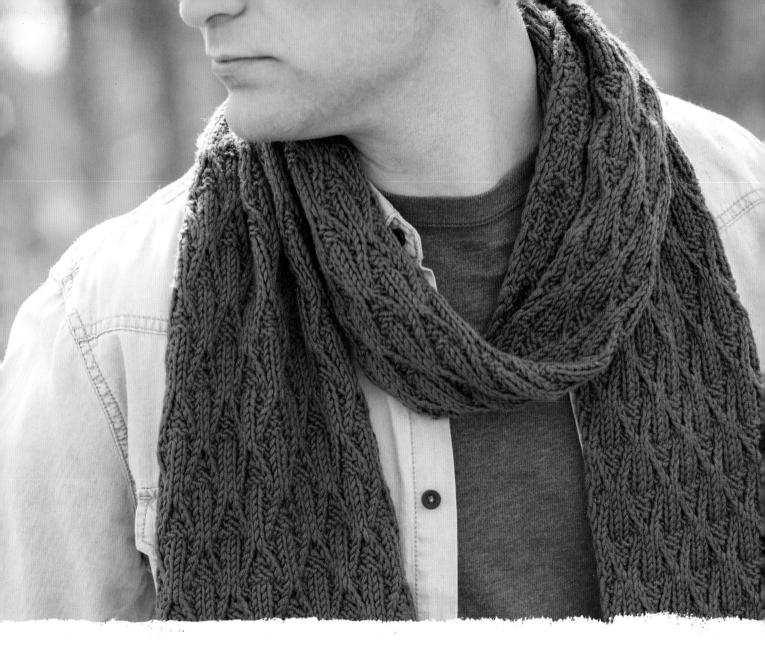

WICKERWORK

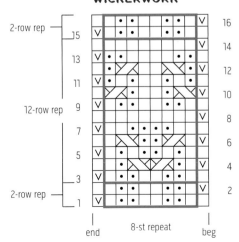

2-row rep — 15
12-row rep — 9
2-row rep — 1
16 14 13 12 11 10 9 8 7 6 5 4 3 2 1

end 8-st repeat beg

☐ k on RS, p on WS

• p on RS, k on WS

V sl 1 kwise wyb on RS, sl 1 pwise wyb on WS

⟋⟍ RT (see Stitch Guide)

⟍⟋ LT (see Stitch Guide)

☐ pattern repeat

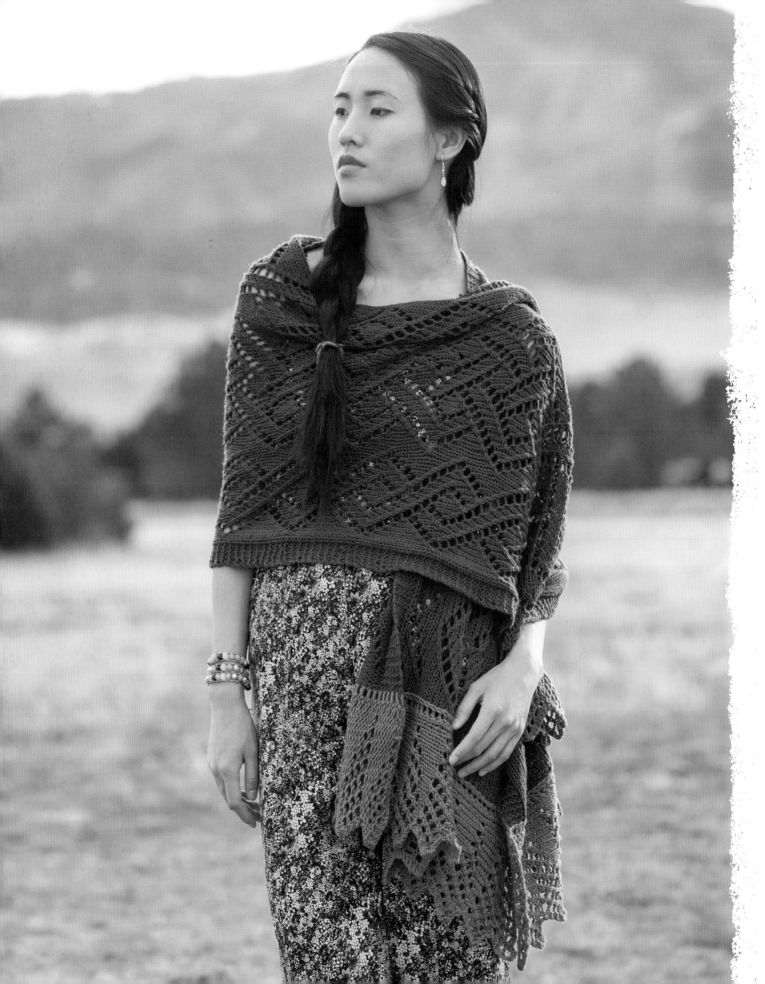

celtic winter
WRAP

designed by KAREN JOAN RAZ

What could be more comforting than a sumptuously soft wrap on a cool evening? This wrap is even more luxurious with a lacy Celtic design and fancy edging. It's a joy to knit and a delight to wear!

FINISHED SIZE

About 23" (58.5 cm) wide and 79" (200.5 cm) long.

YARN

Worsted weight (#4 Medium).

Shown here: Cascade Yarns Longwood (100% superwash extrafine merino wool; 191 yd [175 m]/100 g): #14 Zinfadel (A), 4 balls; #13 Rose (B), 1 ball.

NEEDLES

Size 10 (6 mm): straight.

Adjust needle size if necessary to obtain the correct gauge.

NOTIONS

Waste yarn for provisional cast-on; tapestry needle.

GAUGE

12 sts and 19½ rows = 4" (10 cm) in lace pattern, after blocking.

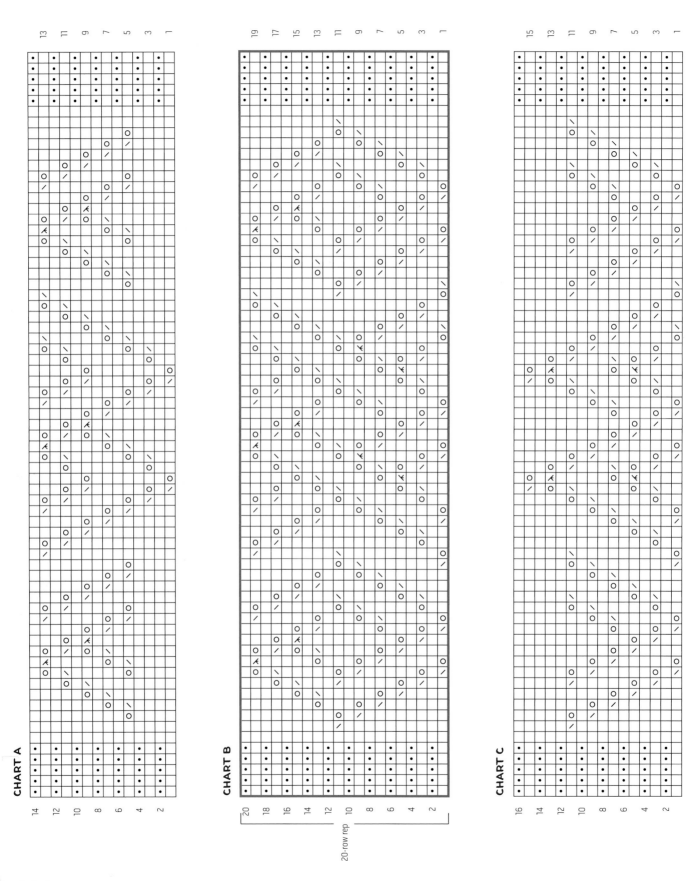

CHART A

CHART B

20-row rep

CHART C

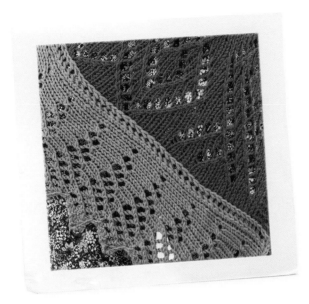

NOTES:
On Row 9 of Chart D, five stitches are used to bind off four stitches.

The leftmost ssk on Chart D is worked with one edging stitch and one body stitch; after working the ssk on a right-side row, turn the work and work the wrong-side row as usual.

As with most lace shawls, the exact gauge is not as important as the drape and hand of the fabric, but gauge will affect yarn requirement.

□	k on RS, p on WS
•	p on RS, k on WS
o	yo
/	k2tog
\	ssk
⋏	k3tog
⋌	sssk
⌒	bind off
▢	pattern repeat

CHART D

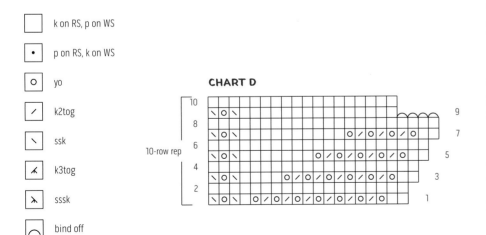

10-row rep

wrap

With waste yarn and using a provisional method (see Glossary), CO 70 sts.

BODY
Join A and knit 1 (RS) row.

Next row: (WS) K1, k2tog, k3, place marker (pm), p59, pm, k5—69 sts rem.

Work Rows 1–14 of Chart A.

Work Rows 1–20 of Chart B 15 times—piece measures about 64½" (164 cm) from CO.

Work Rows 1–16 of Chart C.

Next row: (WS) K2, k1f&b (see Glossary), k2, p59, k5—70 sts.

Cut A.

TOP EDGING
With RS facing, join B and use the backward-loop method (see Glossary) to CO 18 sts.

Work Rows 1–10 of Chart D 14 times, joining edging to live body sts at the end of every RS row—no body sts rem.

Loosely BO all sts.

BOTTOM EDGING
Carefully remove waste yarn from provisional CO and place exposed sts on needle. Work as for top edging.

finishing

Weave in loose ends.

Block to measurements.

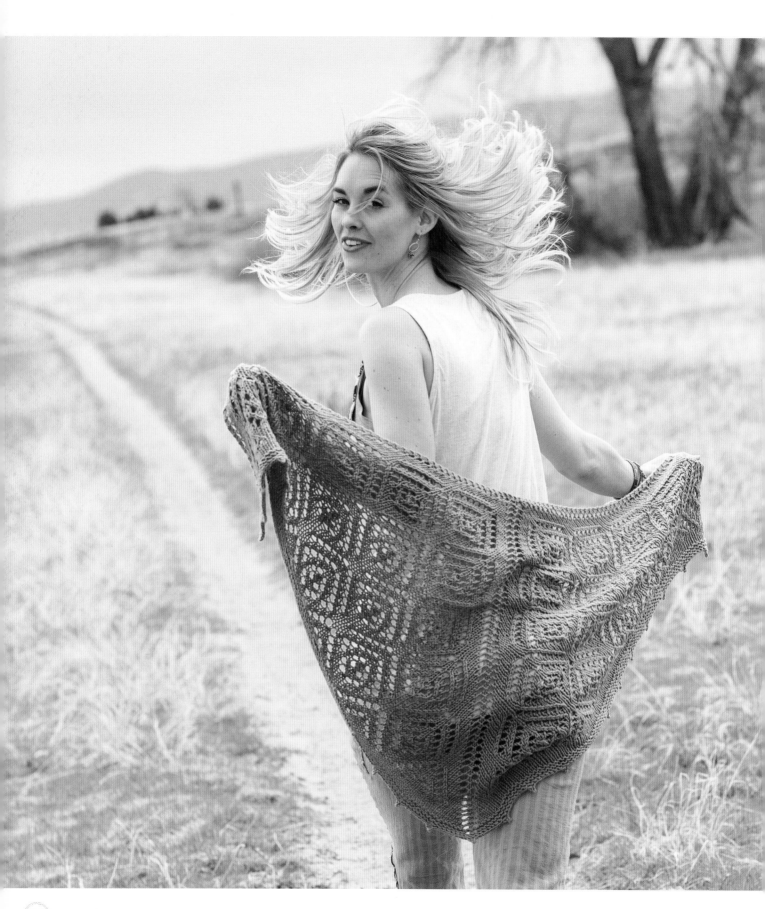

cowls + shawls

[FOR THE NECK]

Adorn yourself artfully with a quick cowl or shawl. Easy to knit and easy to wear, these designs can be worn throughout the year and make perfect gifts.

fair isle infinity
COWL

designed by TANIS GRAY

An ode to Turkish tapestries, this allover Fair Isle infinity cowl is a wonderful introduction to colorwork. Knitted entirely in the round and finished off with Kitchener stitch, there's no wrong side. Use up your leftover bits and bobs of yarn or pick a bright palette to fight off the winter blahs.

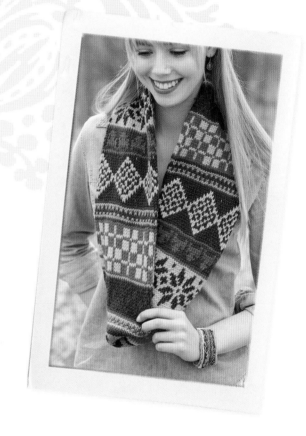

FINISHED SIZE
46" (117 cm) long and 13½" (34.5 cm) circumference.

YARN
Worsted weight (#4 Medium).

Shown here: Cascade Yarns Longwood (100% superwash extrafine merino wool; 191 yd [175 m]/100 g): #19 Deep Ocean (dark blue; A), #21 Blue (B), #06 Red Clay (C), #08 Artisan Gold (D), and #20 Cyan (E), 1 ball each.

NEEDLES
Size U.S. 8 (5 mm): 16" (40 cm) circular (cir).

Adjust needle size if necessary to obtain the correct gauge.

NOTIONS
Waste yarn and size G/6 (4 mm) crochet hook for provisional cast-on; marker (m); tapestry needle.

GAUGE
20½ sts and 20 rnds = 4" (10 cm) in Fair Isle patt.

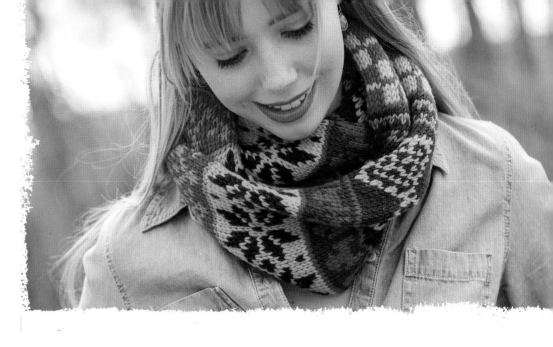

×	A	•	D	
▪	B	○	E	
▫	C	☐	pattern repeat	

FAIR ISLE

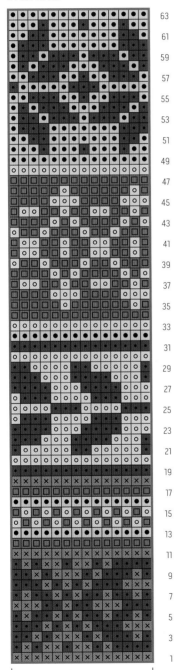

14-st rep
work 5 times

FAIR ISLE, CONTINUED

14-st rep
work 5 times

cowl

With waste yarn, A, and crochet hook, use the crochet chain method (see Glossary) to provisionally CO 70 sts. Place marker (pm) and join for working in rnds.

Work Rnds 1–114 of Fair Isle chart, then work Rnds 1–113 once more, working each 14-st rep 5 times in each rnd— piece measures 46" (117 cm) from CO.

Do not BO.

Place sts onto waste-yarn holder.

finishing

Secure loose ends inside tube. Block well.

Carefully remove waste yarn from provisional CO and place 70 exposed sts onto one needle. Place 70 held sts onto another needle.

With E threaded on a tapestry needle, use the Kitchener st (see Glossary) to graft the sts tog.

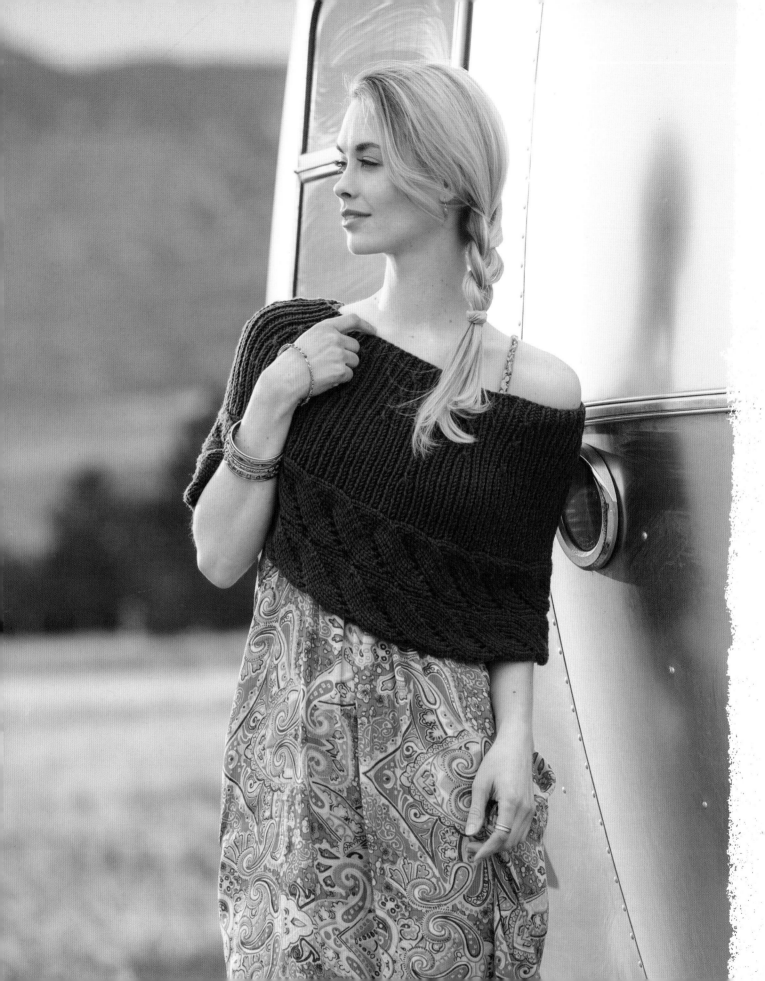

cabled
CAPELET

designed by ANGELA HAHN

The ribbed yoke of this capelet adjusts nicely to the wearer's shoulders, while the faux ribbed cable band adds an architectural element. The worsted-weight yarn is held doubled throughout, increasing the impact of the contrasting surface textures.

FINISHED SIZE

About 50½ (55½, 60¾, 65¾, 70¾)" (128.5 [141, 154.5, 167, 179.5] cm) bottom edge circumference, 24 (27, 28, 28, 28)" (61 [68.5, 71, 71, 71] cm) top edge circumference, and 13¼ (14½, 15¼, 15½, 15½)" (33.5 [37, 38.5, 39.5, 39.5] cm) long.

Capelet shown measures 50½" (128.5 cm) bottom circumference.

YARN

Worsted weight (#4 Medium), held double.

Shown here: Cascade Yarns Longwood (100% superwash extrafine merino wool; 191 yd [175 m]/100 g): #25 Deep Wisteria, 5 (5, 6, 6, 7) balls.

NEEDLES

Cable: size U.S. 10½ (6.5 mm): straight or circular (cir), any length.

Rib: size U.S. 9 (5.5 mm): 20" or 24" (50 or 60 cm) cir for upper rib and 24" to 40" (60 to 100 cm) cir for lower rib, depending on selected garment size.

Adjust needle size if necessary to obtain the correct gauge.

NOTIONS

Waste yarn for provisional CO; markers (m); tapestry needle.

GAUGE

15 sts and about 19 rows = 4" (10 cm) in faux cable st worked on larger needles.

16 sts and 22 rows = 4" (10 cm) in rib patt worked in rnds on smaller needles.

STITCH GUIDE

Sk2p: Sl 1 knitwise, k2tog, pass slipped st over de-creased st.

NOTES:
The yarn is held double throughout.

The faux cabled band is worked sideways and the ends are joined by the contrast color/duplicate-stitch method of grafting or by seaming; stitches are then picked up from one side of the band and worked in the round to the neck opening.

capelet
FAUX CABLE BAND FOR GRAFTED OPTION

With larger needles and waste yarn held double, CO 21 sts.

Purl 1 row, then knit 1 row.

Cut waste yarn and join main yarn, held double.

Next row: Work Row 1 of Faux Cable chart.

Work through Row 12 of chart, then rep these 12 rows 18 (20, 22, 24, 26) more times—19 (21, 23, 25, 27) 12-row reps total.

Work Rows 1–11 once more—piece measures about 50¼ (55¼, 60½, 65½, 70½)" (127.5 [140.5, 153.5, 166.5, 179] cm) from CO.

Cut yarn, leaving 1½ yd (1.5 meter) tail for grafting.

Join waste yarn, held double.

Knit 1 row, then purl 1 row.

BO all sts.

Graft Ends Together

With RS facing, fold band so that BO and CO edges are parallel and so that the BO edge is below the CO edge and the main yarn tail is at lower right.

Fold under the waste-yarn sections so that the edges of these sections are at the fold. Thread both yarn tails onto a single tapestry needle and join edges, following path of contrasting yarn as foll:

For the first st on the right-hand edge of the CO band, work through a single loop of main yarn. Bring the yarn back to the BO end and follow the path of contrasting yarn as it loops through two loops of main yarn. (Except for the band edges, the grafting yarn should always pass through two loops of main yarn before crossing to the other side).

Cont from right to left along the rows of contrasting waste yarn, for the CO edge, follow just the top loops of the waste yarn; for the BO edge, follow just the bottom loops of waste yarn. Pull the stitches gently to reveal the path of the waste yarn, to review the working yarn's path, and to ensure that no stitches are repeated or skipped. (Errors can be corrected by simply undoing stitches made by working yarn and redoing them.)

At the left-hand edge of the band, end by passing the working yarn through a single loop of the main yarn.

Once satisfied with the appearance of the graft, start at one edge of band and carefully cut loops of waste yarn that pass through loops of main yarn to free the waste yarn from the band.

FAUX CABLE BAND FOR SEAMED OPTION

With larger needles and yarn held double, CO 21 sts.

Work Rows 1–12 of Faux Cable of chart 19 (21, 23, 25, 27) times, then work Rows 1–12 once more—piece measures about 50½ (55½, 60¾, 65¾, 70¾)"

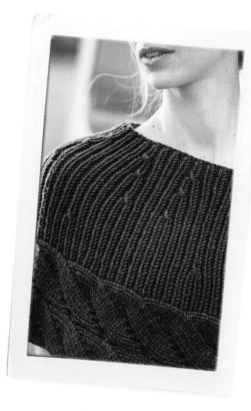

(128.5 [141, 154.5, 167, 179.5] cm) from CO.

BO all sts in patt.

With yarn threaded on a tapestry needle, sew CO and BO edges tog as invisibly as possible.

RIBBED YOKE

With RS facing, yarn held double, and using smaller, longer cir needle, pick up and knit 180 (198, 216, 234, 252) sts evenly spaced (3 sts for every 4 rows or 9 sts per 12-row patt rep) around cable band.

Place marker (pm) and join for working in rnds.

Cont for your size as foll.

Size 50½" only
Skip to All sizes.

Sizes 55½ (60¾, 65¾, 70¾)" only
Set-up rnd (dec): Knit and at the same time dec 6 (6, 10, 12) sts evenly spaced—192 (210, 224, 240) sts rem.

All sizes

Rnd 1: *K1, p1; rep from *.

Rep this rnd 10 (10, 12, 14, 14) more times.

Cont for your size as foll.

Sizes 50½ (60¾)" only

Next rnd (dec): *[K1, p1] 8 times, sk2p (see Stitch Guide), [p1, k1] 5 times, p1; rep from *—168 (196) sts rem.

Work even in k1, p1 rib for 11 (13) rnds.

Next rnd (dec): *[K1, p1] 3 times, sk2p, [p1, k1] 7 times, p1, sk2p, p1; rep from *—144 (168) sts rem.

Work even in k1, p1 rib for 7 (11) rnds.

Next rnd (dec): *[K1, p1] 3 times, sk2p, [p1, k1] 5 times, p1, sk2p, p1; rep from *—120 (140) sts rem.

Work even in k1, p1 rib for 5 (7) rnds.

Next rnd (dec): *[K1, p1] 3 times, sk2p, [p1, k1] 3 times, p1, sk2p, p1; rep from *—96 (112) sts rem.

Skip to All sizes.

Size 55½" only

Next rnd (dec): *[K1, p1] 9 times, sk2p (see Stitch Guide), [p1, k1] 5 times, p1; rep from *—180 sts rem.

Work even in k1, p1 rib for 11 rnds.

Next rnd (dec): *[K1, p1] 4 times, sk2p, [p1, k1] 7 times, p1, sk2p, p1; rep from *—156 sts rem.

Work even in k1, p1 rib for 11 rnds.

Next rnd (dec): *[K1, p1] 4 times, sk2p, [p1, k1] 5 times, p1, sk2p, p1; rep from *—132 sts rem.

Work even in k1, p1 rib for 7 rnds.

Next rnd (dec): *[K1, p1] 4 times, sk2p, [p1, k1] 3 times, p1, sk2p, p1; rep from *—108 sts rem.

Skip to All sizes.

Size 65¾" only

Next rnd (dec): *[K1, p1] 3 times, sk2p (see Stitch Guide), [p1, k1] 9 times, p1, sk2p, p1; rep from *—196 sts rem.

Work even in k1, p1 rib for 15 rnds.

Next rnd (dec): *[K1, p1] 3 times, sk2p, [p1, k1] 7 times, p1, sk2p, p1; rep from *—168 sts rem.

Work even in k1, p1 rib for 7 rnds.

Next rnd (dec): *[K1, p1] 3 times, sk2p, [p1, k1] 5 times, p1, sk2p, p1; rep from *—140 sts rem.

Work even in k1, p1 rib for 7 rnds.

Next rnd (dec): *[K1, p1] 3 times, sk2p, [p1, k1] 3 times, p1, sk2p, p1; rep from *—112 sts rem.

Skip to All sizes.

Size 70¾" only

Next rnd (dec): *[K1, p1] 3 times, sk2p (see Stitch Guide), [p1, k1] 8 times, p1, sk2p, p1; rep from *—208 sts rem.

Work even in k1, p1 rib for 15 rnds.

Next rnd (dec): *[K1, p1] 3 times, sk2p, [p1, k1] 6 times, p1, sk2p, p1; rep from *—176 sts rem.

Work even in k1, p1 rib for 7 rnds.

Next rnd (dec): *[K1, p1] 3 times, sk2p, [p1, k1] 4 times, p1, sk2p, p1; rep from *—144 sts rem.

Work even in k1, p1 rib for 7 rnds.

Next rnd (dec): *[K1, p1] 3 times, sk2p, [p1, k1] 2 times, p1, sk2p, p1; rep from *—112 sts rem.

Skip to All sizes.

All sizes

Work even in k1, p1 rib for 6 (6, 6, 8, 8) rnds. BO all sts in patt.

finishing

Weave in loose ends.

Block to measurements.

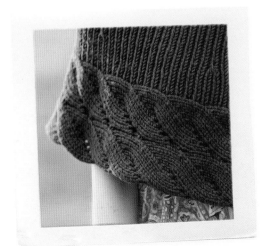

FAUX CABLE

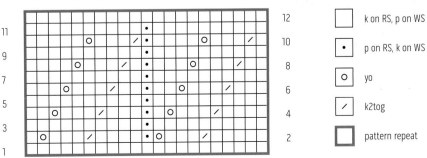

□	k on RS, p on WS
•	p on RS, k on WS
○	yo
╱	k2tog
⬜	pattern repeat

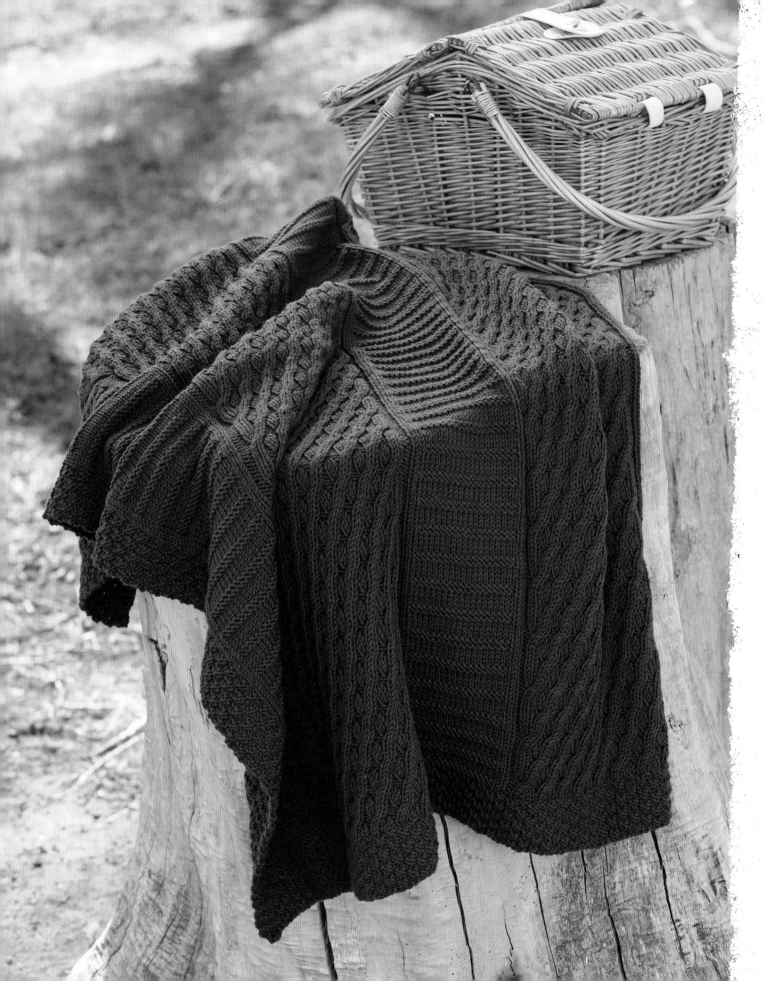

chutes + ladders
BLANKET

designed by LYNN M. WILSON

This cozy blanket was inspired by the children's game Chutes & Ladders. The diagonal "chutes" cable panels are worked with an unusual five-stitch cable pattern. While the instructions may appear complex, once you've worked a few rows, you'll find the pattern easy to master.

FINISHED SIZE

About 30½ (36½)" (77.5 [92.5] cm) wide and 40 (47)" (101.5 [119.5] cm) long.

Shawl/blanket shown measures 36½" (92.5 cm) wide.

YARN

Worsted weight (#4 Medium).

Show here: Cascade Yarns Longwood (100% superwash extrafine merino wool; 191 yd [175 m]/100 g): #19 Deep Ocean, 7 (9) balls.

NEEDLES

Size U.S. 7 (4.5 mm): 24" (60 cm) circular (cir).

Adjust needle size if necessary to obtain the correct gauge.

NOTIONS

Markers (m); cable needle (cn); tapestry needle.

GAUGE

25 sts and 28 rows = 4" (10 cm) in chutes patt.

17½ sts and 26 rows = 4" (10 cm) in ladders patt.

23 sts and 28 rows = 4" (10 cm) in double seed st.

STITCH GUIDE

2/3 RC: Sl 3 sts onto cn and hold in back of work, k2, return purl st from cn to left needle tip and purl this st, then k2 from cn.

DOUBLE SEED STITCH
(mult of 4 sts)

Rows 1 and 2: *P2, k2; rep from *.

Rows 3 and 4: *K2, p2; rep from *.

Rep Rows 1–4 for patt.

LADDERS PATTERN
(panel of 16 [22] sts)

Row 1: (RS) K2, p12 (18), k2.

Row 2: (WS) P2, k12 (18), p2.

Rows 3 and 5: Knit.

Rows 4 and 6: Purl.

Rep Rows 1–6 for patt.

CHUTES PATTERN
(mult of 6 sts + 3)

Rows 1 and 3: (RS) P2, *k2, p1; rep from * to last st, p1.

Rows 2 and 4: K2, *p2, k1; rep from * to last st, k1.

Row 5: P2, *2/3 RC (see above), p1; rep from * to last st, p1.

Rows 6, 8, and 10: K2, *p2, k1; rep from * to last st, k1.

Rows 7 and 9: P2, *k2, p1; rep from * to last st, p1.

Row 11: P2, k2, p1, *2/3 RC, p1; rep from * to last 4 sts, k2, p2.

Row 12: K2, *p2, k1; rep from * to last st, k1.

Rep Rows 1–12 for patt.

Note:
Two sizes are provided; the smaller size is suitable for a baby blanket and the larger size is suitable for a throw.

blanket

CO 148 (176) sts.

Work Rows 1–4 of double seed st (see Stitch Guide) 4 times, then work Row 1 once more—17 rows total.

Cont for your size as foll.

Size 30½" only
Set-up row: (WS) Work 10 sts in double seed st as established, place marker (pm), *p16, pm, p2, M1P (see Glossary), [(p4, M1P) 2 times, (p3, M1P) 2 times] 2 times, [p4, M1P] 2 times, p2, pm; rep from * once, p16, pm, work rem 10 sts in double seed st as established—170 sts.

Size 36½" only
Set-up row: (WS) Work 10 sts in double seed st as established, place marker (pm), *p22, pm, p2, M1P (see Glossary), [(p4, M1P) 2 times, p3, M1P] 3 times, [p4, M1P] 2 times, p2, pm; rep from * once, p22, pm, work rem 10 sts in double seed st at established—200 sts.

Both sizes
Next row: Work as established to first m, sl m, [work Row 1 of ladders patt (see Stitch Guide or chart) to next m, slip marker (sl m), work Row 1 of chutes patt (see Stitch Guide or chart) to next m, sl m] 2 times, work Row 1 of ladders patt to next m, sl m, work as established to end.

Cont in patts as established until piece measures 38 (45)" (96.5 [114.5] cm)

from CO or 2" (5 cm) less than desired total length, ending with Row 2 or 8 of chutes patt.

Cont for your size as foll.

Size 30½" only
Dec row: (RS) Removing markers as you come to them, work 10 sts as established, *k16, k2, k2tog, [k3, k2tog, k2, k2tog] 5 times, k2; rep from * once, k16; work as established to end—148 sts rem.

Size 36½" only
Dec row: (RS) Removing markers as you come to them, work 10 sts as established, *k22, k2, k2tog, [(k3, k2tog) 2 times, k2, k2tog] 3 times, k3, k2tog, k2, k2tog, k2; rep from * once, k22, work as established to end—176 sts rem.

Both sizes
Work all sts in double seed st for 16 rows.

Loosely BO all sts in patt.

finishing

Weave in loose ends.

Block to measurements.

⬜	k on RS, p on WS
•	p on RS, k on WS
✕	2/3RC (see Stitch Guide)
⬜	pattern repeat

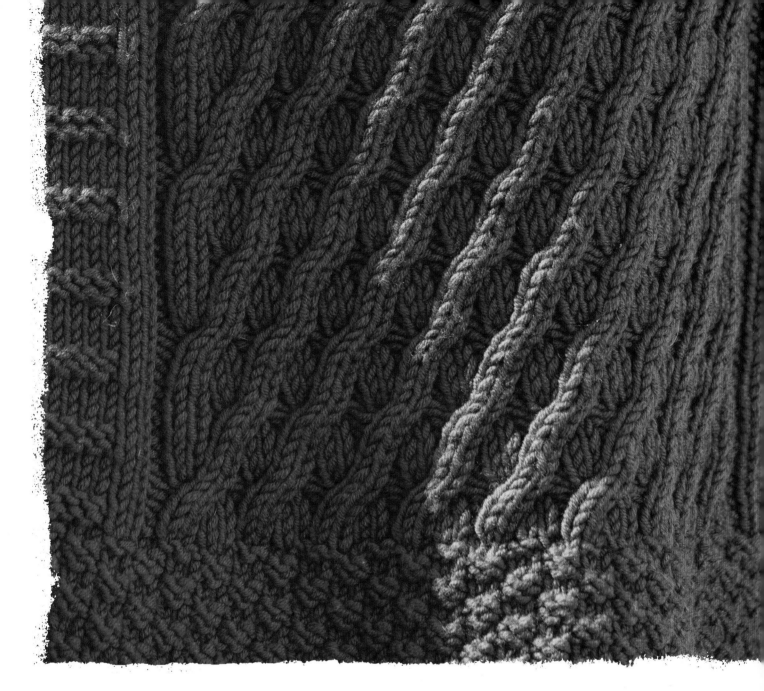

CHUTES

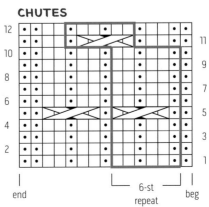

LADDERS

end

12 sts
work for size 30½"

18 sts
work for size 36½"

beg

6-st
repeat

cabled
COWL

designed by DEBBIE O'NEILL

Cowls make wonderful alternatives to scarves. They don't fall off, they don't get tangled, they're stylish, and they're the perfect canvas for playing with new stitch patterns. This cowl is a perfect example!

FINISHED SIZE
About 23½ (31¼)" (59.5 [79.5] cm) in circumference and 10 (14¾)" (25.5 [37.5] cm) tall.

Cowl shown measures 23½" (59.5 cm).

YARN
Worsted weight (#4 Medium).

Shown here: Cascade Yarns Longwood (100% superwash extrafine merino wool; 191 yd [175 m]/100 g): #15 Green Olive, 2 (3) balls.

NEEDLES
Size U.S. 6 (4 mm): 24" (60 cm) circular (cir).

Adjust needle size if necessary to obtain the correct gauge.

NOTIONS
Markers (m); cable needle (cn); tapestry needle.

GAUGE
21 sts and 32 rnds = 4" (10 cm) in St st worked in rnds.

48 sts and 63 rnds = 8" (20.5 cm) in cable patt worked in rnds.

STITCH GUIDE

2/1 LC: Sl 2 sts onto cn and hold in front of work, k1, then k2 from cn.

2/1 RC: Sl 1 st onto cn and hold in back of work, k2, then k1 from cn.

2/2 LC: Sl 2 sts onto cn and hold in front of work, k2, then k2 from cn.

2/2 RC: Sl 2 sts onto cn and hold in back of work, k2, then k2 from cn.

2/3 RC: Sl 3 sts onto cn and hold in back of work, k2, then k3 from cn.

SEED STITCH
(mult of 2 sts)

Rnd 1: *K1, p1; rep from *.

Rnd 2: *P1, k1; rep from *.

Rep Rnds 1 and 2 for patt.

cowl

CO 128 (170) sts.

Place marker (pm) and join for working in rnds, being careful not to twist sts.

Work in seed st (see Stitch Guide) for 4 (6) rnds.

Next rnd: Beg with Rnd 1 (Rnd 13), work Cable chart and *at the same time* using the M1 method (see Glossary), inc 13 (18) sts evenly spaced—141 (188) sts total.

Note: Sts are decreased in the last rnd of the charted patt; read all the way through the foll instructions before proceeding.

Work through Rnd 24 of chart, then rep Rnds 1–24 two (three) more times, then work Rnd 1 (Rnds 1–13) once again—piece measures about 9½ (13)" (24 [33] cm) from CO.

At the same time on the last rnd of chart (Rnd 1 or 13), dec 13 (18) sts evenly spaced—128 (170) sts rem.

Work even in seed st for 4 (6) rnds.

BO all sts in patt.

finishing

Weave in loose ends.

Block to measurements.

☐ k

⊙ yo

⟋ k2tog

⟍ ssk

⤬ 2/1 RC (see Stitch Guide)

⤬ 2/1 LC (see Stitch Guide)

⤬ 2/2 RC (see Stitch Guide)

⤬ 2/2 LC (see Stitch Guide)

⤬ 2/3 RC (see (Stitch Guide)

☐ pattern repeat

CABLE

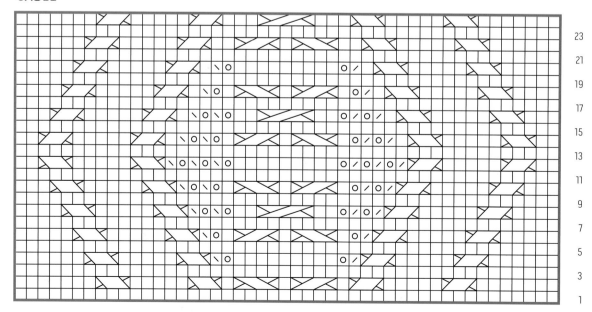

23
21
19
17
15
13
11
9
7
5
3
1

47-st repeat

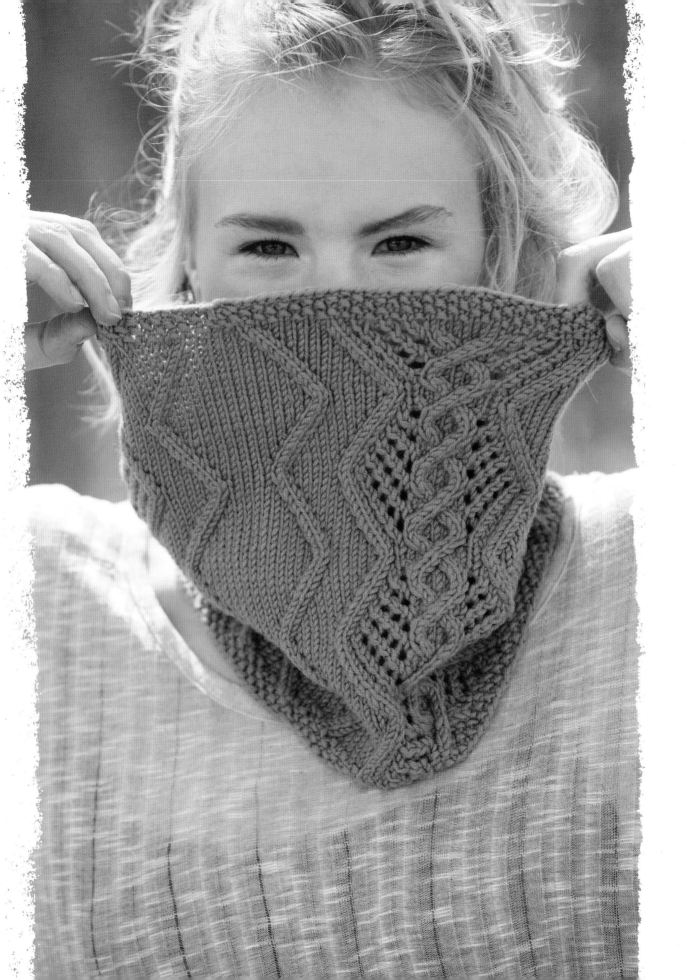

brubaker
COWL

designed by MINDY WILKES

Cowls are becoming a wardrobe staple. A variation of 2×2 ribbing is combined with twisted stitches to create an interesting texture that resembles allover cables in this version. Worked in the round, this everyday accessory knits up fast!

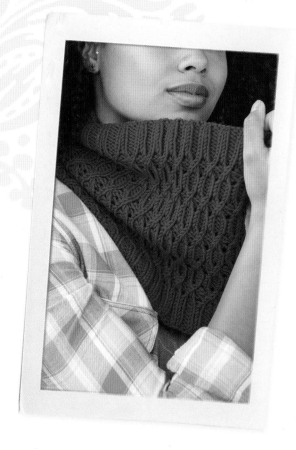

FINISHED SIZE
About 24½" (62 cm) in circumference and 10" (25.5 cm) long.

YARN
Worsted weight (#4 Medium).

Shown here: Cascade Yarns Longwood (100% superwash extrafine merino wool; 191 yd [175 m]/100 g): #04 Red, 2 balls.

NEEDLES
Size U.S. 7 (4.5 mm): 24" (60 cm) circular (cir).

Adjust needle size if necessary to obtain the correct gauge.

NOTIONS
Marker (m); tapestry needle.

GAUGE
19 sts and 24 rnds = 4" (10 cm) in twisted rib patt worked in rnds.

STITCH GUIDE

LEFT TWIST (LT): Skip the first st on the left needle tip, knit second st through the back loop (tbl) but leave sts on left needle, then k2togtbl and drop both sts off left needle.

RIGHT TWIST (RT): K2tog but leave both sts on left needle tip, knit the first st again, then drop both sts off left needle.

K2, P2 RIB
(mult of 4 sts)

All rnds: *K1, p2, k1; rep from *.

TWISTED RIB
(mult of 4 sts)

Rnds 1 and 2: *K1, p2, k1; rep from *.

Rnd 3: *LT (see above), RT (see above); rep from *.

Rnd 4: *P1, k2, p1; rep from *.

Rnd 5: *P1, RT, p1; rep from *.

Rnd 6: *P1, k2, p1; rep from *.

Rnd 7: *RT, LT; rep from *.

Rnds 8 and 9: *K1, p2, k1; rep from *.

Rep Rnds 1–9 for patt.

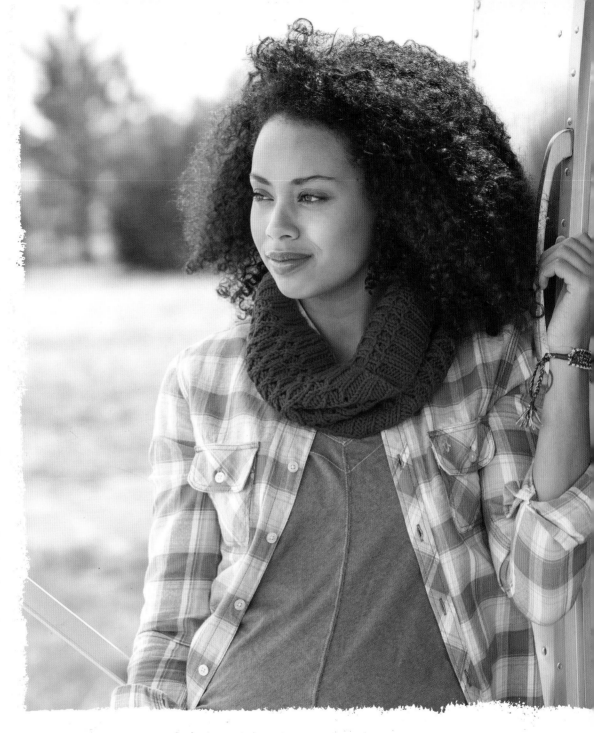

cowl

CO 116 sts. Place marker (pm) and join for working in rnds, being careful not to twist sts.

Work k2, p2 rib (see Stitch Guide) for 6 rnds.

Work Rnds 1–9 of twisted rib (see Stitch Guide) 5 times.

Work k2, p2 rib for 6 more rnds.

Loosely BO all sts in patt.

finishing

Weave in ends.

Block to measurements.

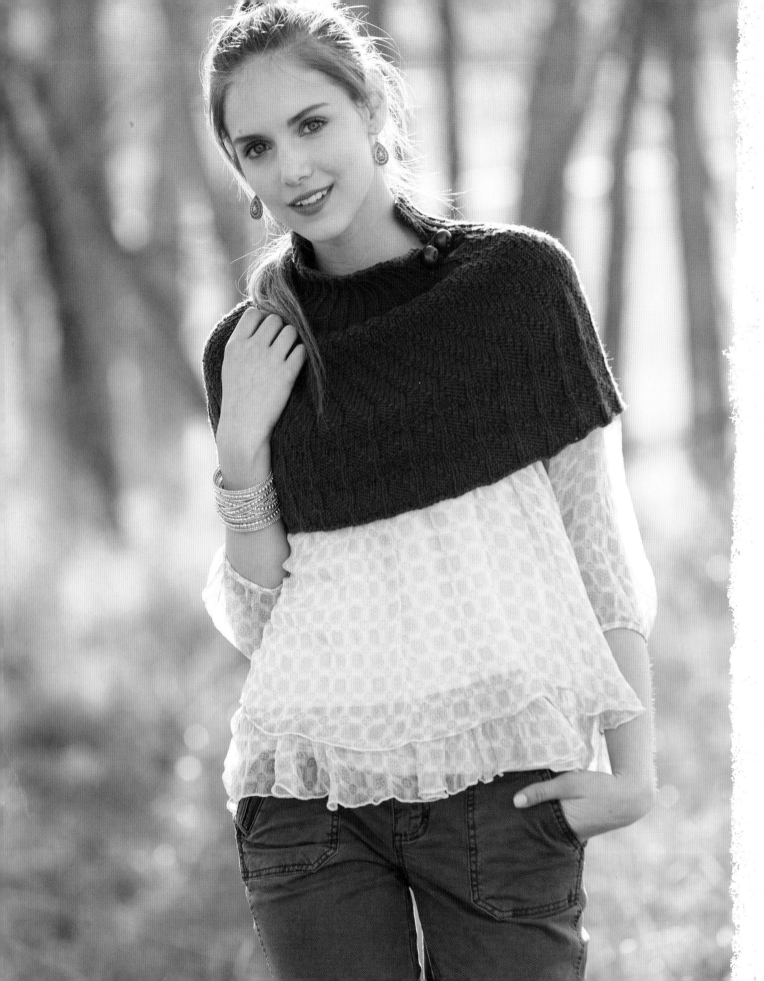

progression
C O W L

designed by ROBIN MELANSON

This cowl is worked in the round from the lower edge to the collar. It progresses with decreases worked into the stitch pattern to shape the shoulders. The cowl is fully reversible and the button fastenings can be placed so that the large buttons can be on either face of the fabric. Position the collar opening at the center or at one side for an asymmetrical look.

FINISHED SIZE
About 40 (44, 48)" (101.5 [112, 122] cm) in circumference at lower edge, 20 (22, 24)" (51 [56, 61] cm) in circumference at upper edge (before collar), and 13¾" (35 cm) long (including collar).

Cowl shown measures 40" (101.5 cm) at lower edge.

YARN
Worsted weight (#4 Medium).

Shown here: Cascade Yarns Longwood (100% superwash extrafine merino wool; 191 yd [175 m]/100 g): #28 Plum, 2 (3, 3) balls.

NEEDLES
Cowl: size U.S. 8 (5 mm): 32" and 24" (80 and 60 cm) circular (cir).

Collar: Size U.S. 7 (4.5 mm): 16" (40 cm) cir.

Adjust needle size if necessary to obtain the correct gauge.

NOTIONS
Markers (m); two ⅞" (22 mm) buttons; two ½" (13 mm) buttons; tapestry needle; 12" (30.5 cm) length of ⅛" (3 mm) leather cord.

GAUGE
18 sts and 28 rnds = 4" (10 cm) in seaweed st on larger needles.

STITCH GUIDE

SEAWEED STITCH
(mult of 6 sts)

Rnds 1 and 2: *P2, k4; rep from *.

Rnds 3 and 4: *P3, k3; rep from *.

Rnds 5 and 6: *P4, k2; rep from *.

Rnds 7 and 8: K1, *p4, k2; rep from * to last 5 sts, p4, k1.

Rnds 9 and 10: K2, *p3, k3; rep from * to last 4 sts, p3, k1.

Rnds 11 and 12: K3, *p2, k4; rep from * to last 3 sts, p2, k1.

Rep Rnds 1–12 for patt.

cowl

With larger, longer cir needle, CO 180 (198, 216) sts. Place marker (pm) and join for working in rnds, being careful not to twist sts.

Work Rnds 1–12 of seaweed patt (see Stitch Guide) 3 times.

SHAPE SHOULDERS
Rnds 1 and 2: *K4, p2; rep from *.

Rnds 3 and 4: P1, *k4, p2; rep from * to last 5 sts, k4, p1.

Rnds 5 and 6: *P2, k4; rep from *.

Rnds 7 and 8: K1, *p2, k4; rep from * to last 5 sts, p2, k3.

Rnd 9: *K2, p1, p2tog, k1; rep from *—150 (165, 180) sts rem.

Rnd 10: K2, *p2, k3; rep from * to last 3 sts, p2, k1.

Rnds 11 and 12: *K3, p2; rep from *.

Rnds 13 and 14: P1, *k3, p2; rep from * to last 4 sts, k3, p1.

Rnds 15 and 16: *P2, k3; rep from *.

Rnds 17 and 18: K1, *p2, k3; rep from * to last 4 sts, p2, k2.

Rnds 19 and 20: K2, *p2, k3; rep from * to last 3 sts, p2, k1.

Rnd 21: Remove m, k1, replace m, *k2, p1, p2tog; rep from *—120 (132, 144) sts rem.

Change to shorter, larger cir needle.

Rnd 22: *K2, p2, rep from *.

Rnds 23 and 24: P1, *k2, p2; rep from * to last 3 sts, k2, p1.

Rnds 25 and 26: *P2, k2; rep from *.

Rnds 27 and 28: K1, *p2, k2; rep from * to last 3 sts, p2, k1.

Rnd 29: *K2, p2, rep from *.

Rnds 30, 31, and 32: Rep Rnds 22, 23, and 24.

Rnd 33: P1, *ssk, p2; rep from * to last 3 sts, ssk, p1—90 (99, 108) sts rem.

COLLAR
Change to smaller cir needle.

Set-up rnd: K1, *k1, p2; rep from * to last 2 sts, k2, remove m.

Cont back and forth in rows as foll.

Row 1: (WS) K1, *p1, k2; rep from * to last 2 sts, p1, k1.

Row 2: (RS) K1, *k1, p2; rep from * to last 2 sts, k2.

Rep the last 2 rows 11 more times or until collar measures 4" (10 cm).

BO all sts in patt.

finishing

Weave in loose ends.

Block to measurements.

BUTTONS
Using a few plies of yarn threaded on a tapestry needle, attach each smaller button to a larger button. Push the smaller buttons through each side of collar opening at desired spot—larger buttons are on RS. Buttons may be reversed if WS of cowl is preferred.

Tie leather cord between buttons as desired.

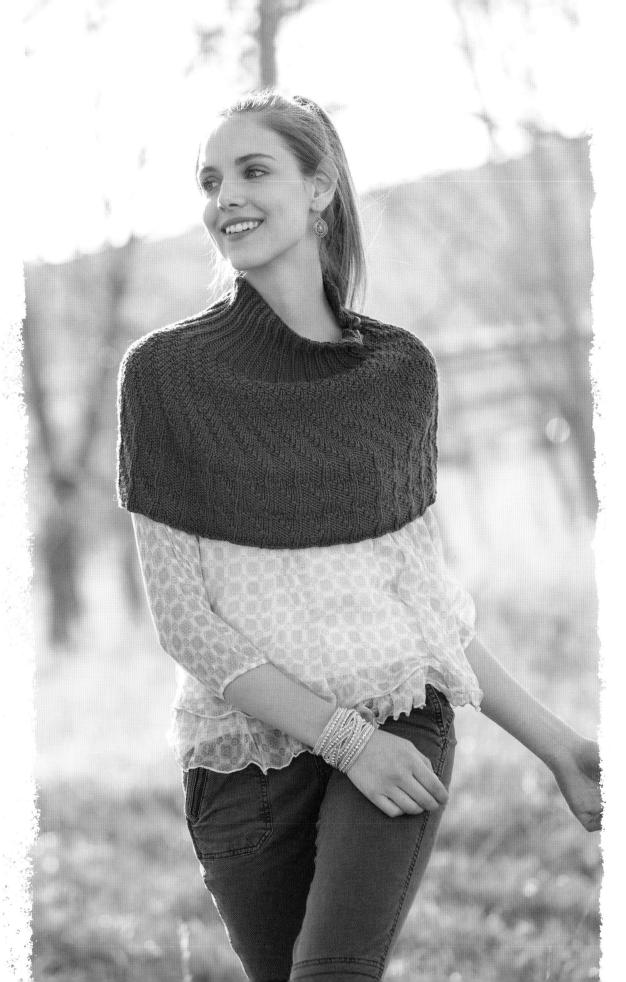

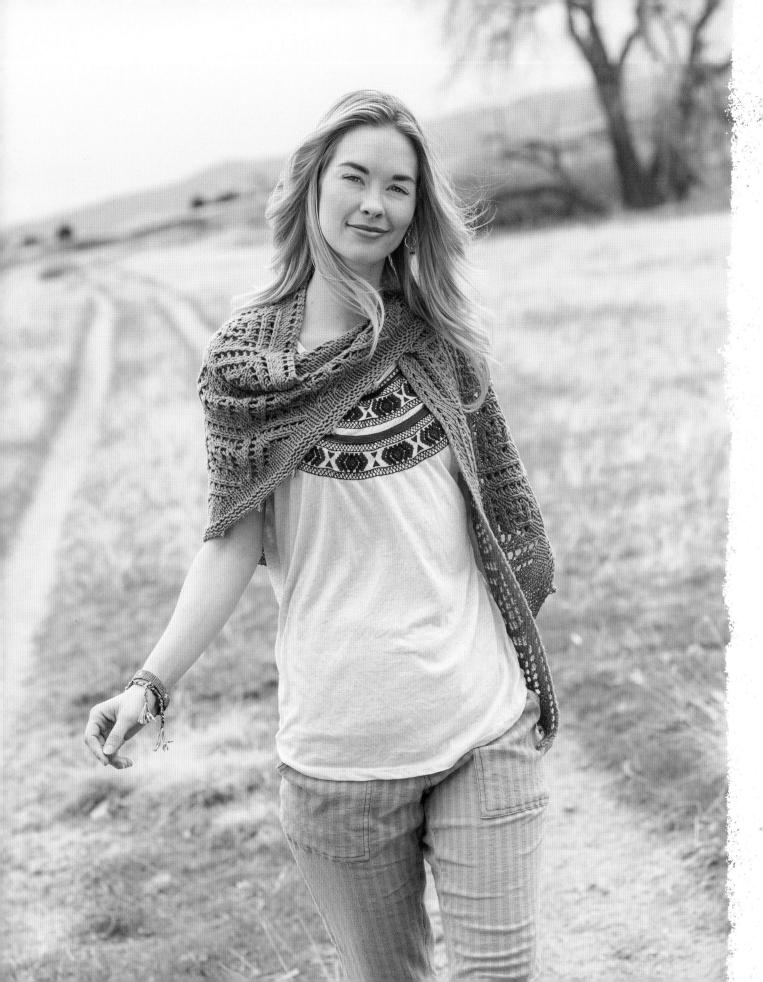

quixote
SHAWL

designed by JUDY MARPLES

Inspired by stories of medieval knits and flights of fancy, this triangular shawl is both simple and satisfying. Cast on with a few stitches at the top and work your way down the body in an easy lace pattern and end with a stretchy bind-off that's an essential technique for all shawl knitters.

FINISHED SIZE

About 58"
(147.5 cm) wide and
26" (66 cm) long.

YARN

Worsted weight (#4 Medium).

Shown here:
Cascade Yarns Longwood (100% superwash extrafine merino wool; 191 yd [175 m]/100 g): #27 Lilac, 3 balls.

NEEDLES

Size U.S. 6 (4 mm): 24" or 32" (60 or 80 cm) circular (cir).

Adjust needle size if necessary to obtain the correct gauge.

NOTIONS

Markers (m); tapestry needle.

GAUGE

15 sts and 24 rows = 4" (10 cm) in St st, unblocked.

Note: Gauge is not critical but may affect yardage used.

STITCH GUIDE

MAKE PICOT (MP): Return st from right needle back to left needle tip, use the knitted method (see Glossary) to CO 2 sts, then use the standard method (see Glossary) to BO 2 sts.

DECREASE BIND-OFF: K2, *return these 2 sts back to left needle tip, then k2tog through back loops (tbl), k1; rep from *.

Note: Keep in mind that one stitch will remain on right needle tip after a picot is made, so you'll begin with k1 instead of k2 to continue binding off.

NOTES:
The shawl begins at the center top edge and is worked downward to the bottom edge, ending with a garter-stitch border and picot bind-off.

The four edge stitches (two stitches at each end of every row) are not represented on the charts; they are worked in garter stitch (knit every row) throughout.

The center stitch is not represented on the charts—it is knitted on every row.

Charts A, B, and C each represents one-half of the shawl; work the chart, work the center st, then work the chart again.

To change the shawl dimensions, work more or fewer repeats of Charts B. Each sixteen-row repeat with add or subtract about 5½" (14 cm) in overall length. Keep in mind that doing so will affect yardage requirements.

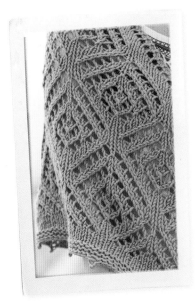

shawl

Using the backward-loop method (see Glossary), CO 2 sts.

Knit 6 rows.

Next row: K2, do not turn work, but rotate it one-quarter turn to the right, then pick up and knit 3 sts along the left side edge (1 st in each garter ridge). Turn the work another quarter turn to the right and pick up and knit 2 sts (1 st in each loop) from CO edge—7 sts total.

Next row: (WS) K2, p1, place marker (pm), k1 (center st), pm, p1, k2.

Set-up row: K2 (edge sts; knit every row), work Row 1 of Chart A to m, sl m, k1 (center st; knit every row), sl m, work

Row 1 of Chart A again to last 2 sts, k2 (edge sts; knit every row)—4 sts inc'd.

Cont in patt as established, work Rows 2–16 of Chart A—39 sts.

Next row: K2, work Row 1 of Chart B to m, sl m, k1, sl m, work Row 1 of Chart B to last 2 sts, k2—4 sts inc'd.

Cont in patt, work Rows 2–16 of Chart B (see Notes), then rep Rows 1–16 four more times.

Work Rows 1–6 of Chart B once more—211 sts.

Next row: K2, work Row 1 of Chart C to m, sl m, k1, sl m, work Row 1 of Chart C to last 2 sts, k2—4 sts inc'd.

Cont in patt, work Rows 2–10 of Chart C, noting that there are no incs worked in Row 9—227 sts.

With RS facing, and using the decrease method (see Stitch Guide), BO 8 sts, *make picot (see Stitch Guide), BO 8 sts; rep from * to last 11 sts, make picot, BO rem 10 sts.

finishing

Weave in loose ends but do not trim the tails.

Soak shawl in cool water and no-rinse wool wash for at least 30 minutes to allow the fibers to become completely saturated. Block as desired.

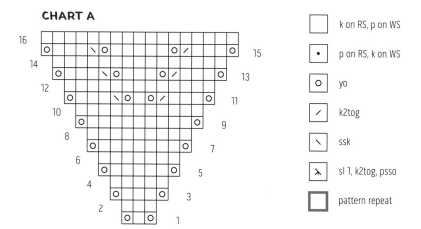

CHART A

☐	k on RS, p on WS
•	p on RS, k on WS
○	yo
╱	k2tog
╲	ssk
⋏	sl 1, k2tog, psso
☐	pattern repeat

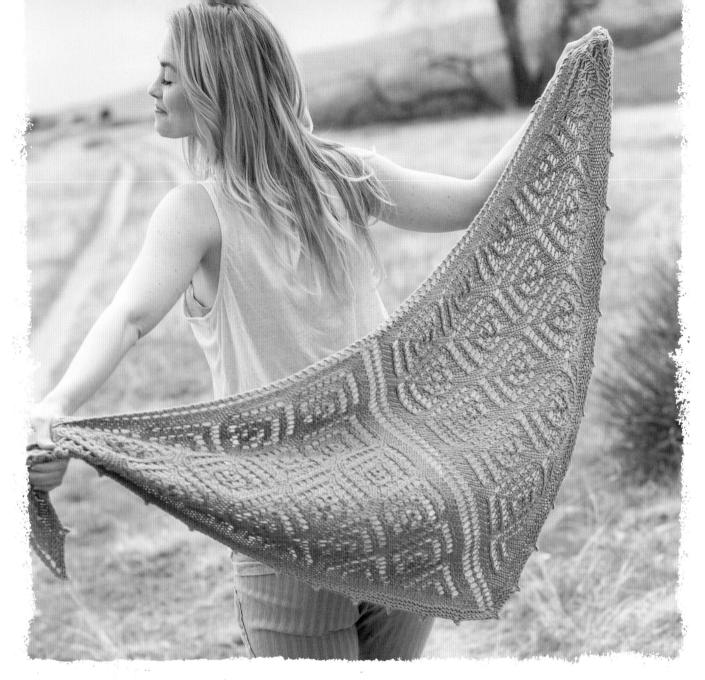

CHART B

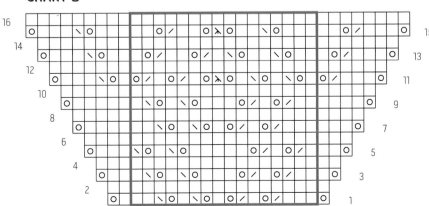

16-st repeat

CHART C

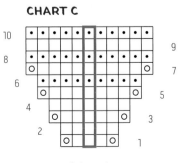

1-st repeat

hats

[FOR THE HEAD]

Take your look due north and knit yourself a hat for each day of the week! From cables to lace, textured stitches to simple stripes, you'll find more than one to fit your style.

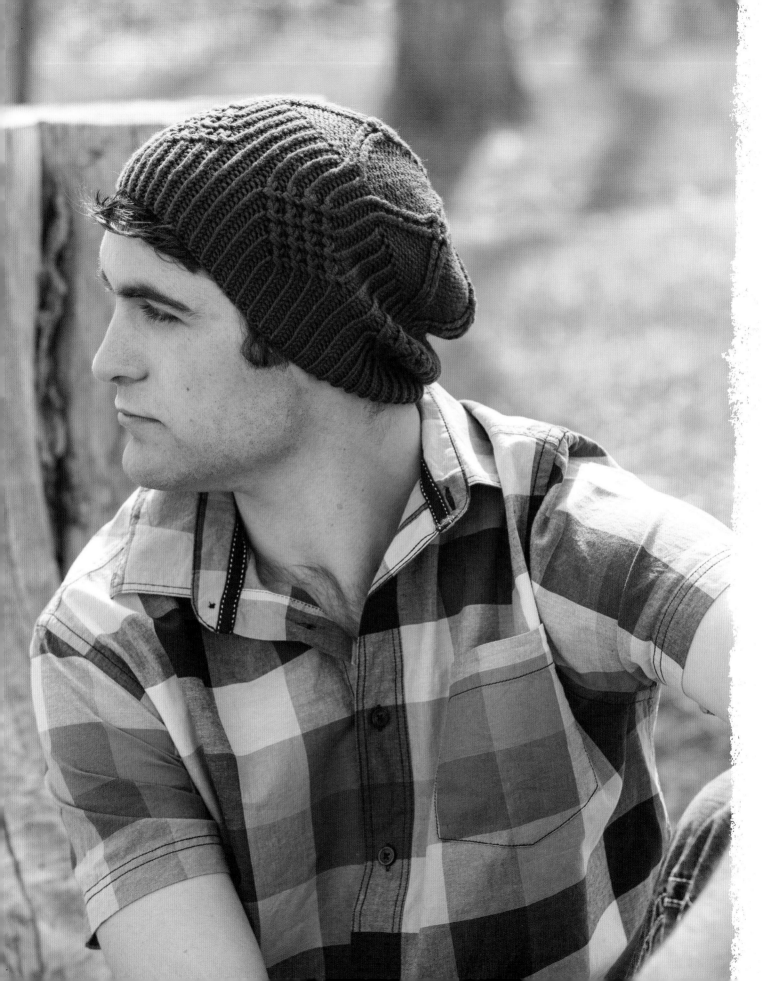

flurry
HAT

designed by PAULINA POPIOLEK

As fun to knit as it to wear, this textured hat includes a wrap-stitch diamond motif on the deep twisted-rib brim. The design takes a different turn at the crown, where twisted stitches follow curved lines and form a starburst at the top. The extrafine merino wool adds wonderful definition to the stitch work.

FINISHED SIZE

About 17¼" (44 cm) in circumference (will stretch to about 23" [58.5 cm]) wide and 10" (25.5 cm) tall.

YARN

Worsted weight (#4 Medium).

Shown here: Cascade Yarns Longwood (100% superwash extrafine merino wool; 191 yd [175 m]/100 g): #19 Deep Ocean, 1 ball.

NEEDLES

Lower brim: size U.S. 7 (4.5 mm): 16" (40 cm) circular (cir).

Upper brim and crown: size U.S. 8 (5 mm): 16" (40 cm) cir and set of 4 or 5 double-pointed (dpn).

Adjust needle size if necessary to obtain the correct gauge.

NOTIONS

Markers; cable needle (cn); tapestry needle.

GAUGE

28 sts and 26 rnds = 4" (10 cm) in twisted rib patt worked in rnds on larger needles, after light blocking.

STITCH GUIDE

TWISTED RIB
(mult of 2 sts)

All rnds: *K1 through back loop (tbl), p1; rep from *.

1/1RPT: Sl 1 st onto cn and hold in back of work, k1 through back loop (tbl), then p1 from cn.

1/1LPT: Sl 1 st onto cn and hold in front of work, p1, then k1tbl from cn.

K2TOG TWISTED: Sl 1 st purlwise, sl next st purlwise, insert left needle from right to left through front loop and return it to left needle tip, return first slipped st to left needle tip, then knit them tog—1 st dec'd.

WRAP: K1, p1, k1, sl these 3 sts onto cn, loosely wrap working yarn 2 times counterclockwise around these 3 sts, return wrapped sts to right needle.

Note:
The position of the beginning of rounds changes three times as the hat is worked.

hat

With larger cir needle, CO 120 sts. Place marker (pm) and join for working in rnds, being careful not to twist sts.

BRIM
Change to smaller cir needle and work 12 rnds in twisted rib (see Stitch Guide).

Change to larger cir needle and work Rnds 1–14 of Chart A.

Work in twisted rib as established for 7 more rnds.

CROWN
Work Rnds 1–10 of Chart B—108 sts.

Remove m, p1, replace m to denote new beg of rnd.

Next rnd: *P1, [1/1RPT (see Stitch Guide)] 2 times, p9, [1/1LPT (see Stitch Guide)] 2 times; rep from *.

Next rnd: *[P1, k1 through back loop (tbl)] 2 times, p11, k1tbl, p1, k1tbl; rep from * 4 more times, [p1, k1tbl] 2 times, p11, pm to denote new beg of rnd—2 markers.

Removing previous beg-of-rnd m when you come to it, work Rnds 1–6 of Chart C.

Next rnd: Remove m, [k1tbl, p1] 2 times, replace m to denote new beg of rnd.

TOP
Work Rnds 1–15 of Chart D—12 sts rem.

Cut yarn leaving 12" (30.5 cm) tail. Thread tail on a tapestry needle, draw through rem sts, pull tight to close hole, then secure on WS.

finishing

Weave in loose ends.

Block lightly.

CHART A

20-st repeat

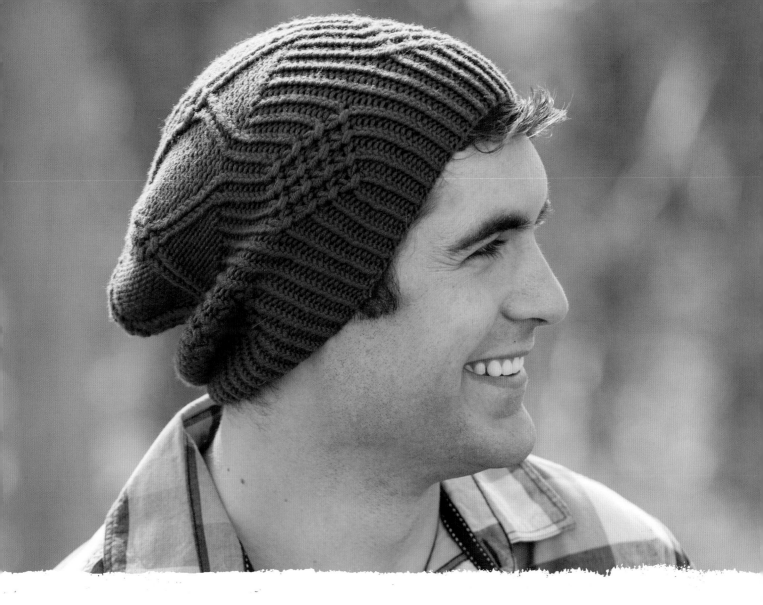

CHART B

9
7
5
3
1

18-st repeat

CHART C

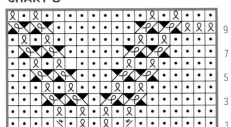

5
3
1

18-st repeat

CHART D

15
13
11
9
7
5
3
1

16-st repeat

☐	k
•	p
℺	k tbl
⅄	sk2p
⤬	1/1RPT (see Stitch Guide)
⤬	1/1LPT (see Stitch Guide)
⤺	k2tog twisted (see Stitch Guide)
⤻	sl1 tbl, k1, psso
⌣	wrap (see Stitch Guide)
▨	no stitch
☐	pattern repeat

carousel
HAT

designed by LOREN CHERENSKY

This striped cap was inspired by the colorful canopy of a vintage carousel. It's worked back and forth in rows with a separate yarn source for each color block, intarsia fashion, with the yarns twisted at the color changes to prevent holes. The hat is seamed and a fluffy pom-pom tops off the cheerful look.

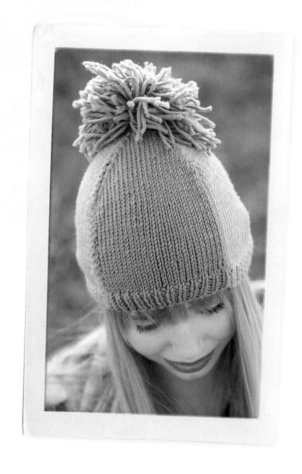

FINISHED SIZE
About 18¾"
(47.5 cm) in circumference and 8¼"
(21 cm) tall.

YARN
Worsted weight (#4 Medium).

Shown here: Cascade Yarns Longwood (100% superwash extrafine merino wool; 191 yd [175 m]/100 g): #08 Artisan Gold (A) and #20 Cyan (B), 1 ball each.

NEEDLES
Size U.S. 8 (5 mm): straight.

Adjust needle size if necessary to obtain the correct gauge.

NOTIONS
Tapestry needle; 2½" (6.5 cm) pom-pom maker.

GAUGE
21 sts and 26 rows = 4" (10 cm) in St st.

NOTES:

The hat is worked back and forth in rows, then seamed.

Use a separate bobbin of yarn for each color block and twist the yarn around each other at color changes to prevent holes from forming.

hat

CO 25 sts with A, CO 25 more sts with B, CO 25 sts with a separate ball of A, then CO 26 sts with a separate ball of B—101 sts total.

Twisting yarns at color changes, work in k1, p1 rib until piece measures 1" (2.5 cm) from CO. Change to St st (knit RS rows; purl WS rows) and work even until piece measures 5" (12.5 cm) from CO, ending with a WS row.

Dec row: (RS) [With B, k2tog, knit to last 2 sts of B, ssk; with A, k2tog, knit to last 2 sts of A, ssk] 2 times—8 sts dec'd.

Purl 1 row even.

Rep the last 2 rows until 29 sts rem, then rep dec row once more—21 sts rem.

Next row: (WS) [With A, ssp (see Glossary), then purl to last 2 sts of A, p2tog; with B, ssp, then purl to last 2 sts of B, p2tog] 2 times—13 sts rem.

Next row: (RS) With B, k2tog, ssk; with A, k2tog, k1; with B, k2tog, k1; with A, k2tog, k1—8 sts rem.

Cut yarn, leaving a 24" (61 cm) tail. Thread tail on a tapestry needle, draw through rem sts, and pull tight to close hole.

finishing

Use tail to sew seam. Weave in loose ends along matching colors.

With yarn threaded on a tapestry needle, sew selvedges tog.

Block lightly.

With B, use a pom-pom maker to make a 2½" (6.5 cm) pom-pom. Sew pom-pom to top of hat.

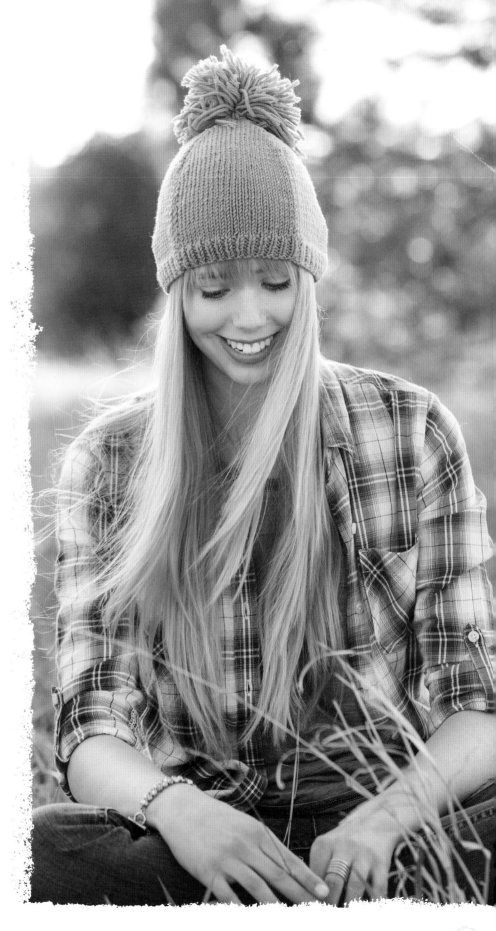

winter waves
SLOUCH HAT

designed by MELISSA LABARRE

This long, lacy slouch is a great cool-weather accessory. It uses a variation of the feather and fan stitch, separated by purl "welts" that form ripples. Requiring just one ball of worsted-weight yarn, it's both quick to knit and fun to wear.

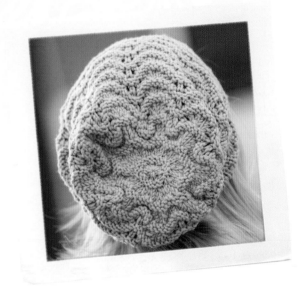

FINISHED SIZE
About 20" (51 cm) in circumference and 10¾" (27.5 cm) tall.

YARN
Worsted weight (#4 Medium).

Shown here: Cascade Yarns Longwood (100% superwash extrafine merino wool; 191 yd

[175 m]/100 g): #23 Stonewash, 1 ball

NEEDLES
Size U.S. 7 (4.5 mm): 16" (40 cm) circular (cir) and set of 4 double-pointed (dpn).

Adjust needle size if necessary to obtain the correct gauge.

NOTIONS
Marker (m); tapestry needle.

GAUGE
21½ sts and 31 rnds = 4" (10 cm) in ripple patt worked in rnds.

STITCH GUIDE

RIPPLE PATTERN
(mult of 12 sts)

Rnds 1 and 2: Purl.

Rnd 3: *K1, [k2tog] 2 times, [yo, k1] 3 times, yo, [ssk] 2 times; rep from *.

Rnd 4: Knit.

Rnd 5: Rep Row 3.

Rnd 6: Knit.

Rep Rnds 1–6 for patt.

hat

With cir needle and using the long-tail method (see Glossary), CO 84 sts. Place marker (pm) and join for working in rnds, being careful not to twist sts.

Work in k1, p1 rib until piece measures 1" (2.5 cm) from CO.

Inc rnd: [K1f&b (see Glossary)] 4 times, *k3, k1f&b; rep from *—108 sts.

Work Rnds 1–6 of ripple patt (see Stitch Guide) 10 times.

Purl 2 rnds—piece measures 9" (23 cm) from CO.

SHAPE TOP

Note: Change to dpn when too few sts rem to work comfortably on a cir needle.

Rnd 1: *K1, [k2tog] 2 times, k3, [ssk] 2 times; rep from *—72 sts rem.

Rnd 2: Knit.

Rnd 3: *K1, k2tog, k3, ssk; rep from *—54 sts rem.

Rnd 4: Knit.

Rnds 5 and 6: Purl.

Rnd 7: *K1, k2tog, k1, ssk; rep from *—36 sts rem.

Rnd 8: Knit.

Rnd 9: *K2tog, ssk; rep from *—18 sts rem.

Rnd 10: Knit.

Rnds 11 and 12: Purl.

Rnd 13: *K2tog, rep from *—9 sts rem.

Cut yarn, leaving an 8" (20.5 cm) tail. Thread tail on a tapestry needle, draw through rem sts, pull tight to close hole, and secure on WS.

finishing

Weave in loose ends.

Block lightly.

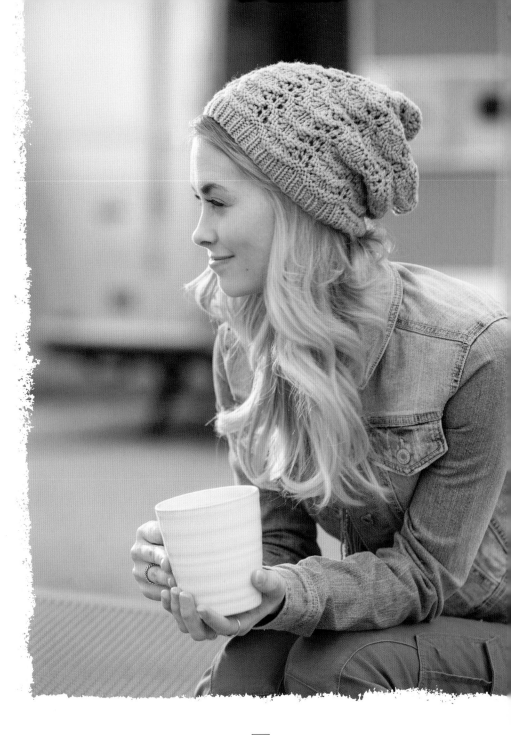

RIPPLE PATTERN

12-st repeat

5

3

1

□ k

• p

○ yo

/ k2tog

\ ssk

□ pattern repeat

cocoon
HAT

designed by RAYA BUDREVICH

Small textured cocoons nestle among waving ribs to create a flowing and bumpy fabric along the brim of this textural hat. The cocoons, created by a combination of increases and decreases, flow into simple ribs that stand out against a reverse stockinette-stitch background, then converge at the top of the crown.

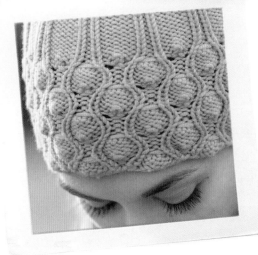

FINISHED SIZE
About 18" (45.5 cm) in circumference and 7¾" (19.5 cm) tall.

YARN
Worsted weight (#4 Medium).

Shown here: Cascade Yarns Longwood (100% superwash extrafine merino wool; 191 yd [175 m]/100 g): #08 Artisan Gold, 1 ball.

NEEDLES
Size U.S. 6 (4 mm): 16" (40 cm) circular (cir) and set of 4 or 5 double-pointed (dpn).

Adjust needle size if necessary to obtain the correct gauge.

NOTIONS
Markers (m); tapestry needle.

GAUGE
22 sts and 30 rnds = 4" (10 cm) in St st worked in rnds.

17 sts and 29 rnds = 3" (7.5 cm) in cocoon patt, lightly blocked.

hat

With cir needle, CO 104 sts. Place marker (pm) and join for work working in rnds, being careful not to twist sts.

Rnds 1–3: *P5, k1, p1, k1; rep from *.

Rnd 4: *P5tog, k1, M1P (see Glossary), work (p1, k1, p1) all in the next st, M1P, k1; rep from *.

Rnds 5–9: *P1, k1, p5, k1; rep from *.

Rnd 10: *M1P, work (p1, k1, p1) in the next st, M1P, k1, p5tog, k1; rep from *.

Rnds 11 and 12: *P5, k1, p1, k1; rep from *.

Rep Rnds 1–12 once, then rep Rnds 1–9 once more.

Cont in rib patt as established until piece measures 6" (15 cm) from CO.

SHAPE CROWN

Note: Change to dpn when there are too few sts rem to work comfortably on a cir needle.

Rnd 1: *P4, k2tog, p1, k1; rep from *—91 sts rem.

Rnd 2: *P4, k1, p1, k1; rep from *.

Rnd 3: *P3, k2tog, p1, k1; rep from *—78 sts rem.

Rnd 4: *P3, k1, p1, k1; rep from *.

Rnd 5: *P2, k2tog, p1, k1; rep from *—65 sts rem.

Rnd 6: *P2, k1, p1, k1; rep from *.

Rnd 7: *P1, k2tog, p1, k1; rep from *—52 sts rem.

Rnd 8: *P1, k1, p1, k1; rep from *.

Rnd 9: *K2tog, p1, k1; rep from *—39 sts rem.

Rnd 10: *K1, p1, k1; rep from *, ending last rep 1 st before m and moving m to this position.

Rnd 11: *K2tog, p1; rep from *—26 sts rem.

Rnd 12: *K1, p1; rep from *, ending last rep 1 st before m and moving m to this position.

Rnd 13: *K2tog; rep from *—13 sts rem.

Remove m.

Rnd 14: *K2tog; rep from * to last st, k1—7 sts rem.

Cut yarn leaving an 8" (20.5 cm) tail. Thread tail on a tapestry needle, draw through rem sts, pull tight to close hole, and secure on WS.

finishing

Weave in loose ends.

Block lightly.

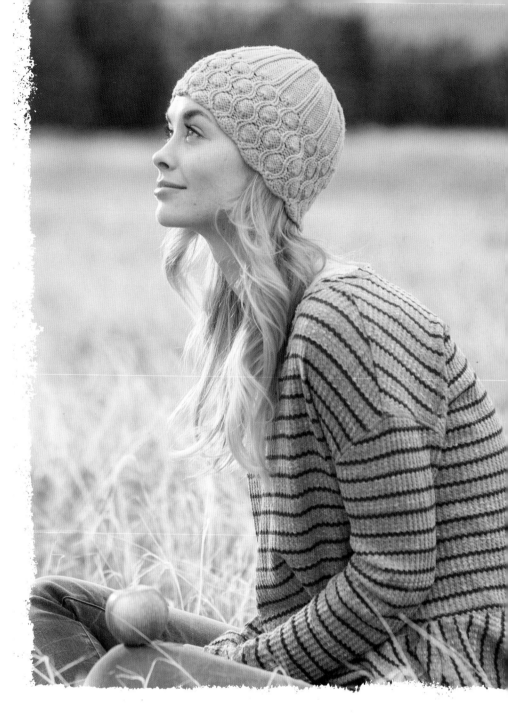

karite

designed by SVETLANA VOLKOVA

A simple ribbing evolves into faux cables (requiring no cable needle) that create waves on top of a garter-stitch foundation in this seamless hat. The "waves" converge at the top of the hat in a radiating flower shape.

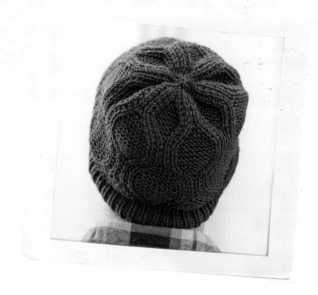

FINISHED SIZE
About 16 (19¼)" (40.5 [49] cm) in circumference and 8½" (21.5 cm) tall.

Hat shown measures 19¼" (49 cm).

YARN
Worsted weight (#4 Medium).

Shown here: Cascade Yarns Longwood (100% superwash extrafine merino wool; 191 yd [175 m]/100 g): #24 Midnight Blue, 1 ball.

NEEDLES
Size U.S. 7 (4.5 mm): 16" (40 cm) circular (cir) and set of 4 or 5 double-pointed (dpn).

Adjust needle size if necessary to obtain the correct gauge.

NOTIONS
Markers (m); tapestry needle.

GAUGE
20 sts and 32 rnds = 4" (10 cm) in pattern worked in rnds.

hat

With cir needle, CO 80 (96) sts. Place marker (pm) and join for working in rnds, being careful not to twist sts.

Beg with p1, work in k1, p1 rib for 12 rnds.

Work in faux cable patt as foll.

Rnd 1: *[P1, k1] 3 times, p9, k1; rep from *.

Rnd 2 and all even-numbered rnds: Knit.

Rnd 3: *P1, k1, M1P-right slant (see Glossary), p1, M1P-left slant (see Glossary), k1, p1, k1, ssp (see Glossary), p5, p2tog, k1; rep from *.

Rnd 5: *P1, k1, M1P-right slant, p3, M1P-left slant, k1, p1, k1, ssp, p3, p2tog, k1; rep from *.

Rnd 7: *P1, k1, M1P-right slant, p5, M1P-left slant, k1, p1, k1, ssp, p1, p2tog, k1; rep from *.

Rnd 9: *P1, k1, M1P-right slant, p7, M1P-left slant, k1, p1, k1, p3tog, k1; rep from *.

Rnds 11, 13, 15, 17, and 19: *P1, k1, p9, [k1, p1] 2 times, k1; rep from *.

Rnd 21: *P1, k1, ssp, p5, p2tog, k1, p1, k1, M1P-right slant, p1, M1P-left slant, k1; rep from *.

Rnd 23: *P1, k1, ssp, p3, p2tog, k1, p1, k1, M1P-right slant, p3, M1P-left slant, k1; rep from *.

Rnd 25: *P1, k1, ssp, p1, p2tog, k1, p1, k1, M1P-right slant, p5, M1P-left slant, k1; rep from *.

Rnd 27: *P1, k1, p3tog, k1, p1, k1, M1P-right slant, p7, M1P-left slant, k1; rep from *.

Rep Rnds 1 and 2 five times, then work Rnds 3–12 once more—piece measures 7¼" (18.5 cm) from CO.

SHAPE CROWN

Note: Change to dpn when too few sts rem to work comfortably on a cir needle.

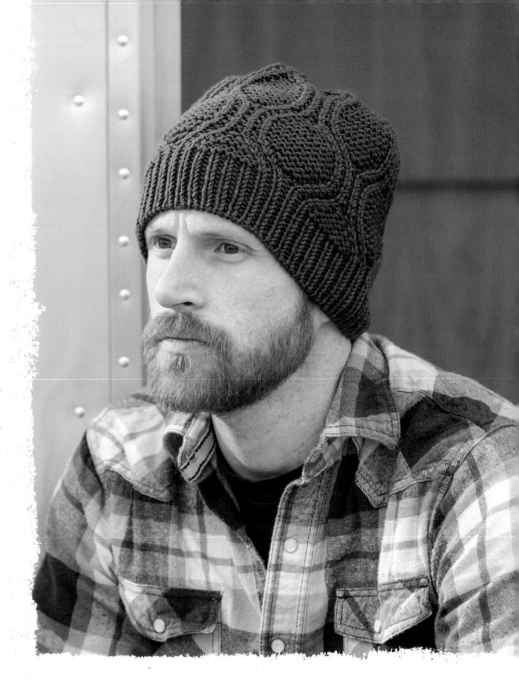

Rnd 1: *P1, k1, ssp, p5, p2tog, [k1, p1] 2 times, k1; rep from *—70 (84) sts rem.

Rnds 2, 4, 6, and 8: Knit.

Rnd 3: *P1, k1, ssp, p3, p2tog, [k1, p1] 2 times, k1; rep from *—60 (72) sts rem.

Rnd 5: *P1, k1, ssp, p1, p2tog, [k1, p1] 2 times, k1; rep from *—50 (60) sts rem.

Rnd 7: *P1, k1, p3tog, [k1, p1] 2 times, k1; rep from *—40 (48) sts rem.

Rnds 9, 10, and 11: *K2tog; rep from *—5 (6) sts rem after Rnd 11.

Cut yarn leaving an 8" (20.5 cm) tail. Thread tail on a tapestry needle, draw through rem sts, pull tight to close hole, and secure on WS.

finishing

Weave in loose ends.

Block lightly.

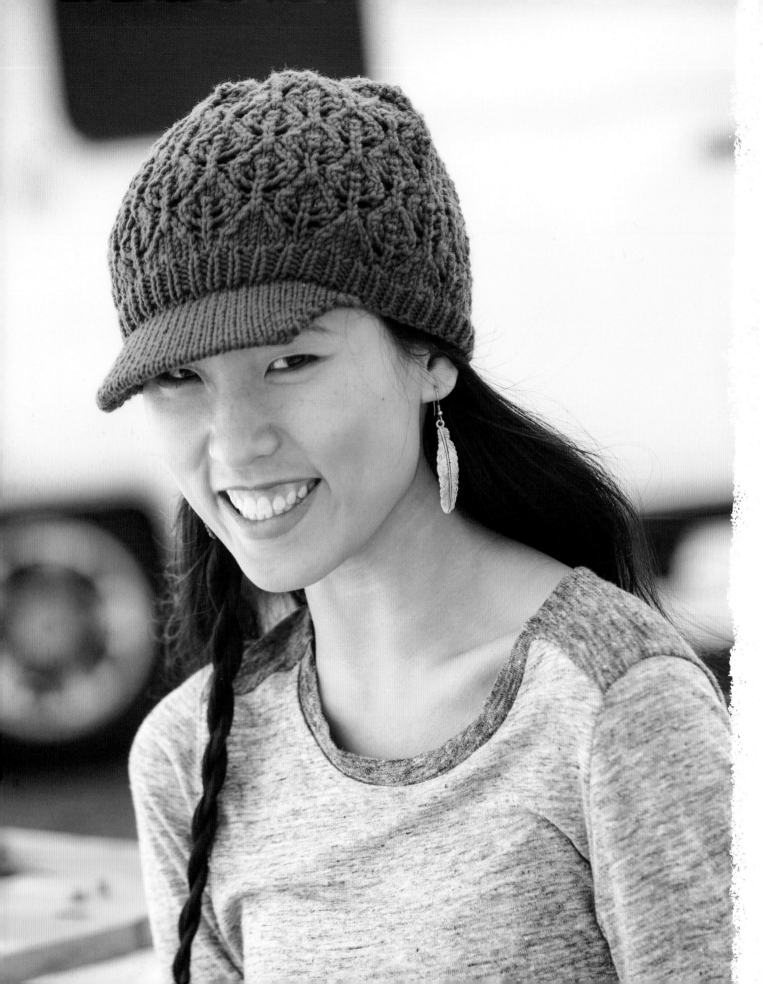

cascading leaves

designed by SIMONE VAN IDERSTINE

This brimmed cap is knitted in modular fashion, beginning with a short-row pocket for the brim. The remainder of the band is cast on for working in the round, and is worked to completion so that the leaf pattern appears to cascade down from the crown. Choose from a closer fitting cap version or a fuller newsboy style hat, as shown here.

FINISHED SIZE

About 18" (45.5 cm) in circumference at top of rib and 6½ (8¼)" (16.5 [21] cm) tall.

Hat shown measures 8¼" (21 cm) tall.

YARN

Worsted weight (#4 Medium).

Shown here: Cascade Yarns Longwood (100% superwash extrafine merino wool; 191 yd [175 m]/100 g): #17 Deep Green, 1 ball.

NEEDLES

Size U.S. 7 (4.5 mm): 16" (40 cm) circular (cir) and set of 4 or 5 double-pointed needles (dpn).

Adjust needle size if necessary to obtain the correct gauge.

NOTIONS

Waste yarn for provisional cast-on; markers (m); stitch holders and waste yarn; plastic for brim measuring 7" (18 cm) long by 3¼" (8.5 cm) wide; an extra U.S. 7 (4.5 mm) cir needle; stitch holders; tapestry needle.

GAUGE

21 sts and 29 rnds = 4" (10 cm) in leaf lace pattern worked in rnds.

cap

With cir needle and waste yarn, use a provisional method (see Glossary) to CO 35 sts.

FLAT BRIM

Set-up row: (WS) Purl.

Cont working short-rows (see Glossary) to shape brim as foll.

Row 1: (RS) K33, wrap next st and turn work (w&t).

Row 2: (WS) P31, w&t.

Row 3: K30, w&t.

Row 4: P29, w&t.

Row 5: K28, w&t.

Row 6: P27, w&t.

Row 7: K26, w&t.

Row 8: P25, w&t.

Row 9: K24, w&t.

Row 10: P23, w&t.

Row 11: K22, w&t.

Row 12: P21, w&t.

Working wraps tog with wrapped sts when you come to them, cont as foll.

Row 13: K22, w&t.

Row 14: P23, w&t.

Row 15: K24, w&t.

Row 16: P25, w&t.

Row 17: K26, w&t.

Row 18: P27, w&t.

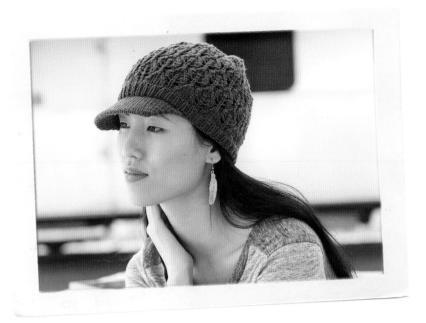

Row 19: K28, w&t.

Row 20: P29, w&t.

Row 21: K30, w&t.

Row 22: P31, w&t.

Row 23: K33.

Row 24: Sl 1 purlwise, p34.

Carefully remove waste yarn from provisional CO and place exposed sts onto a spare cir needle—35 sts each on 2 cir needles.

PLASTIC INSERT

Using a pen, carefully trace the shape of the knitted flat brim on a piece of paper (the piece in the hat shown measures 7" [18 cm] long and 2¼" [5.5 cm] wide at widest point), then cut it out with scissors. Using this as a guide, cut the same shape out of plastic. Fit the plastic inside the knitted brim and trim if necessary for a snug fit without the plastic showing through.

Place the plastic form inside the brim pocket and hold the two cir needles parallel with the WS of the fabric facing tog.

Joining row: With RS facing, *k1 from front needle tog with 1 st from back needle; rep from *—35 sts.

Place sts onto holder.

RIBBED BAND

With cir needle and using the long-tail method (see Glossary), CO 55 sts, k35 held peak sts—90 sts total. Place marker (pm) and join for working in rnds, being careful not to twist sts.

Set-up rnd: *K1 through back loop (tbl), p1; rep from *.

Rep this rnd until piece measures 1" (2.5 cm) from band CO.

Inc rnd: K1, *M1 (see Glossary), k3; rep from * to last 2 sts, M1, k2—120 sts.

BODY

Follow Rows 1–12 of Chart A or row-by-row instructions as foll.

Rnd 1: *K7, p1, k1, p1; rep from *.

Rnd 2: *Ssk, k3, k2tog, p1, yo, k1, yo, p1; rep from *.

Rnd 3: *K5, p1, k3, p1; rep from *.

Rnd 4: *Ssk, k1, k2tog, p1, [k1, yo] 2 times, k1, p1; rep from *.

Rnd 5: *K3, p1, k5, p1; rep from *.

Rnd 6: *Sl2-k1-p2sso (see Stitch Guide), p1, k2, yo, k1, yo, k2, p1; rep from *.

Rnd 7: *K1, p1, k7, p1; rep from *.

Rnd 8: *Yo, k1, yo, p1, ssk, k3, k2tog, p1; rep from *.

Rnd 9: *K3, p1, k5, p1; rep from *.

Rnd 10: *[K1, yo] 2 times, k1, p1, ssk, k1, k2tog, p1; rep from *.

Rnd 11: *K5, p1, k3, p1; rep from *.

Rnd 12: *K2, yo, k1, yo, k2, p1, sl2-k1-p2sso, p1; rep from *.

Rep these 12 rnds 1 (2) more time(s)—24 (36) rnds total; piece measures 4¼ (6)" (11 [15] cm) from CO.

CROWN

Follow Rows 1–13 of Chart B or row-by-row instructions as foll, changing to dpn when there are too few sts to fit comfortably on cir needle.

Rnd 1: *K7, p1, k1, p1; rep from *.

Rnd 2: *Ssk, k3, k2tog, p1, yo, k1, yo, p1, ssk, k3, k2tog, p1, k1, p1; rep from *—108 sts rem.

Rnd 3: *K5, p1, k3, p1, k5, p1, k1, p1; rep from *.

Rnd 4: *Ssk, k1, k2tog, p1, [k1, yo] 2 times, k1, p1, ssk, k1, k2tog, p1, k1, p1; rep from *—96 sts rem.

Rnd 5: *K3, p1, k5, p1, k3, p1, k1, p1; rep from *.

Rnd 6: *Sl2-k1-p2sso, p1, k2, yo, k1, yo, k2, p1, sl2-k1-p2sso, p1, k1, p1; rep from *—84 sts rem.

Rnd 7: *K1, p1, k7, [p1, k1] 2 times, p1; rep from *.

Rnd 8: *K1, p1, ssk, k3, k2tog, [p1, k1] 2 times, p1; rep from *—72 sts rem.

Rnd 9: *K1, p1, k5, [p1, k1] 2 times, p1; rep from *.

Rnd 10: *K1, p1, ssk, k1, k2tog, [p1, k1] 2 times, p1; rep from *—60 sts rem.

Rnd 11: *K1, p1, k3, [p1, k1] 2 times, p1; rep from *.

Rnd 12: *K1, p1, sl2-k1-p2sso, [p1, k1] 2 times, p1; rep from *—48 sts rem.

Rnd 13: *K1, p1; rep from *.

Next 3 rnds: *Ssk; rep from *—6 sts rem after third rnd is completed.

Cut yarn, leaving an 8" (20.5 cm) tail. Thread tail on a tapestry needle, draw through rem sts, pull tight to close hole, and secure on WS.

finishing

Weave in loose ends.

Soak until thoroughly wet, then gently stuff the hat with grocery bags, being sure not to stretch and distort the hat, and allow to fully dry.

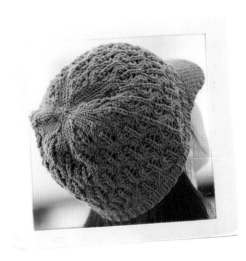

CHART A

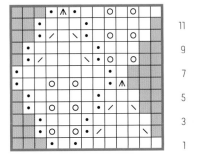

10-st repeat

CHART B

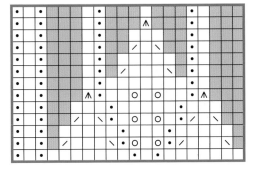

20-st repeat

☐ k

• p

○ yo

╱ k2tog

╲ ssk

⋀ sl2-k1-p2sso (see Stitch Guide)

▨ no stitch

☐ pattern repeat

striped slouchy
HAT

designed by DEBBIE O'NEILL

This slouchy hat is suitable for both men and women. Play with different color combinations for you own distinct looks The best part? You can stay warm while avoiding the dreaded "hat head" look!

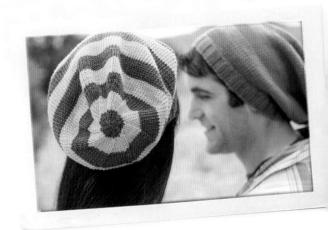

FINISHED SIZE
About 20 (21, 22, 23)" (51 [53.5, 56, 58.5] cm) in circumference and 11½ (11¾, 12½, 12¾)" (29 [30, 31.5, 32.5] cm) tall.

Plum and gold hat shown measures 21" (53.5 cm); brown and red hat shown measures 22" (56 cm).

YARN
Worsted weight (#4 Medium).

Shown here: Cascade Yarns Longwood (100% superwash extrafine merino wool; 191 yd [175 m]/100 g): #28 Plum or #11 Walnut (MC) and #08 Artisan Gold or #06 Red Clay (CC), 1 ball each (all sizes).

NEEDLES
Size U.S. 6 (4 mm): 16" (40 cm) circular (cir) and set of 4 or 5 double-pointed (dpn).

Adjust needle size if necessary to obtain the correct gauge.

NOTIONS
Markers (m); tapestry needle.

GAUGE
22 sts and 30 rnds = 4" (10 cm) in St st worked in rnds.

Note:
For best results, cut yarn between stripes instead of carrying the unused color along the inside of the hat.

hat

With MC, CO 100 (105, 110, 115) sts.

Place marker (pm) and join for working in rnds, being careful not to twist sts.

Work in k3, p2 ribbing until piece measures 1½" (3.8 cm) or desired length.

Change to CC (see Note) and St st.

Knit 1 rnd even.

Next rnd: Inc 10 (10, 11, 11) sts evenly spaced—110 (115, 121, 126) sts total.

Knit 6 rnds even.

Change to MC and knit 8 rnds.

Cont to alternate 8 rnds each of CC and MC until piece measures 9 (9, 10, 10)" (23 [23, 25.5, 25.5] cm) or desired length from CO.

Cont for your size as foll.

Size 21" only
Dec rnd: Cont in stripe patt, *k21, k2tog; rep from *—110 sts rem.

Knit 1 rnd even.

Skip to All sizes.

Size 23" only
Dec rnd: Cont in stripe patt, *k23, k2tog; rep from * to last st, k1—121 sts rem.

Knit 1 rnd even.

All sizes
Cont in stripe patt, dec as foll.

Rnd 1: *K9, k2tog; rep from *—100 (100, 110, 110) sts rem.

Rnd 2 and all even-numbered rnds: Knit.

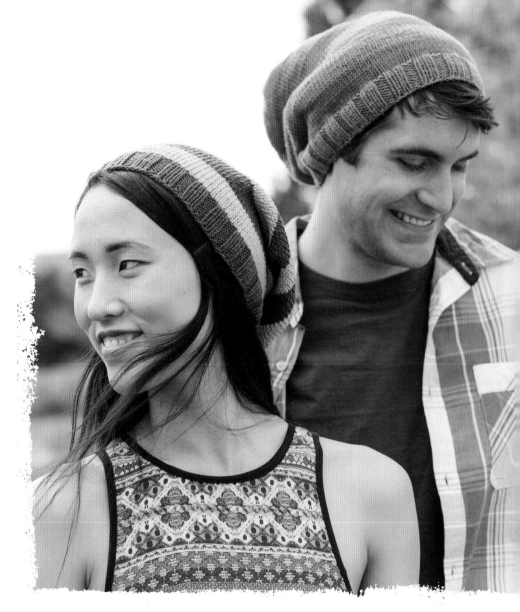

Rnd 3: *K8, k2tog; rep from *—90 (90, 99, 99) sts rem.

Rnd 5: *K7, k2tog; rep from *—80 (80, 88 88) sts rem.

Rnd 7: *K6, k2tog; rep from *—70 (70, 77, 77) sts rem.

Rnd 9: *K5, k2tog; rep from *—60 (60, 66, 66) sts rem.

Rnd 11: *K4, k2tog; rep from *—50 (50, 55, 55) sts rem.

Rnd 13: *K3, k2tog; rep from *—40 (40, 44, 44) sts rem.

Rnd 15: *K2, k2tog; rep from *—30 (30, 33, 33) sts rem.

Rnd 17: *K1, k2tog; rep from *—20 (20, 22, 22) sts rem.

Rnd 19: *K2tog; rep from *—10 (10, 11, 11) sts rem.

Cut yarn, leaving a 10" (25.5 cm) tail. Thread tail on a tapestry needle, draw through rem sts, pull tight to close hole, and secure on WS.

finishing

Weave in loose ends.

Block as desired.

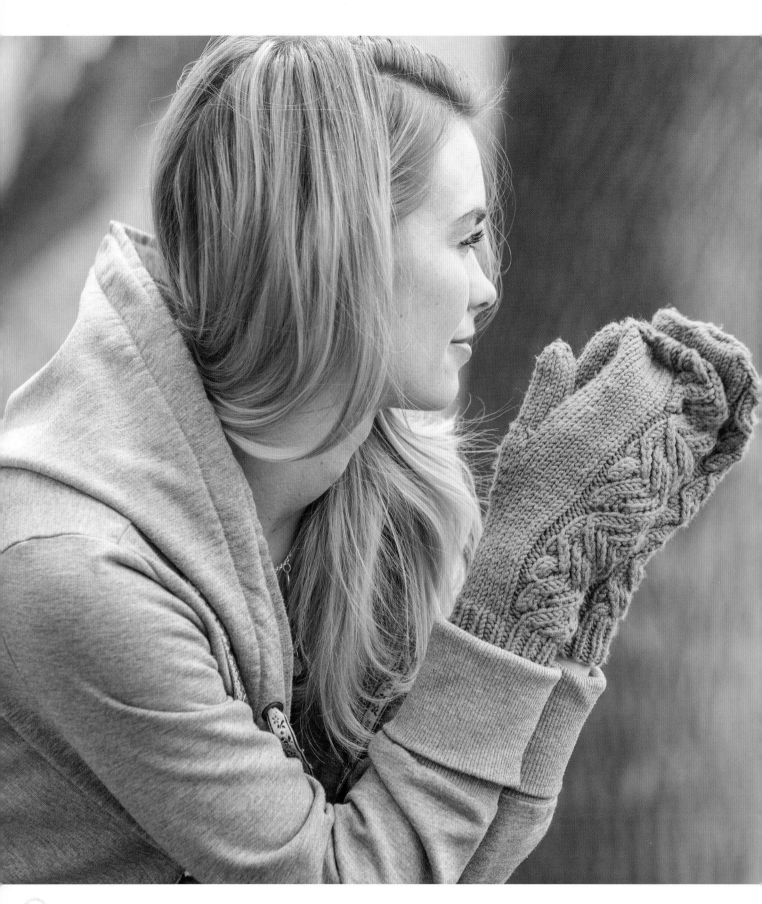

mittens + wristers

[FOR THE HANDS]

Cold hands, warm heart. From flip-top mitts for the commuter, cabled wristers for the chilly office, to mittens sized for the entire family, you're bound to find a project to keep your digits covered.

kennett square
WRISTERS

designed by CAROL SULCOSKI

Plump and cozy merino wool makes these wristers warm; the worsted-weight yarn means they knit up in a snap. Rows of bobbles provide textural interest while k1, p1 ribbing ensures a flexible fit. This one-ball project makes a great and quick-knit gift!

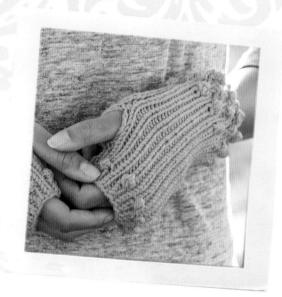

FINISHED SIZE
About 5¼ (6¼)" (13.5 [16] cm) in circumference, unstretched, and 5¾ (6¾)" (14.5 [17] cm) long.

YARN
Worsted weight (#4 Medium).

Shown here: Cascade Yarns Longwood (100% superwash extrafine merino wool; 191 yd [175 m]/100 g): #07 Nectarine (orange), 1 ball.

NEEDLES
Size U.S. 7 (4.5 mm): straight.

Adjust needle size if necessary to obtain the correct gauge.

NOTIONS
Tapestry needle.

GAUGE
28 sts and 28 rows = 4" (10 cm) in k1, p1 ribbing, unstretched.

STITCH GUIDE

MAKE BOBBLE (MB): Work [p1, k1 through back loop (tbl), p1, k1 tbl, p1] into next st to make 5 sts from 1, slip the fifth, fourth, third, and second sts over the first and off the needle to form bobble—1 st rem.

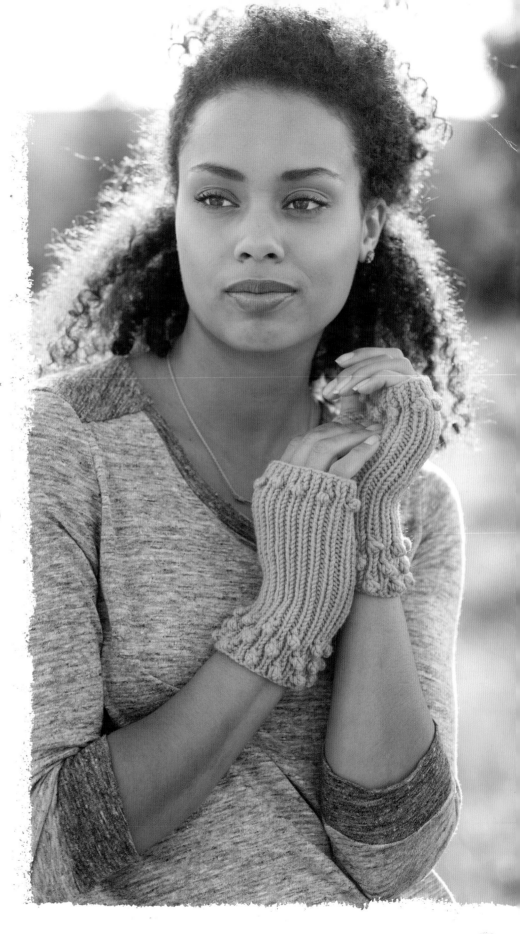

NOTES:
These wristers are knitted flat and seamed to allow an opening for the thumb.

wristers

Leaving a 24" (61 cm) tail for seaming later, CO 36 (44) sts.

Row 1: (RS) *K1, p1; rep from *.

Row 2 and all even-numbered rows: (WS) *K1, p1, rep from *.

Row 3: K1, *p1, k1, p1, MB (see Stitch Guide); rep from * to last 3 sts, p1, k1, p1.

Row 5: Rep Row 1.

Row 7: K1, p1, *MB, p1, k1, p1; rep from * to last 2 sts, MB, p1.

Row 9: Rep Row 1.

Row 11: Rep Row 3.

Row 12: Rep Row 2.

Rep Rows 1 and 2 until piece measures 5 (6)" (12.5 [15] cm) from CO, or ¾" (2 cm) less than desired finished length.

Rep Rows 3–6 once.

BO all sts in patt.

Cut yarn, leaving an 18" (45.5 cm) tail.

finishing

Thread CO tail on a tapestry needle, then sew side seam for 3¼ (4)" (8.5 [10] cm) up from CO edge. Thread BO tail on tapestry needle, then sew side seam for 1½ (1¾)" (3.8 [4.5] cm) from BO edge—about 1" (2.5 cm) opening rem for thumb.

Weave in loose ends.

Block lightly.

windowpane
MITTS

designed by JENNIFER WOOD

The diamonds shapes in these mitts bring to mind lattice windowpanes. A lot less complicated than it appears, the pattern is created by different arrangements of simple right and left twists. Side-seam thumb gussets make these mitts equally comfortable on either hand.

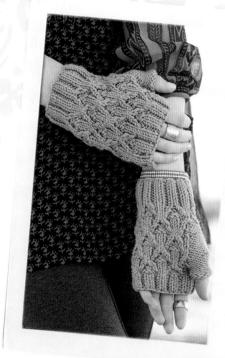

FINISHED SIZE

About 8" (20.5 cm) hand circumference, 6½" (16.5 cm) wrist circumference, and 7" (18 cm) long.

YARN

Worsted weight (#4 Medium).

Shown here: Cascade Yarns Longwood (100% superwash extrafine merino wool; 191 yd [175 m]/100 g): #22 Sky Blue, 1 ball.

NEEDLES

Size U.S. 7 (4.5 mm): set of 4 or 5 double-pointed (dpn).

Adjust needle size if necessary to obtain the correct gauge.

NOTIONS

Markers (m); cable needle (cn); stitch holders or waste yarn; tapestry needle.

GAUGE

24 sts and 28 rnds = 4" (10 cm) in Hand chart worked in rnds.

NOTES:

When dividing the stitches over the needles, make sure there is a multiple of 8 stitches on each needle to prevent the cables from being split between two needles.

mitt

CO 48 sts. Place marker (pm) and join for working in rnds, being careful not to twist sts.

CUFF

Set-up rnd: K1, *p2, k2, rep from * to last 3 sts, p2, k1.

Rep the last rnd 9 more times—10 rnds total.

LOWER HAND

Work Rows 1 and 2 of Hand chart.

SHAPE THUMB GUSSET

Set-up rnd: Work Row 3 of Hand chart over 24 sts, pm for thumb gusset, M1P (see Glossary), pm, work Row 3 of chart to end—49 sts; 1 gusset st between markers.

Next 2 rnds: Work next row of chart to m, slip marker (sl m), p1, sl m, work chart to end.

Inc rnd: Work next row of chart to m, sl m, M1P, purl to next m, M1P, sl m, work chart to end—2 gusset sts inc'd.

Rep the last 3 rnds 5 more times, working inc'd sts in Rev St st—61 sts total; 13 gusset sts.

Work 1 rnd even.

Next rnd: Work in patt as established to m, sl 13 gusset sts onto holder to work later for thumb, work to end—48 sts rem.

Work 7 rnds even in patt, ending with Row 6 of chart.

EDGING

Rep Row 6 of chart 4 more times.

Dec rnd: K1 *p2tog, k2; rep from * to last 3 sts, p2tog, k1—36 sts rem.

Loosely BO all sts in patt.

THUMB

Divide 13 held sts onto 3 dpn.

With RS facing, join yarn and pick up and knit 1 st at boundary between thumb and upper hand, pm, and join for working in rnds—14 sts total.

Next rnd: Purl to last st, k1 through back loop (tbl).

Rep the last rnd 4 more times.

Loosely BO all sts purlwise.

finishing

Weave in loose ends.

Block lightly.

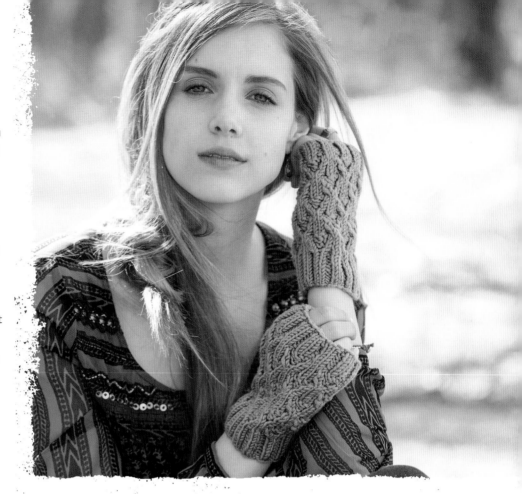

HAND

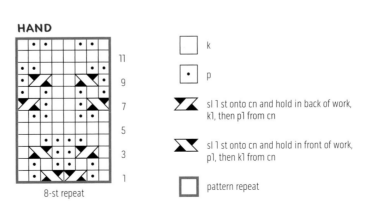

8-st repeat

	k
	p
	sl 1 st onto cn and hold in back of work, k1, then p1 from cn
	sl 1 st onto cn and hold in front of work, p1, then k1 from cn
	pattern repeat

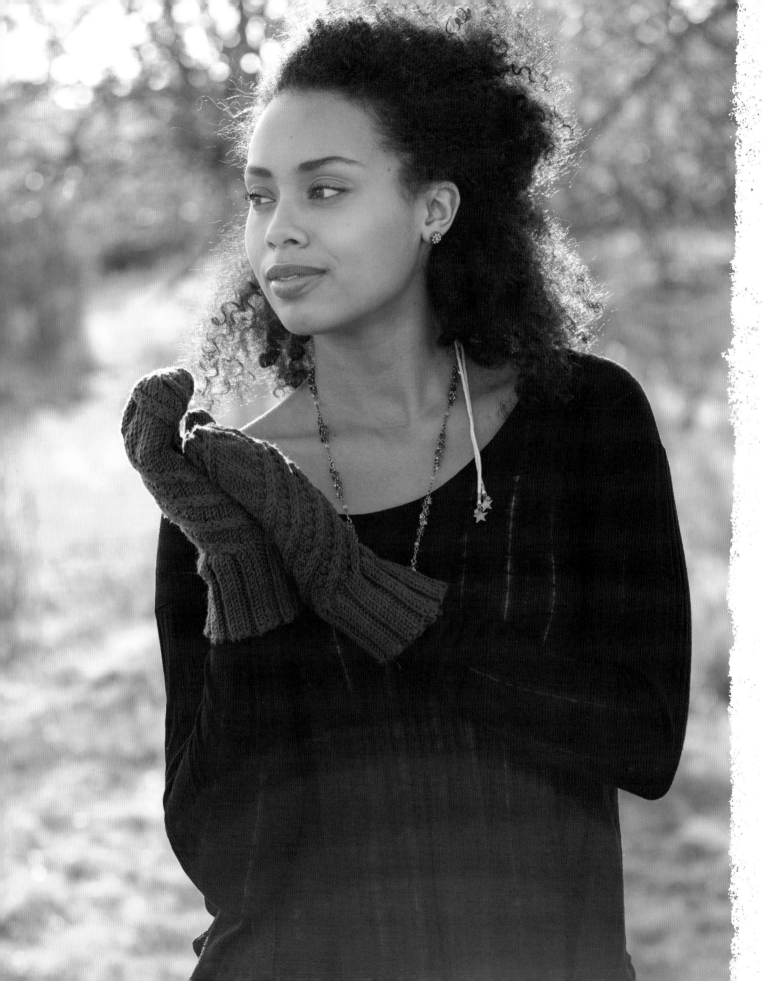

coiled cable
MITTENS

designed by KELLY HERDRICH

Knitted at an intentionally dense gauge, these mittens will keep you warm when the temperatures are too cold for comfort. They feature deep ribbing on the cuffs and cables that coil around the hands. The cables coil in opposite directions on the two mittens; you can change hands for slightly different looks.

FINISHED SIZE
About 6½" (16.5 cm) in circumference and 9½" (24 cm) long.

YARN
Worsted weight (#4 Medium).

Shown here: Cascade Yarns Longwood (100% superwash extrafine merino wool; 191 yd [175 m]/100 g): #25 Deep Wisteria, 1 ball.

NEEDLES
Size U.S. 5 (3.75 mm): set of 4 or 5 double-pointed (dpn).

Adjust needle size if necessary to obtain the correct gauge.

NOTIONS
Cable needle (cn); markers (m); waste yarn or stitch holder; tapestry needle.

GAUGE
About 29½ sts and 32 rnds = 4" (10 cm) in charted patt worked in rnds.

STITCH GUIDE

2/2LC: Sl 2 sts onto cn and hold in front of work, k2, then k2 from cn.

2/2RC: Sl 2 sts onto cn and hold in back of work, k2, then k2 from cn.

K3, P2 RIB
(mult of 5 sts)

All rnds: *K3, p2; rep from *.

LEFT-LEANING COILED CABLE
(mult of 8 sts)

Rnd 1: *K4, 2/2LC (see above); rep from *.

Rnds 2, 4, and 6: Knit.

Rnd 3, 5, and 7: K6, *2/2LC, k4; rep from * to last 2 sts, removing end-of-rnd m, 2/2LC, pm for new beg of rnd.

Rnd 8: Knit.

Rep Rnds 1–8 for patt.

RIGHT-LEANING COILED CABLE
(multiple of 8 sts)

Rnd 1: *K4, 2/2RC (see above); rep from *.

Rnds 2 and 4: Knit.

Rnd 3: *K2, 2/2RC, k2; rep from *.

Rnd 5: *2/2RC, k4; rep from *.

Rnds 6 and 8: Knit to last 2 sts, sl 2, remove end-of-rnd m, sl 2 sts back to left needle tip, pm for new beg of rnd.

Rnd 7 and 9: *2/2RC, k4; rep from *.

Rnd 10: Knit.

Rep Rnds 3–10 for patt.

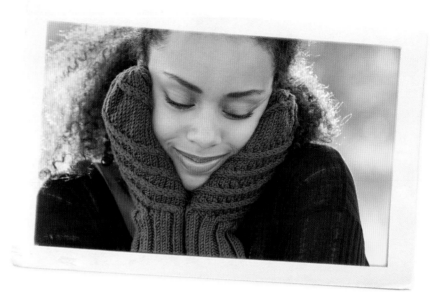

NOTES:

Some cable rounds will cross over the start of the next round; the left-leaning cable shifts two stitches to the left every other round and the right-leaning cable shifts to stitches to the right every other round.

The length of these mittens is customizable for a perfect fit. But as a result, the cable pattern will be slightly different.

For very long hands, you might need a second skein of yarn.

right mitten

CO 50 sts. Place marker (pm) and join for working in rnds, being careful not to twist sts.

Foll charts or row-by-row instructions (see Stitch Guide), work in k3, p2 rib until piece measures 2½" (6.5 cm) from CO.

Set-up rnd: K23, k2tog, k23, k2tog—48 sts rem.

Work Rows 1–8 of Left-Leaning Coiled Cable, then work Rows 1–7 once more.

SHAPE THUMB GUSSET

Set-up rnd: (Row 8 of chart) Work as established to last 4 sts, pm, k1f&b (see Glossary), k2, k1f&b—2 sts inc'd; 6 gusset sts between markers.

Slip markers (sl m) when you come to them. Omit beginning new cable at beg of rnds.

Rnd 1: Work in patt as established, knitting gusset sts between markers.

Rnd 2: Work in patt to m, sl m, k1f&b, knit to last st, k1f&b—2 gusset sts inc'd.

Rep the last 2 rnds once more—54 sts total; 10 gusset sts between markers.

Next rnd: Work in patt to m, remove m, place 10 gusset sts onto holder, use the backward-loop method (see Glossary) to CO 4 sts over the gap—48 sts rem.

UPPER HAND

Next rnd: Resume patt with Rnd 6 of patt.

Next rnd: (Rnd 7 of patt) Work in patt, resuming the cable that was stopped by the thumb gusset.

Cont in patt until piece meaures about 4" (10 cm) from CO at top of thumb gusset.

Dec for tip as foll.

Rnd 1: *K2, k2tog; rep from *—36 sts rem.

Rnd 2: *K1, k2tog; rep from *—24 sts rem.

Rnd 3: *K2tog; rep from *—12 sts rem.

Rnd 4: *K2tog; rep from *—6 sts rem.

Cut yarn, leaving a 10" (25.5 cm) tail. Thread tail on a tapestry needle, draw through rem sts, pull tight to close hole, and secure on WS.

THUMB

Place 10 held gusset sts onto 2 dpn. Join yarn and knit these sts. With another dpn, pick up and knit 6 sts in the gap between the thumb and upper hand—16 sts total. Pm and join for working in rnds.

Work 18 rnds even in St st, or until piece measures just below the tip of your thumb.

Dec rnd: *K2tog; rep from *—8 sts rem.

Rep dec rnd once more—4 sts rem.

Cut yarn, leaving an 8" (20.5 cm) tail. Thread tail on a tapestry needle, draw through rem sts, pull tight to close hole, and secure on WS.

left mitten

CO 50 sts. Work cuff as right mitten to start of thumb gusset, substituting Right-Leaning Coiled Cable patt for Left-Leaning Coiled Cable patt, working Rnds 1–10 once, then Rnds 1–7 once more, and omitting beginning new cable before thumb gusset—48 sts rem.

SHAPE THUMB GUSSET

Set-up rnd: (Row 8 of patt) K1f&b, k2, k1f&b, pm, work as established to end of rnd—2 sts inc'd; 6 gusset sts between markers.

Rnd 1: Work in patt as established but knit the gusset sts between markers.

Rnd 2: K1f&b, knit to 1 st before m, k1f&b, sl m, work in patt to end of rnd.

Rep the last 2 rnds once more—54 sts total; 10 gusset sts between markers.

Next rnd: Sl end-of-rnd m, place 10 gusset sts onto holder, use the backward-loop method to CO 4 sts, remove next m, work in patt to end of rnd—48 sts rem.

UPPER HAND AND THUMB

Work as right mitten, substituting the Right-Leaning Coiled Cable patt for Left-Leaning Coiled Cable patt.

finishing

Weave in loose ends.

Block lightly.

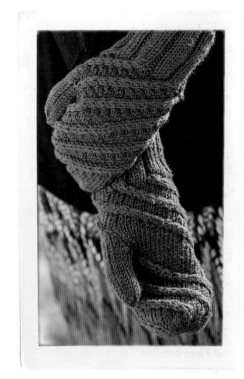

LEFT-LEANING COILED CABLE

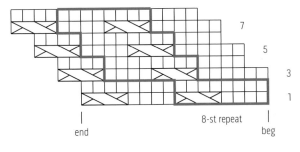

end 8-st repeat beg

7

5

3

1

RIGHT-LEANING COILED CABLE

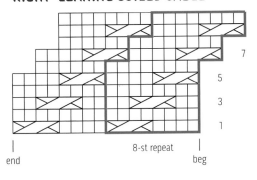

end 8-st repeat beg

9

7

5

3

1

K3, P2 RiB

 1

k

p

⬛ 2/2RC (see Stitch Guide)

⬛ 2/2LC (see Stitch Guide)

☐ pattern repeat

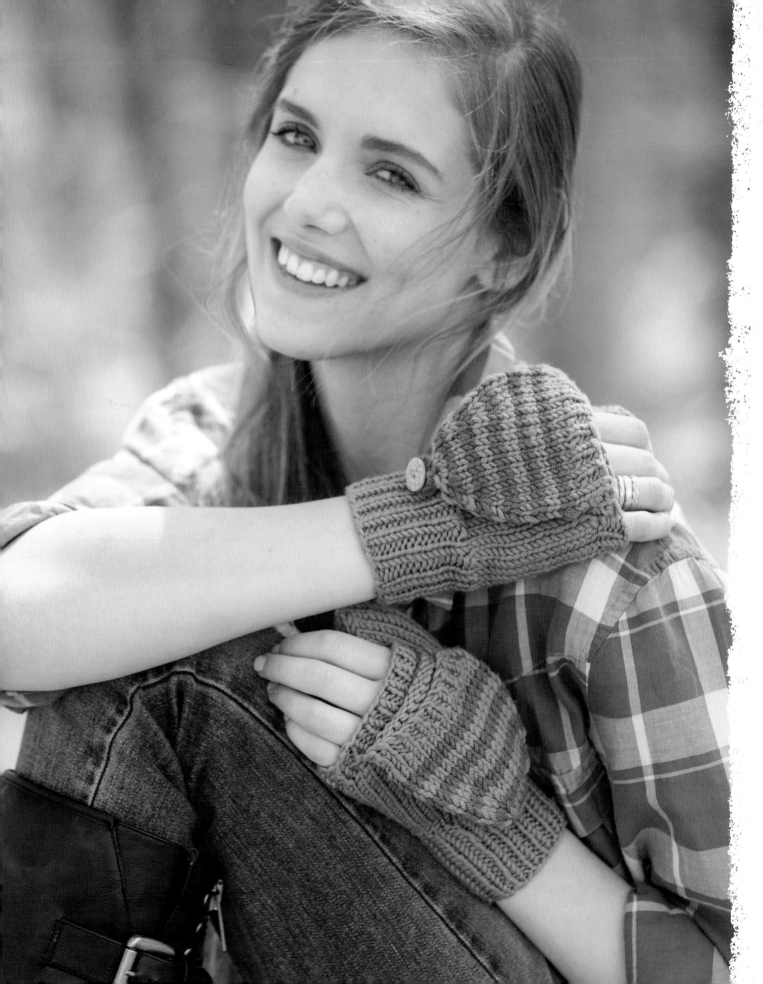

flip-top
MITTS

designed by TERRI KRUSE

Can't decide if you want your fingertips covered or not? Here's your solution! Fold the striped flap over your fingers for full coverage or secure the flap out of the way with a single button when you want your fingers to be free.

FINISHED SIZE
About 6½ (7, 7½)" (16.5 [18, 19] cm) in circumference.

Mitts shown measure 7" (18 cm).

YARN
Worsted weight (#4 Medium).

Shown here: Cascade Yarns Longwood (100% superwash extrafine merino wool; 191 yd [175 m]/100 g): #02 Gray Frost (MC), #20 Cyan (CC1), and #13 Rose (CC2), 1 ball each.

NEEDLES
Ribbing: size U.S. 6 (4 mm): set of 4 or 5 double-pointed (dpn).

Mitten body: size U.S. 7 (4.5 mm): set of 4 or 5 dpn.

Adjust needle size if necessary to obtain the correct gauge.

NOTIONS
Marker (m); waste-yarn holder; tapestry needle; two ⅝" (16 mm) buttons.

GAUGE
17 sts and 28 rnds = 4" (10 cm) in St st worked in rnds on larger needles.

STITCH GUIDE

STRIPE PATTERN

Rnds 1 and 2: Knit with CC1.

Rnds 2 and 4: Knit with CC2.

Rep Rnds 1–4 for patt.

Note:
When picking up stitches for the flap, pick up through just one leg of each stitch.

mitts

With MC and smaller dpn, CO 28 (30, 32) sts. Arrange sts on 3 or 4 dpn, place marker (pm), and join for working in rnds, being careful not to twist sts.

Work k1, p1 rib for 16 (16, 18) rnds.

Change to larger dpn.

Inc rnd: Knit to last st, M1 (see Glossary)—29 (31, 33) sts.

SHAPE GUSSET

Rnd 1: K14 (15, 16), pm, M1L (see Glossary), k1, M1R (see Glossary), pm, knit to end—31 (33, 35) sts; 3 gusset sts between markers.

Rnds 2 and 3: Knit.

Rnd 4: Knit to m, slip marker (sl m), M1L, knit to next m, M1R, sl m, knit to end—2 gusset sts inc'd.

Rnds 5 and 6: Knit.

Rep Rnds 4–6 three (four, five) more times—39 (43, 47) sts; 11 (13, 15) gusset sts.

Knit 3 (1, 1) rnd(s) even.

Next rnd: Knit to m, remove m, place 11 (13, 15) gusset sts onto waste-yarn holder, remove m, knit to end—28 (30, 32) sts rem.

UPPER HAND

Knit 2 (2, 3) rnds even.

Change to smaller dpn. Work k1, p1 rib for 4 rnds.

Loosely BO all sts in patt.

FLIP TOP

Work the right and left mitts separately as foll.

Right mitt only

With MC, smaller dpn, RS facing, and thumb facing to the left, pick up and knit 14 (15, 16) sts (see Notes) across the back of the mitt in the last rnd of St st, beg at the outside of the hand and working toward the thumb, then use the backward-loop method (see Glossary) to CO 15 (16, 17) sts—29 (31, 33) sts total.

Left mitt only

With MC, smaller dpn, RS facing, and thumb facing to the right, pick up and knit 14 (15, 16) sts (see Notes) across the back of the mitt in the last rnd of St st, beg at the thumb and working toward the outside of the hand, then use the backward-loop method (see Glossary) to CO 15 (16, 17) sts—29 (31, 33) sts total.

Both mitts

Arrange sts as evenly as possible on 3 or 4 dpn and join for working in rnds.

Set-up rnd: K15 (15, 17), *k1, p1; rep from *.

Rep this rnd 3 more times.

Change to larger dpn and, joining CC2 when necessary, work stripe patt (see Stitch Guide) for 8 (10, 10) rnds.

SHAPE TOP

Cont in stripe patt as established, dec as foll.

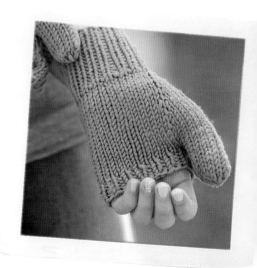

Set-up rnd: Knit and *at the same time* dec 1 (1, 3) st(s) evenly spaced—28 (30, 30) sts rem.

Work 4 (2, 2) rnds even in patt.

Rnd 1: *K5 (8, 8), k2tog; rep from *—24 (27, 27) sts rem.

Rnds 2, 4, 6, and 8: Knit.

Rnd 3: *K4 (7, 7), k2tog; rep from *—20 (24, 24) sts rem.

Rnd 5: *K3 (6, 6), k2tog; rep from *—16 (21, 21) sts rem.

Rnd 7: *K2 (5, 5), k2tog; rep from *—12 (18, 18) sts rem.

Rnd 9: *K1 (4, 4), k2tog; rep from *—8 (15, 15) sts rem.

Cont for your size as foll.

Size 6½" only
Rnd 10: *K2tog; rep from *—4 sts rem.

Rnd 11: K2, k2tog—3 sts rem.

Sizes (7, 7½)" only
Rnd 10: *K3, k2tog; rep from *—(12, 12) sts rem.

Rnd 11: *K2tog; rep from *—(6, 6) sts rem.

Rnd 12: Rep Rnd 11—(3, 3) sts rem.

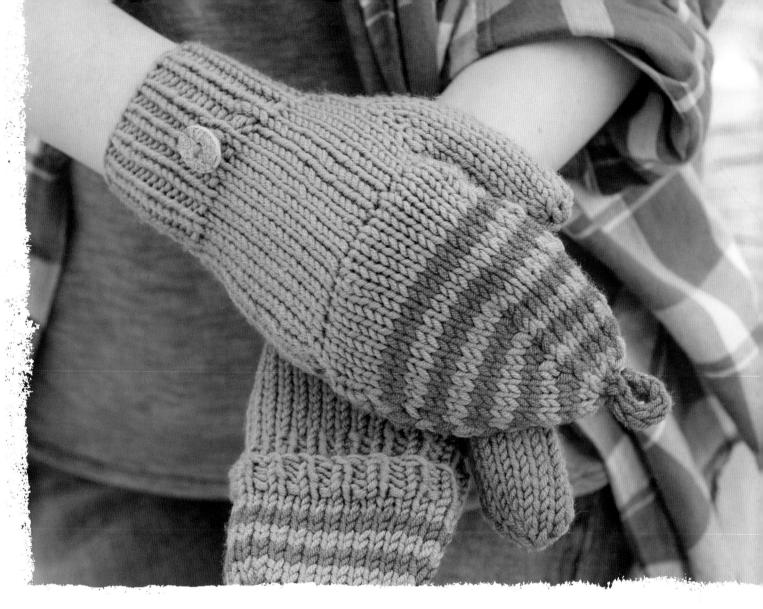

All sizes

Work rem 3 sts in I-cord (see Glossary) until cord measures 2" (5 cm).

BO all sts. Fold cord into a loop and, with yarn threaded on a tapestry needle, secure both ends to tip of flap.

THUMB

Distribute 11 (13, 15) held gusset sts onto 3 larger dpn.

Join MC, k11 (13, 15), pick up and knit 1 st in gap, then join for working in rnds—12 (14, 16) sts total.

Knit 8 (8, 9) rnds even.

Cont for your size as foll.

Size 6½" only

Skip to All sizes.

Size 7" only

Next rnd: K2tog, knit to last 2 sts, k2tog—12 sts rem.

Size 7½" only

Next rnd: K2tog, knit to end—15 sts rem.

All sizes

Rnd 1: *K2 (2, 3), k2tog; rep from *—9 (9, 12) sts rem.

Rnd 2: *K1 (1, 2), k2tog*; rep from *—6 (6, 9) sts rem.

Size 7½" only

Next rnd: *K1, k2tog; rep from *—6 sts rem.

finishing

Cut yarn, leaving an 8" (20.5 cm) tail. Thread tail on a tapestry needle, draw through rem 6 sts, pull tight to close hole, and secure on WS.

Weave in loose ends.

Block lightly.

Fold flip top to back of mitt and mark center of loop on rib near top of rib. Sew buttons to mitts as marked.

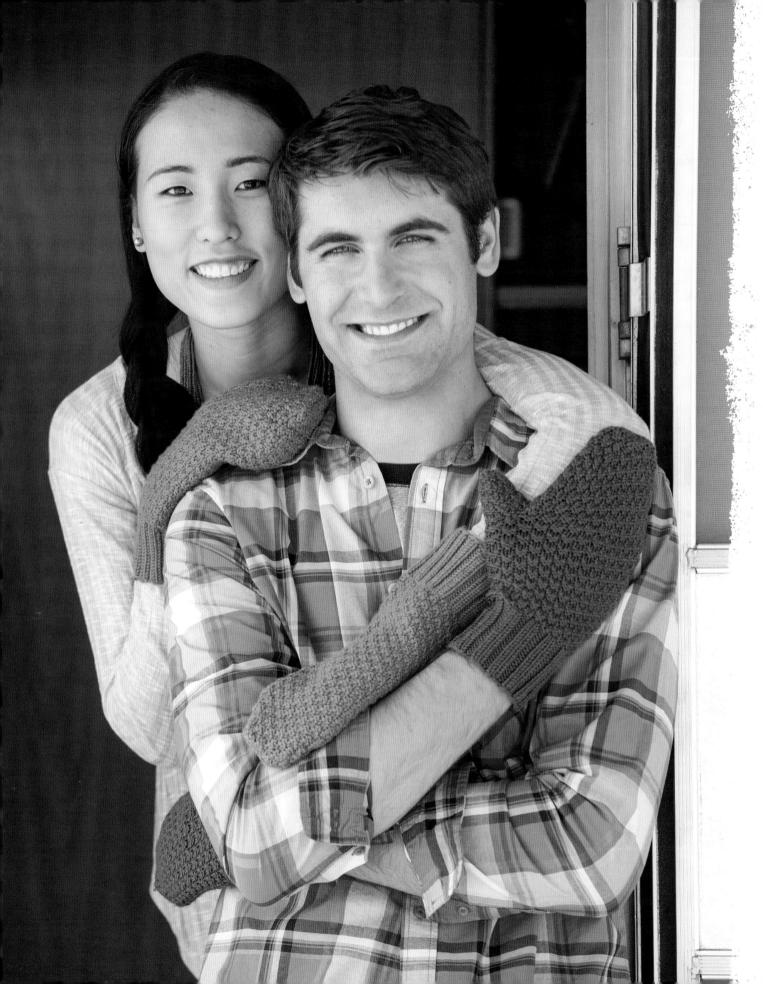

moss-stitch
MITTENS

designed by DEBBIE O'NEILL

These mittens are knitted up in a cozy moss-stitch pattern suitable for the entire family! The afterthought thumb makes it a breeze to knit from cuff to fingertips. Extra-long cuffs ensure that wrists stay warm, but they can easily be made shorter to suit any wearer's taste.

FINISHED SIZE

About 6¼ (7¾, 8¼, 9, 9¾)" (16 [19.5, 21, 23, 25] cm) in circumference.

Green mittens shown measure 8¼" (21 cm); gold mittens measure 9" (23 cm).

YARN

Worsted weight (#4 Medium).

Shown here: Cascade Yarns Longwood (100% superwash extrafine merino wool; 191 yd [175 m]/100 g): 1 (1, 2, 2, 2) ball(s). Shown in #16 Chive and #09 Mustard.

NEEDLES

Size U.S. 4 (3.5 mm): set of 4 double-pointed (dpn).

Adjust needle size if necessary to obtain the correct gauge.

NOTIONS

Markers (m); waste yarn; tapestry needle.

GAUGE

24 sts and 34 rnds = 4" (10 cm) in moss st worked in rnds, before washing and blocking.

23 sts and 37 rnds = 4" (10 cm) in moss st worked in rnds, after washing and blocking.

STITCH GUIDE

MOSS STITCH
(multi of 4 sts)

Rnds 1 and 2: *P2, k2; rep from *.

Rnds 3 and 4: *K2, p2; rep from *.

Rep Rnds 1–4 for patt.

NOTES:
The thumb appears wider than a normal gusseted thumb; the extra width is required to accommodate the shape of the hand and is not as wide as it might appear.

This yarn changes in length when washed; take time to check how your gauge changes with washing.

The smallest size has a wide top; work another decrease round to make a narrower top if desired.

mittens

CUFF

CO 36 (44, 48, 52, 56) sts.

Divide sts between three needles so that there are 12 (16, 16, 16, 18) sts

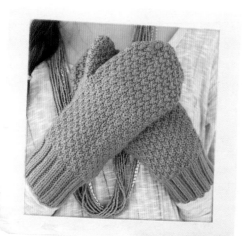

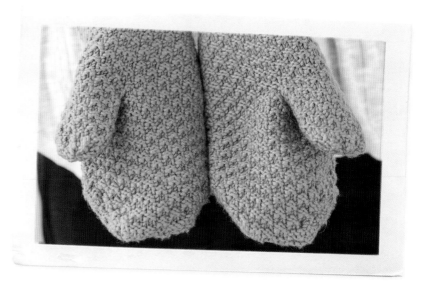

on Needle 1, 12 (12, 16, 20, 20) sts on Needle 2, and 12 (16, 16, 16, 18) sts on Needle 3.

Place marker (pm) and join for working in rnds, being careful not to twist sts.

Work in k2, p2 ribbing until piece measures 2 (2, 2½, 2½, 2½)" (5 [5, 6.5, 6.5, 6.5] cm), or desired length from CO (see Notes).

LOWER HAND

Set-up rnd: Working in moss st (see Stitch Guide), work 8 (10, 12, 14, 14) sts, pm, work 2 sts, pm, work 16 (20, 22, 24, 26) sts, pm, work 2 sts, pm, work to end of rnd.

Slipping markers when you come to them, work even in patt until piece measures 4 (4½, 5½, 6, 6½)" (10 [11.5, 14, 15, 16.5] cm) from CO, or to desired length to base of thumb.

MARK THUMB

Right Mitten

Work in patt to last 9 (11, 12, 12, 14) sts, use waste yarn to k7 (9, 10, 12, 13), sl these waste-yarn sts back onto left needle tip, then beg with the waste-yarn sts, cont with working yarn to end of rnd.

Left Mitten

Work 2 (2, 2, 0, 1) st(s) in patt, use waste yarn to k7 (9, 10, 12, 13), sl these waste-yarn sts back onto left needle tip, then beg with the waste-yarn sts, cont with working yarn to end of rnd.

UPPER HAND

Cont in patt as established until piece measures about ½ (1, 1¼, 1¼, 1½)" (1.3 [2.5, 3.2, 3.2, 3.8] cm) shorter than desired total length, ending with Rnd 2 or 4 of patt.

SHAPE TOP

Rnd 1: Work to 2 sts before m, k2tog or p2tog as necessary to maintain patt, sl m, work 2 sts, sl m, ssk or ssp (see Glossary) as necessary to maintain patt, work to 2 sts before next m, k2tog or p2tog as necessary, sl m, work 2 sts, sl m, ssp, work to end of rnd—4 sts dec'd.

Rnd 2: Work even in established patt.

Rep Rnds 1 and 2 until 24 (20, 20, 24, 24) sts rem; 12 (10, 10, 12, 12) sts each for palm and back of hand (see Notes).

Work palm sts onto one needle and back-of-hand sts onto a second needle.

Cut yarn, leaving a 12" (30.5 cm) tail. Thread tail on a tapestry needle and use the Kitchener st (see Glossary) to graft the sts tog, removing markers as you go.

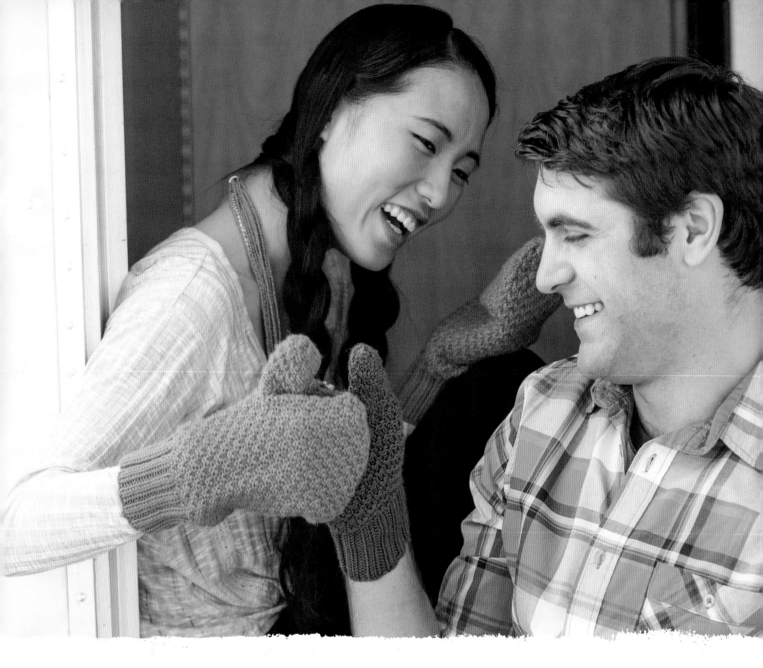

THUMB

Carefully remove waste yarn marking thumb and place 7 (9, 10, 12, 13) exposed lower sts onto one dpn and 8 (10, 11, 13, 14) exposed upper sts onto another dpn—15 (19, 21, 25, 27) sts total.

Arrange sts onto 3 dpn for ease of working in rnds.

Set-up rnd: Join yarn and work in moss st and *at the same time* pick up sts as needed at the corners and work k2tog or p2tog as necessary (dec a picked-up corner st with a st on the needle when possible) to maintain patt as you go to end up with a total of 16 (20, 20, 24, 24) sts.

Work moss st in rnds until piece measures about 2 rnds (¼" or 6 mm) shorter than desired total length, ending with Rnd 2 or 4 of patt.

Dec rnd: Alternate k2tog and p2tog as necessary to maintain patt—8 (10, 10, 12, 12) sts rem.

Work 1 rnd even.

Cut yarn, leaving a 10" (25.5 cm) tail. Thread tail on a tapestry needle, draw through rem sts, pull tight to close hole, and secure on WS.

finishing

Weave in loose ends.

Block as desired.

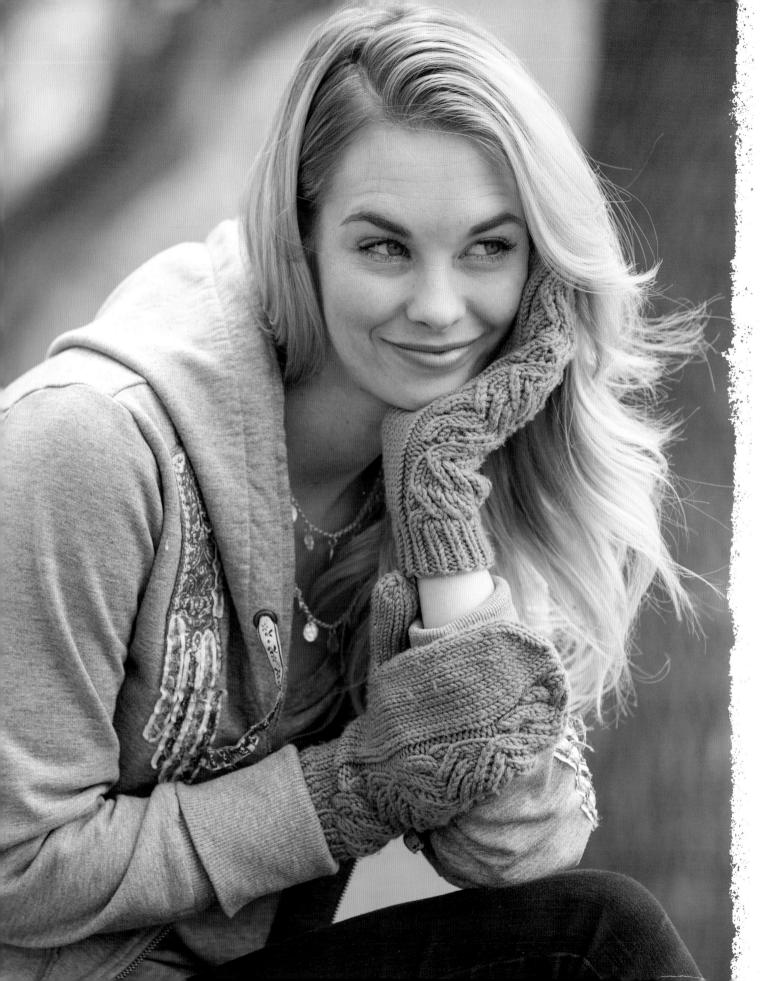

motif
MITTENS

designed by ANGELA HAHN

Acccented with a cable/lace motif, these mittens are a great way to try out a fairly complex cable/lace stitch pattern—working in rounds makes it easier to keep track of lace stitches on every pattern row. The motif is placed asymmetrically, opposite the thumb, and wraps around the outside of the hand.

FINISHED SIZE

About 7¼" (18.5 cm) in circumference and 10¼" (26 cm) long.

YARN

Worsted weight (#4 Medium).

Shown here: Cascade Yarns Longwood (100% superwash extrafine merino wool; 191 yd [175 m]/100 g): #18 Green Spruce, 1 ball.

NEEDLES

Rib: size U.S. 5 (3.75 mm): set of 4 or 5 double-pointed (dpn).

Main: size U.S. 7 (4.5 mm): set of 4 or 5 (dpn).

Adjust needle size if necessary to obtain the correct gauge.

NOTIONS

Markers (m); cable needle (cn); stitch holders or waste yarn; tapestry needle.

GAUGE

21 sts and 28 rnds = 4" (10 cm) in St st worked in rnds on larger needles.

15 sts of cable/lace panel = 2¼" (5.5 cm) wide.

STITCH GUIDE

2/2LC: Slip 2 sts onto cn and hold in front of work, k2, then k2 from cn.

2/2RC: Slip 2 sts onto cn and hold in back of work, k2, then k2 from cn.

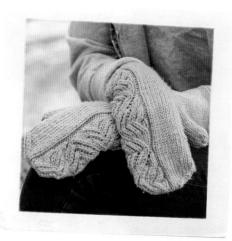

NOTES:
Instructions for left and right mittens are identical up to the top shaping, but the cable/ lace motif is mirrored, so be sure to use the correct chart for each mitten.

left mitten

With smaller dpn, CO 32 sts. Distribute evenly among 3 dpn, place marker (pm), and join for working in rnds, being careful not to twist sts.

Set-up rib: *K1, p1; rep from *.

Rep this rnd 9 more times—piece measures about 1¼" (3.2 cm) from CO.

Change to larger needles.

Set-up Rnd 1: Knit to last 11 sts, work Set-up Row 1 of Left Mitten chart—34 sts.

Set-up Rnd 2: Knit to last 13 sts, work Set-up Row 2 of chart—36 sts.

Set-up motif: Knit to last 15 sts, work Row 1 of chart.

Cont in patt as established until Row 16 of chart has been completed—28 rnds total from CO.

THUMB GUSSET

K10, pm, M1R (see Glossary), k1, M1L (see Glossary), pm, k10, work to end as established—38 sts; 3 sts between gusset markers.

Work 1 rnd even, slipping markers (sl m) when you come to them.

Gusset inc rnd: K10, sl m, M1R, knit to next m, M1L, sl m, work to end as established—2 sts inc'd; 40 sts.

Rep the last 2 rnds 2 more times—44 sts; 9 sts between gusset m.

Work 5 rnds even, ending first 24-row rep of chart, then beg second 24-row rep (see chart).

Next rnd: Knit to gusset m, place 9 gusset sts onto holder for thumb (remove gusset m), turn work so WS is facing and use the knitted method (see Glossary) to CO 6 sts over gap—41 sts.

Turn work so RS is facing and beg with newly CO sts, work in patt as established until second 24-row rep has been completed and Row 35 of chart has been completed—71 rnds total from CO.

SHAPE TOP

K15, k2tog, pm, ssk, k7, work Front portion of Row 36 of chart, pm, work Back portion of chart, remove beg-of-rnd m, k14, k2tog—5 sts dec'd; 18 sts rem each in back and palm sides of mitten (divided by m).

Dec Rnd 1: Ssk, knit to chart panel, work next row of chart, knit to last 2 sts, k2tog—4 sts dec'd.

Rep Dec Rnd 1 once more—4 sts dec'd; 14 sts rem each in back and palm; Back portion of chart completed.

Dec Rnd 2: Ssk, knit to chart panel, work next row of chart, ssk, knit to last 2 sts, k2tog—4 sts dec'd.

Rep Dec Rnd 2 two more times—8 sts dec'd; 8 sts rem each in back and palm.

Cut yarn, leaving an 18" (45.5 cm) tail for three-needle BO.

Turn work inside out. Place back sts onto one dpn and palm sts onto a second dpn. With a third needle, use the three-needle method (see Glossary) to BO the two sets of sts tog.

right mitten

CO and work as for left mitten, substituting Right Mitten chart for Left Mitten chart, to end of thumb gusset—71 rnds total from CO.

☐	k
•	p
o	yo
/	k2tog
\	ssk
⅄	k tbl
MP	M1P (see Glossary)
MR	M1R (see Glossary)
ML	M1L (see Glossary)
⤬	2/2RC (see Stitch Guide)
⤬	2/2LC (see Stitch Guide)
▨	no stitch
☐	pattern repeat

SHAPE TOP

K8, k2tog, pm, ssk, k14, work Back portion of Row 36 of chart, pm, work Front portion of chart, remove beg of rnd m, k7, k2tog—5 sts dec'd, 18 sts rem each in back and palm sides of mitten (divided by m).

Dec Rnd 1: Ssk, knit to chart panel, work next row of chart, knit to last 2 sts, k2tog—4 sts dec'd.

Rep Dec Rnd 1 once more—4 sts dec'd; 14 sts rem each in back and palm; Back portion of chart completed.

Dec Rnd 2: Ssk, knit to 2 sts before m, k2tog, work next row of chart, knit to last 2 sts, k2tog—4 sts dec'd.

Rep Dec Rnd 2 two more times—8 sts dec'd, 8 sts rem each in back and palm.

Cut yarn, leaving an 18" (45.5 cm) tail. Work three-needle BO as for left mitten.

THUMB (BOTH MITTENS)

With dpn and RS facing, pick up and knit 8 sts along CO edge, place 9 held sts onto 2 dpn, then knit these sts—17 sts total.

Pm and join for working in rnds.

Dec Rnd 1: K2tog, k4, ssk, knit to end of rnd—15 sts rem.

Knit 17 rnds even.

Dec Rnd 2: *K1, k2tog; rep from *—10 sts rem.

Next rnd (dec): *K2tog; rep from *—5 sts rem.

Cut yarn, leaving an 8" (20.5 cm) tail.

Thread tail on a tapestry needle, draw through rem sts, pull tight to close hole, then fasten off on WS.

finishing

Weave in loose ends, closing any holes at base of thumb.

Block lightly to measurements.

LEFT MITTEN

RIGHT MITTEN

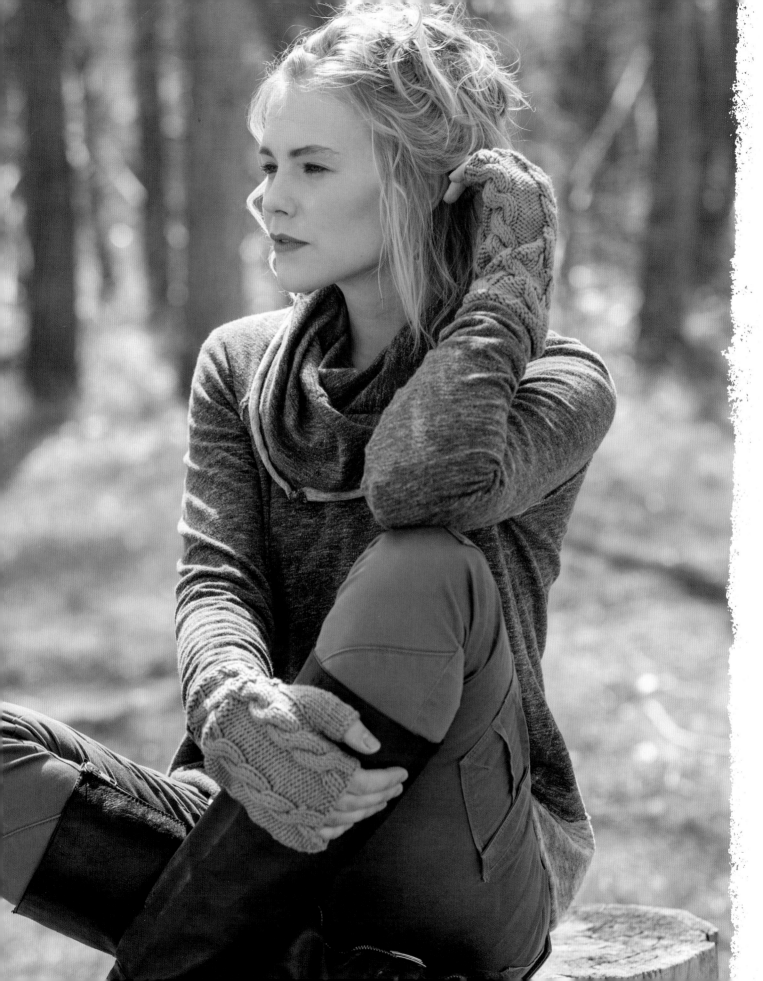

twigg
MITTS

designed by JENNIFER WOOD

The cuff pattern on these mitts is reminiscent of twigs growing out of the cables on the hands, like a tree growing up your arm. All the cables are worked the same—three stitches that cross over three stitches and lean to the left—making this a great pattern for practicing working cables without a cable needle. Side-seam thumb gussets make them fit either hand equally well.

FINISHED SIZE
About 7½" (19 cm) hand circumference, 6½" (16.5 cm) wrist circumference, and 8" (20.5 cm) long.

YARN
Worsted weight (#4 Medium).

Shown here: Cascade Yarns Longwood (100% superwash extrafine merino wool; 191 yd [175 m]/100 g): #15 Green Olive, 1 ball.

NEEDLES
Size U.S. 7 (4.5 mm): set of 4 or 5 double-pointed (dpn).

Adjust needle size if necessary to obtain the correct gauge.

NOTIONS
Markers (m); cable needle (cn); stitch holders or waste yarn; tapestry needle.

GAUGE
25½ sts and 24 rnds = 4" (10 cm) in Hand chart worked in rnds.

STITCH GUIDE

3/3LC: Slip 3 sts onto cn and hold in front of work, k3, then k3 from cn.

mitt

CO 40 sts. Place marker (pm) and join for working in rnds, being careful not to twist sts.

CUFF

Purl 2 rnds.

Work Rows 1–16 of Cuff chart (starting the cable for Row 13 with the last 3 sts of Row 12).

HAND

Inc rnd: P1, M1P (see Glossary), p1, [k6, p1, M1P, p2, M1P, p1] 3 times, k6, p1, M1P, p1—48 sts.

Work Rows 1 and 2 of Hand chart.

SHAPE THUMB GUSSET

Set-up rnd: Work Row 3 of Hand chart over 24 sts, pm for thumb gusset, M1 (see Glossary), pm, work Row 3 of Hand chart to end—49 sts; 1 gusset st between markers.

Rnds 1 and 2: Work next row of Hand chart to m, sl m, k1, sl m, work Hand chart to end.

Rnd 3: Work next row of Hand chart to m, sl m, M1, k1, M1, sl m, work Hand chart to end—2 sts inc'd; 3 gusset sts between markers.

Work 2 rnds even in patt as established, working gusset sts in St st.

Inc rnd: Work next row of Hand chart to m, sl m, RLI (see Glossary), knit to next m, LLI (see Glossary), sl m, work Hand chart to end—2 gusset sts inc'd.

Rep the last 3 rnds 4 more times—61 sts total; 13 gusset sts.

Next rnd: Work in patt to m, sl 13 gusset sts onto holder to work later for thumb, work to end—48 sts rem.

Work 5 rnds even in patt.

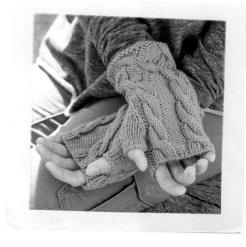

EDGING

Dec rnd: P2, [k2tog, k4, ssk, p4] 3 times, k2tog, k4, ssk, p2—40 sts rem.

Next rnd: P2, [k2, p2, k2, p4] 3 times, [k2, p2] 2 times.

Rep the last rnd 2 more times.

Loosely BO all sts in patt.

THUMB

Divide 13 held sts onto 3 dpn.

With RS facing, join yarn and pick up and knit 1 st at gap between thumb and upper hand, pm, and join for working in rnds—14 sts total.

Knit 5 rnds.

Loosely BO all sts purlwise.

finishing

Weave in loose ends.

Block lightly to measurements.

CUFF

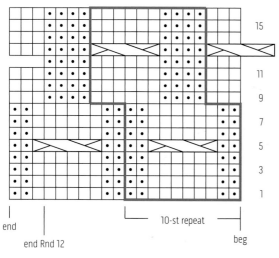

15
13
11
9
7
5
3
1

end
end Rnd 12
10-st repeat
beg

Note: End Rnd 12 three sts before end of rnd and use those sts to work the cable at the beginning of Rnd 13.

HAND

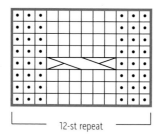

7
5
3
1

12-st repeat

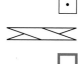

	k
•	p
⟩⟨	3/3LC (see Stitch Guide)
	pattern repeat

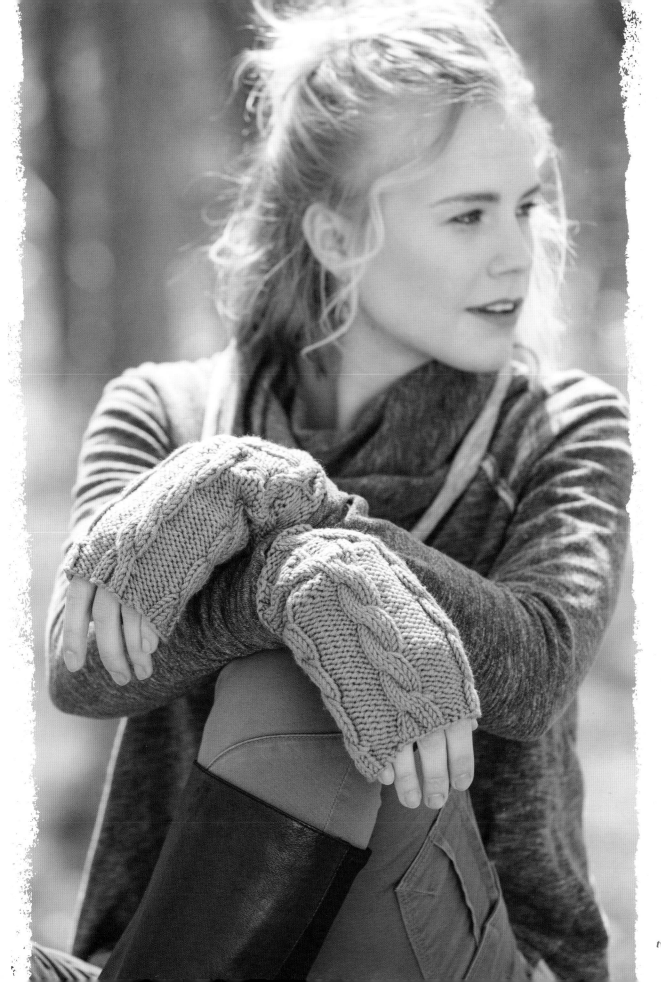

matching sets

[FOR THE FRIENDS]

Show your friends how much they mean to you by knitting up one of these toasty sets in their favorite colors. You'll be sure to find the perfect gift for everyone on your holiday and birthday lists!

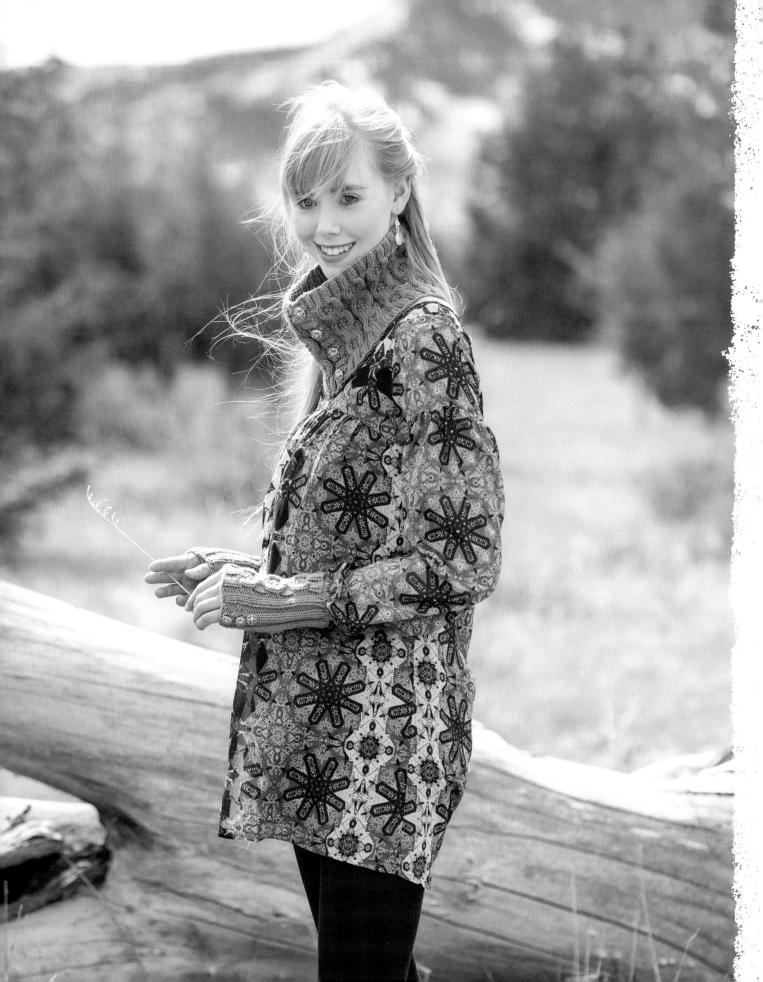

cabled
COWL + WRISTERS

designed by LINDA MEDINA

To protect against the chill, this cabled cowl
is small enough to wear close to your neck,
but long enough to layer over a turtleneck for
added warmth. It's finished with four decorative
buttons sewn to a faux buttonband. The
wristers feature the same cable pattern centered
on 2×2 ribbing, along with decorative buttons.
The ribbing stretches enough to wear the
wristers over gloves on bitter days.

FINISHED SIZE
Cowl: About 21½"
(54.5 cm) in cir-
cumference and 6¼"
(16 cm) long.

Wristers: About
6½" (16.5 cm) in
circumference and
6¼" (16 cm) long.

YARN
Worsted weight (#4
Medium).

Shown here: Cascade
Yarns Longwood
(100% superwash
extrafine me-
rino wool; 191 yd
[175 m]/100 g): #20
Cyan, 2 balls (1 ball
each for cowl and
wristers).

NEEDLES
Size U.S. 7
(4.5 mm): 16"
(40 cm) circular
(cir) and set of 4 or
5 double-pointed
(dpn).

*Adjust needle size if
necessary to obtain
the correct gauge.*

NOTIONS
Marker (m); cable
needle (cn); sewing
needle and matching
embroidery floss for
attaching buttons;
four ¾" (19 mm)
buttons for cowl; six
⅝" (16 mm) buttons
for wristers.

GAUGE
28 sts and 29 rnds =
4" (10 cm) in charted
patt worked in rnds.

STITCH GUIDE

2/2RC: Sl 2 sts onto cn and hold in back of work, k2, then k2 from cn.

2/2LC: Sl 2 sts onto cn and hold in front of work, k2, then k2 from cn.

cowl

With cir needle, CO 152 sts. Place marker (pm) and join for working in rnds, being careful not to twist sts. Slip marker (sl m) when you come to it.

BOTTOM EDGING

Rnd 1: K4, *p2, k2; rep from *.

Rnd 2: Rep Rnd 1.

Rnd 3: P4, *p2, k2; rep from *.

Rnd 4: Rep Rnd 3.

Rnd 5: Rep Rnd 1.

Rnd 6: Rep Rnd 2.

BODY

Rnd 1: P4, p2tog, p2, 2/2RC (see Stitch Guide), k1, 2/2LC (see Stitch Guide), *p3, 2/2RC, k1, 2/2LC; rep from * to last 3 sts, p3—151 sts rem.

Rnd 2: P7, *k2, p1, [k1, p1] 2 times, k2, p3; rep from *.

Rnd 3: K4, p3, *k3, p1, k1, p1, k3, p3; rep from *.

Rnd 4: K4, p3, *k2, p1, [k1, p1] 2 times, k2, p3; rep from *.

Rnd 5: P7, *k3, p1, k1, p1, k3, p3; rep from *.

Rnd 6: Rep Rnd 2.

Rnd 7: K4, p3, *2/2LC, k1, 2/2RC, p3; rep from *.

Rnd 8: K4, p3, *k9, p3; rep from *.

Rnd 9: P7, *k9, p3; rep from *.

Rnd 10: Rep Rnd 9.

Rnds 11 and 12: Rep Rnd 8.

Rnd 13: P7, *2/2RC, k1, 2/2LC, p3; rep from *.

Rep Rnds 2–13 once, then rep Rnds 2–7 once more.

TOP EDGING

Rnd 1: K4, *p2, k2; rep from * to last 3 sts, p2, k1f&b (see Glossary)—152 sts.

Rnd 2: P4, *p2, k2; rep from *.

Rnd 3: Rep Rnd 2.

Rnd 4: K4, *p2, k2; rep from *.

Rnd 5: Rep Rnd 4.

Rnd 6: Rep Rnd 2.

Loosely BO all sts in patt.

finishing

Weave in loose ends. Block lightly. Sew four buttons evenly spaced to faux button band.

wristers

With dpn, CO 44 sts. Place marker (pm) and join for working in rnds, being careful not to twist sts. Slip marker (sl m) when you come to it.

Work in k2, p2 rib for 6 rnds.

Rnd 1: [K2, p2] 7 times, k2, p2tog, p1, 2/2RC (see Stitch Guide), k1, 2/2LC (see Stitch Guide), p2—43 sts rem.

Rnd 2: [K2, p2] 7 times, k2, p2, k2, p1, [k1, p1] 2 times, k2, p2.

Rnd 3: [K2, p2] 7 times, k2, p2, k3, p1, k1, p1, k3, p2.

Rnd 4: Rep Rnd 2.

Rnd 5: Rep Rnd 3.

Rnd 6: Rep Rnd 2.

Rnd 7: [K2, p2] 7 times, k2, p2, 2/2LC, k1, 2/2RC, p2.

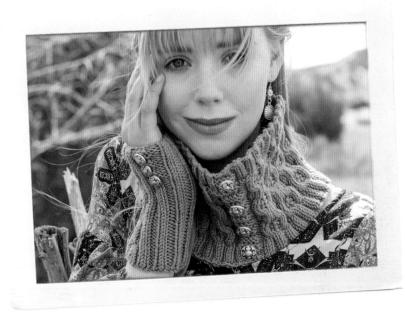

Rnds 8–12: [K2, p2] 7 times, k2, p2, k9, p2.

Rnd 13: [K2, p2] 7 times, k2, p2, 2/2RC, k1, 2/2LC, p2.

Rnds 14–25: Rep Rnds 2–13.

Work left and right wristers separately as foll.

Left Wrister only

Rnd 26: K2, p6, [k2, p2] 6 times, k2, p1, [k1, p1] 2 times, k2, p2.

Rnd 27: K2, p6, [k2, p2] 6 times, k3, p1, k1, p1, k3, p2.

Rnd 28: [K2, p2] 8 times, k2, p1, [k1, p1] 2 times, k2, p2.

Rnd 29: [K2, p2] 8 times, k3, p1, k1, p1, k3, p2.

Rnd 30: Rep Rnd 26.

Rnd 31: K2, p6, [k2, p2] 6 times, 2/2LC, k1, 2/2RC, p2.

Skip to Top Edging.

Right Wrister only

Rnd 26: [K2, p2] 6 times, p4, k2, p2, k2, p1, [k1, p1] 2 times, k2, p2.

Rnd 27: [K2, p2] 6 times, p4, k2, p2, k3, p1, k1, p1, k3, p2.

Rnd 28: [K2, p2] 8 times, k2, p1, [k1, p1] 2 times, k2, p2.

Rnd 29: [K2, p2] 8 times, k3, p1, k1, p1, k3, p2.

Rnd 30: Rep Rnd 26.

Rnd 31: [K2, p2] 6 times, p4, k2, p2, 2/2LC, k1, 2/2RC, p2.

TOP EDGING

Work left and right wristers differently as foll.

Left Wrister only

Rnd 1: [K2, p2] 7 times, k2, p1f&b (see Glossary), [k2, p2] 3 times—44 sts.

Rnd 2: *K2, p2; rep from *.

Rnd 3: K2, p6, *k2, p2; rep from *.

Rnd 4: Rep Rnd 3.

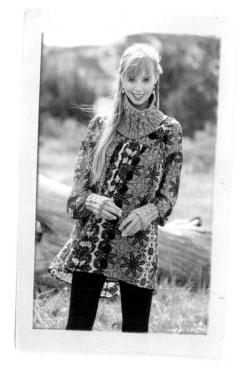

Rnd 5: Rep Rnd 2.

Loosely BO all sts in patt.

Right Wrister only

Rnd 1: [K2, p2] 7 times, k2, p1f&b, [k2, p2] 3 times—44 sts.

Rnd 2: *K2, p2; rep from *.

Rnd 3: [K2, p2] 6 times, p4, [k2, p2] 4 times.

Rnd 4: Rep Rnd 3.

Rnd 5: Rep Rnd 2.

Loosely BO all sts in patt.

finishing

Weave in loose ends.

Block lightly.

Sew three buttons evenly spaced onto faux buttonband on each wrister.

OXO

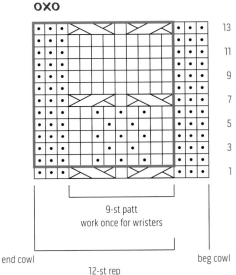

9-st patt
work once for wristers

end cowl beg cowl
12-st rep
work 12 times for cowl

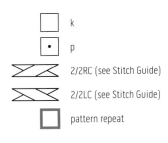

□ k

☐• p

⟩⟨ 2/2RC (see Stitch Guide)

⟩⟨ 2/2LC (see Stitch Guide)

▢ pattern repeat

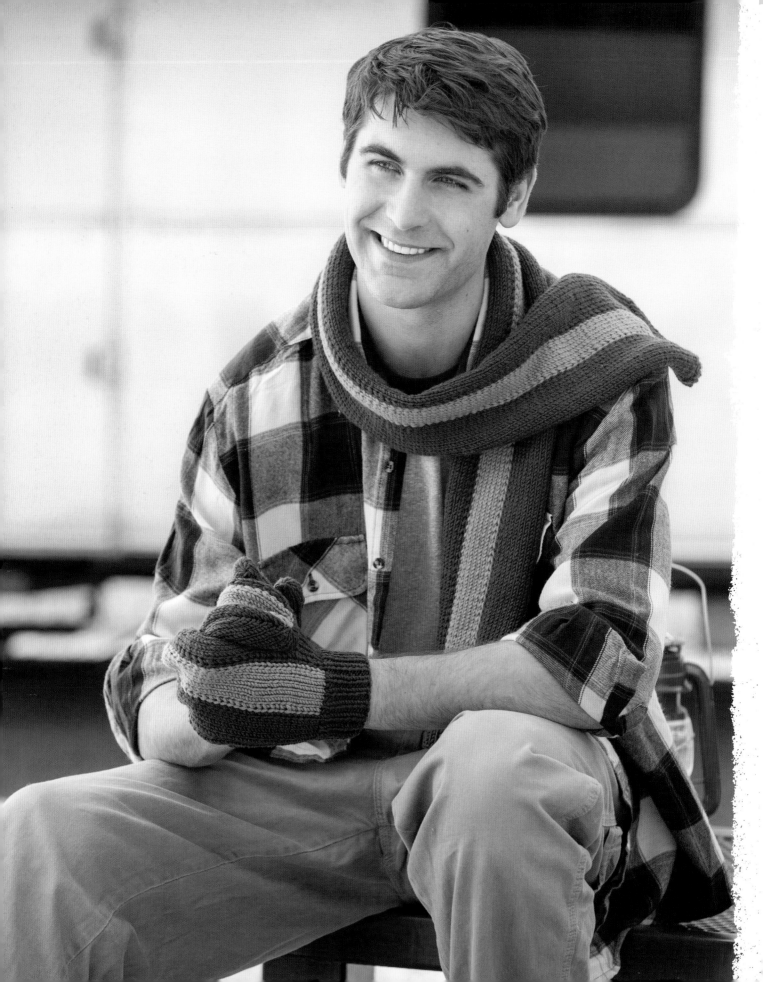

striped

SCARF + MITTENS

designed by LOREN CHERENSKY

For that man who never wants to leave the house properly dressed for the cold, knit this scarf-and-mitten set in his favorite team colors. The mittens are worked flat in rows, then sewn into tubes. The racing stripes will keep him warm while feeling manly.

FINISHED SIZE

Scarf: About 10" (25.5 cm) wide and 50" (127 cm) long.

Mittens: About 7 (8¾)" (18 [22] cm) in circumference and 9 (10)" (23 [25.5] cm) long.

YARN

Worsted weight (#4 Medium).

Shown here: Cascade Yarns Longwood (100% superwash extrafine merino wool; 191 yd [175 m]/100 g): #18 Green Spruce (A), 1 ball each for scarf and mittens; #11 Walnut (B), 2 balls for scarf and 1 ball for mittens.

NEEDLES

Scarf: size U.S. 8 (5 mm): straight.

Mitten cuff: size U.S. 6 (4 mm): straight.

Mitten hand: size U.S. 8 (5 mm): straight.

Adjust needle size if necessary to obtain the correct gauge.

NOTIONS

Markers (m); stitch holder.

GAUGE

18 sts and 28 rows = 4" (10 cm) in St st.

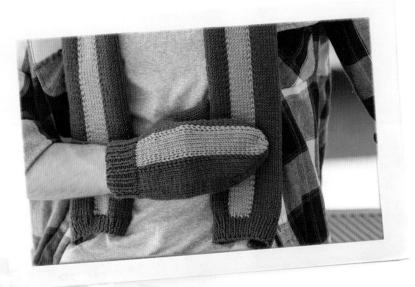

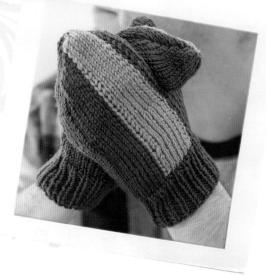

Row 1: (WS) P1, *k1, p1; rep from *.

Row 2: (RS) K1, *p1, k1; rep from *.

Rep Rows 1 and 2 until piece measures 2" (5 cm) from CO, ending with a WS row.

Change to larger needles and St st (knit RS rows; purl WS rows) and work right and left mitten differently as foll.

Right Mitten

Set-up row: (RS) K7 with B, k7 with A, join another ball of B and k21 (27).

Left Mitten

Set-up row: (RS) K21 (27) with B, k7 with A, join another ball of B and k7.

Both Mittens

Cont even as established until piece measures 3¼" (8.5 cm) from CO, ending with a WS row.

SHAPE THUMB GUSSET

Set-up row: (RS) K17 (20), place marker (pm), M1 (see Glossary), k1, M1, pm, k17 (20)—37 (43) sts; 3 gusset sts between markers.

Purl 1 WS row.

Inc row: (RS) Knit to m, slip marker (sl m), M1, knit to 1 st before next m, M1, sl m, knit to end—2 gusset sts inc'd.

Rep the last 2 rows 4 (5) more times—47 (55) sts; 13 (15) gusset sts between markers, ending with a WS row.

UPPER HAND

K17 (20), place 13 (15) gusset sts onto holder to work later for thumb (remove markers), k17 (20)—34 (40) sts rem.

Cont even in patt until piece measures 7½ (8½)" (19 [21.5] cm) from CO or 1½ (1¾)" (3.8 [4.5] cm) less than desired length, ending with a WS row and placing a marker between the 2 center sts.

scarf

With B, CO 45 sts.

Work in k1, p1 rib until piece measures 1" (2.5 cm) from CO.

Change to stripe patt in St st as foll.

Set-up row: K19 with B, k7 with A, join another ball of B and knit to end.

Twisting yarns at each color change to prevent holes, cont even in St st (knit RS rows, purl WS rows) until piece measures 49" (124.5 cm) from CO, ending with a WS row.

Cut A and cont with B only.

Work in k1, p1 rib for 1" (2.5 cm).

Loosely BO all sts in patt.

mittens

With B and smaller needles, CO 35 (41) sts.

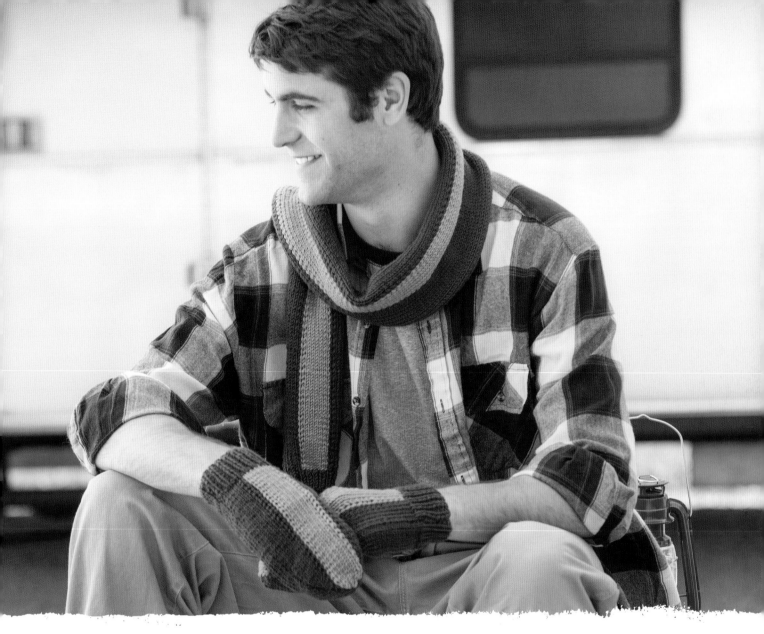

SHAPE TOP

Dec row: (RS) Ssk, knit to 2 sts before center m, k2tog, sl m, ssk, knit to last 2 sts, k2tog—4 sts dec'd.

Work 1 WS row even.

Rep the last 2 rows 3 (4) more times, ending with a WS row—18 (20) sts rem.

Next row: (RS) *K2tog; rep from *—9 (10) sts rem.

Work 1 WS row even.

Cut yarn, leaving a 10" (25.5 cm) tail. Thread tail on a tapestry needle, draw through rem sts 2 times, pull tight to close hole, and secure on WS.

THUMB

With RS facing, return 13 (15) held gusset sts onto larger needle, join B, knit to end.

Next row: P5 (6), p2tog, p6 (7)—12 (14) sts rem.

Work 4 (6) rows even in St st.

Dec row: *K2tog; rep from *—6 (7) sts rem.

Cut yarn, leaving a 10" (25.5 cm) tail. Thread tail on a tapestry needle, draw through rem sts 2 times, pull tight to close hole, and secure on WS.

finishing

Weave in loose ends along matching colors.

With yarn threaded on a tapestry needle, sew side seam on mittens and close gap between thumb and upper hand.

Block lightly.

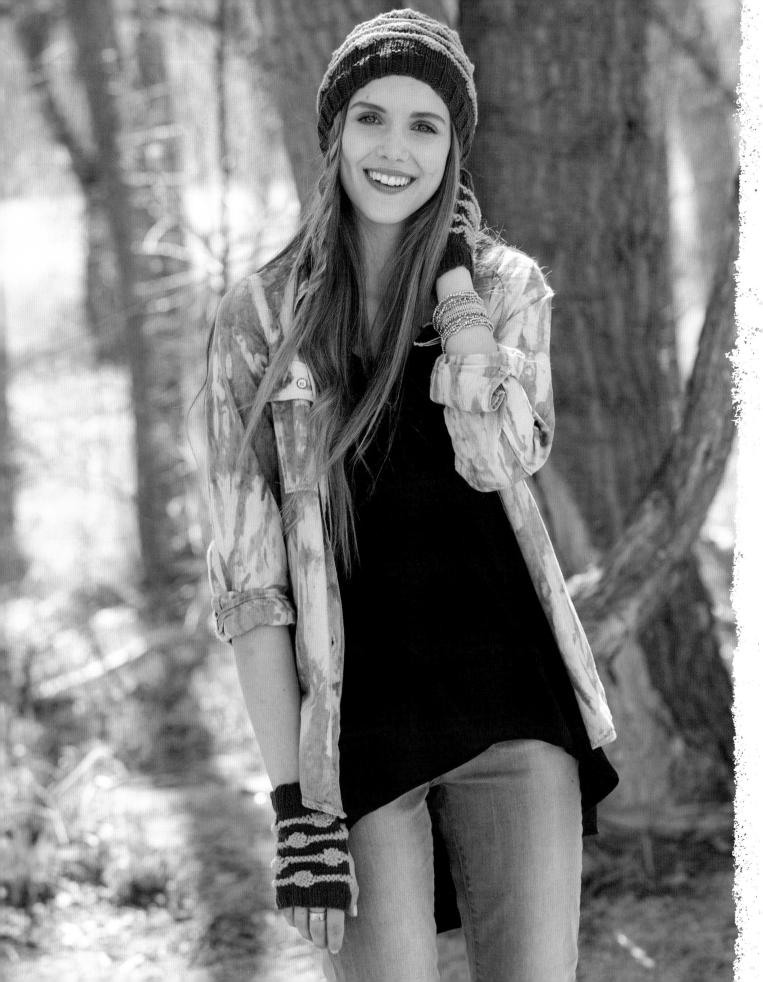

stripes + dots
HAT AND MITTS

designed by TERRI KRUSE

Textured gold stripes and dots liven up the purple background of these coordinating hat and fingerless mitts. The top of the hat is shaped with spiral decreases. The simple mitts can be worn on either hand.

FINISHED SIZE

Hat: About 19¼" (49 cm) in circumference and 8" (20.5 cm) tall.

Mitts: About 7¼" (18.5 cm) in circumference and 6" (15 cm) long.

YARN

Worsted weight (#4 Medium).

Shown here: Cascade Yarns Longwood (100% superwash extrafine merino wool; 191 yd [175 m]/100 g): #28 Plum (MC) and #08 Artisan Gold (CC), 1 ball each.

NEEDLES

Hat and mitts ribbing: size U.S. 6 (4 mm): set of 4 or 5 double-pointed (dpn).

Hat and mitts body: size U.S. 7 (4.5 mm): set of 4 or 5 dpn.

Adjust needle size if necessary to obtain the correct gauge.

NOTIONS

Marker (m), tapestry needle.

GAUGE

20 sts and 26 rnds = 4" (10 cm) worked in St st worked in rnds on larger needles.

STITCH GUIDE

STRIPES + DOTS PATTERN
(mult of 12 sts)

Rnds 1, 2, and 3: With MC, knit.

Rnd 4: With CC, k11, [turn work, sl 1 purlwise with yarn in front (pwise wyf), k3, turn work, p4, k12] 7 times for hat (2 times for mitts), turn work sl 1 pwise wyf, k3, turn work, p4, k1.

Rnd 5: With CC, p7, [p4, turn work, k3, sl 1 pwise wyf, turn work, p12] 7 times for hat (2 times for mitts), p4, turn work, k3, sl 1 pwise wyf, p5.

Rnd 6: With MC, k8, [sl 2 sts pwise with yarn in back (wyb), k10] 7 times for hat (2 times for mitts), sl 2 sts pwise wyb, k2.

Rnds 7, 8, and 9: Rep Rnds 1, 2, and 3.

Rnd 10: With CC, k5, [turn work, sl 1 pwise wyf, k3, turn work, p4, k12] 7 times for hat (2 times for mitts), turn work, sl 1 pwise wyf, k3, turn work, p4, k7.

Rnd 11: With CC, p1, [p4, turn work, k3, sl 1 pwise wyf, turn work, p12] 7 times for hat (2 times for mitts), p4, turn work, k3, sl 1 pwise wyf, turn work, p11.

Rnd 12: With MC, k2, [sl 2 sts pwise wyb, k10] 7 times for hat (2 times for mitts), sl 2 sts pwise wyb, k8.

Rep Rnds 1–12 for patt.

hat

With smaller cir needle and MC, CO 96 sts. Place marker (pm) and join for working in rnds, being careful not to twist sts.

Work k2, p2 ribbing for 8 rnds.

Change to larger cir needle.

Knit 3 rnds.

Work Rnds 1–12 of Stripes + Dots patt (see Stitch Guide) 2 times—piece measures about 5½", (14 cm) from CO.

Cut CC. With MC, knit 3 rnds.

SHAPE CROWN

Rnd 1: *K10, k2tog; rep from *—88 sts rem.

Rnds 2, 4, 6, 8, and 10: Knit.

Rnd 3: *K9, k2tog; rep from *—80 sts rem.

Rnd 5: *K8, k2tog; rep from *—72 sts rem.

Rnd 7: *K7, k2tog; rep from *—64 sts rem.

Rnd 9: *K6, k2tog; rep from *—56 sts rem.

Rnd 11: *K5, k2tog; rep from *—48 sts rem.

Rnd 12: *K4, k2tog; rep from *—40 sts rem.

Rnd 13: *K3, k2tog; rep from *—32 sts rem.

Rnd 14: *K2, k2tog; rep from *—24 sts rem.

Rnd 15: *K1, k2tog; rep from *—16 sts rem.

Rnd 16: *K2tog; rep from *—8 sts rem.

Cut yarn leaving an 8" (20.5 cm) tail. Thread tail on a tapestry needle, draw through rem sts, pull tight to close hole, and secure on WS.

finishing

Weave in loose ends.

Block lightly.

mitts

With smaller dpn, CO 32 sts. Place marker (pm) and join for working in rnds, being careful not to twist sts.

Work k2, p2 ribbing for 6 rnds.

Change to larger dpn.

Inc rnd: *K8, M1 (see Glossary); rep from *—36 sts.

Work Rnds 1–12 of Stripes + Dots patt (see Stitch Guide) once, then work Rnd 1 once more—piece measures 3" (7.5 cm) from CO.

THUMB OPENING

Next rnd: With MC, k14, BO 8 sts, knit to end—28 sts rem.

Next rnd: With MC, k14, use the knitted method (see Glossary) to CO 8 sts over gap, knit to end—36 sts.

UPPER HAND

Work Rnds 4–12 of Stripes + Dots patt.

Cut CC. With MC, knit 3 rnds.

Change to smaller dpn.

Work k2, p2 rib for 4 rnds.

Loosely BO all sts in patt.

finishing

Weave in loose ends.

Block lightly.

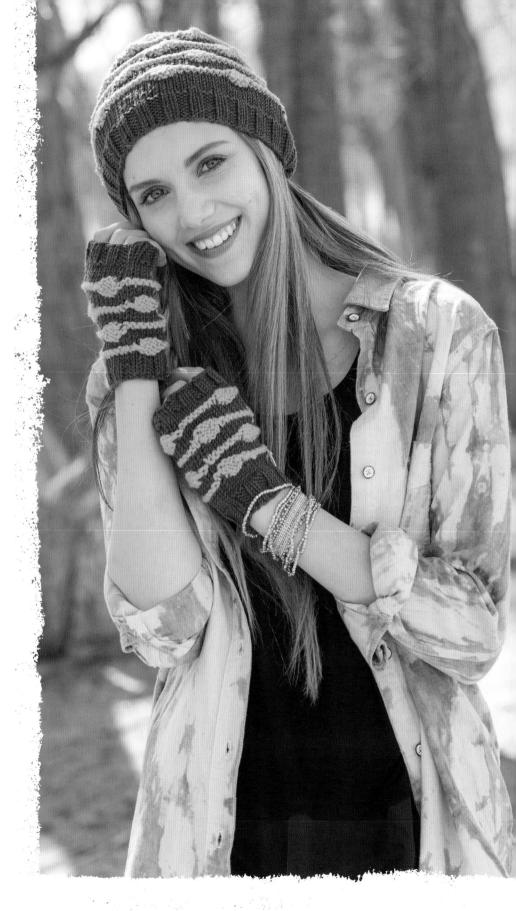

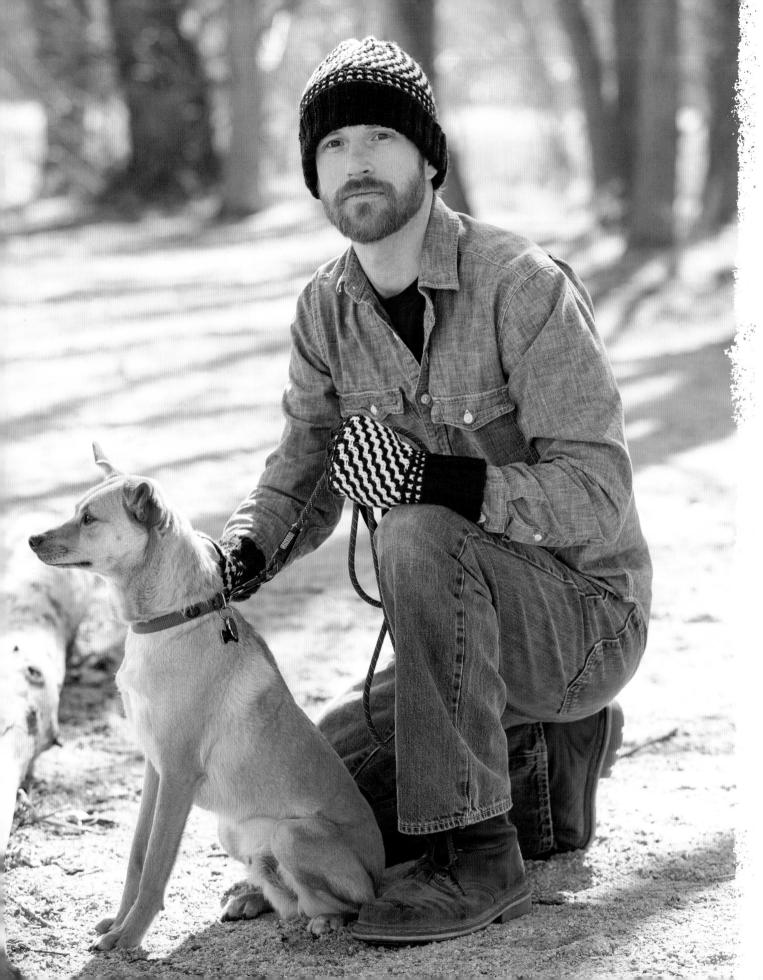

tweed
HAT + MITTS

designed by LYNN M. WILSON

Slip-stitch patterns are an easy way to create interesting colorwork and texture in knitting. They use only one color per row while the color from the previous row is "slipped" to create the design. This set was knitted with bold, highly contrasting colors. Use less contrasting colors for a totally different look.

FINISHED SIZE
Hat: About 17½ (19)" (44.5 [48.5] cm) in circumference; will stretch to 20 (22)" (51 [56] cm).

Mitts: About 7¼" (18.5 cm) in circumference and 9½" (24 cm) long.

YARN
Worsted weight (#4 Medium).

Shown here: Cascade Yarns Longwood (100% superwash extrafine merino wool; 191 yd [175 m]/100 g): #03 Ebony (A), 1 ball each for hat and mitts; #01 White (B) 1 ball for both hat and mitts.

NEEDLES
Hat ribbing: size U.S. 7 (4.5 mm): 16" (40 cm) circular (cir).

Hat body: size U.S. 8 (5 mm): 16" (40 cm) cir and set of 4 double-pointed (dpn).

Mitts ribbing: size U.S. 7 (4.5 mm): set of 4 dpn.

Mitts body: size U.S. 8 (5 mm): set of 4 dpn.

Adjust needle size if necessary to obtain the correct gauge.

NOTIONS
Markers (m); tapestry needle; size H/8 (5 mm) crochet hook for mitts.

GAUGE
22 sts and 40 rnds = 4" (10 cm) in diagonal tweed patt, worked in rnds.

STITCH GUIDE

K2, P2 RIB
(mult of 4 sts)

All rnds: *K2, p2; rep from *.

CHECK PATTERN
(even number of sts)

Rnd 1: With A, purl.

Rnd 2: With B, *k1, sl 1 (see Notes) with yarn in back (wyb); rep from *.

Rnd 3: With B, *p1, sl 1 wyb; rep from *.

Rnd 4: With A, knit.

Rep Rnds 1–4 for patt.

DIAGONAL TWEED PATTERN
(mult of 4 sts)

Rnds 1 and 2: With B, *sl 1 (see Notes) with yarn in back (wyb), k1, sl 1 with yarn in front (wyf), k1; rep from *.

Rnds 3 and 4: With A, *k1, sl 1 wyb, k1, sl 1 wyf; rep from *.

Rnds 5 and 6: With B, sl 1 wyf, k1, sl 1 wyb, k1; rep from *.

Rnds 7 and 8: With A, k1, sl 1 wyf, k1, sl 1 wyb; rep from *.

Rep Rnds 1–8 for patt.

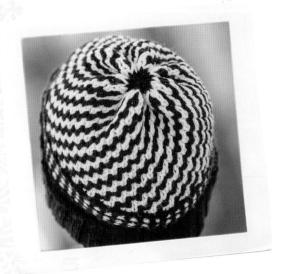

NOTES:
Slip all slipped stitches purlwise.

To prevent puckers, be careful not to pull the yarn too tightly across the slipped stitches in the slip-stitch pattern.

Carry the color not being used loosely up the wrong side of the work.

hat

With A and smaller cir needle, CO 96 (104) sts. Place marker (pm) and join for working in rnds, being careful not to twist sts.

Work in k2, p2 rib until piece measures 4½ (5)" (11.5 [12.5] cm) from CO.

Dec rnd: With A, knit and *at the same time* dec 6 (8) sts evenly spaced—90 (96) sts rem.

Joining B when needed, work Rnds 1–4 of check patt (see Stitch Guide) 3 times.

Purl 1 rnd with A.

Inc rnd: With A, knit and *at the same time* inc 6 (8) sts evenly spaced—96 (104) sts.

Change to larger cir needle.

Rep Rnds 1–8 of diagonal tweed patt (see Stitch Guide) until piece measures about 10 (11)" (25.5 [28] cm) from CO, ending with Rnd 2 or 6 of patt.

Cut B; cont with A only.

SHAPE TOP

Note: Change to dpn when there are too few sts to fit comfortably on cir needle.

Dec Rnd 1: *K2tog; rep from *—48 (52) sts rem.

Dec Rnd 2: *K2tog; rep from *—24 (26) sts rem.

Cut yarn, leaving a 12" (30.5 cm) tail.

Thread tail on a tapestry needle, draw through rem sts, pull tight to close hole, and secure on WS.

mitts

With A and smaller dpn, CO 40 sts. Place marker (pm) and join for working in rnds, being careful not to twist sts.

Work in k2, p2 ribbing until piece measures 3" (7.5 cm) from CO.

Dec rnd: Knit and *at the same time* dec 4 sts evenly spaced—36 sts rem.

Joining B when needed, work Rnds 1–4 of check patt (see Stitch Guide) 2 times.

With A, purl 1 rnd.

Inc rnd: With A, knit and *at the same time* inc 4 sts evenly spaced—40 sts.

Change to larger dpn.

Work Rnds 1–8 of diagonal tweed patt (see Stitch Guide), then work Rnds 1–5 once more.

Next rnd: Using the horizontal strand of B, M1 (see Glossary), work Rnd 6 of patt to end of rnd, M1—42 sts.

THUMB OPENING

Note: The thumb opening is worked back and forth in rows.

Turn work to beg with a WS row.

Row 1: (WS) With A, k1, *sl 1 (see Notes) with yarn in front (wyf), p1, sl 1 with yarn in back (wyb), p1; rep from * to last st, k1.

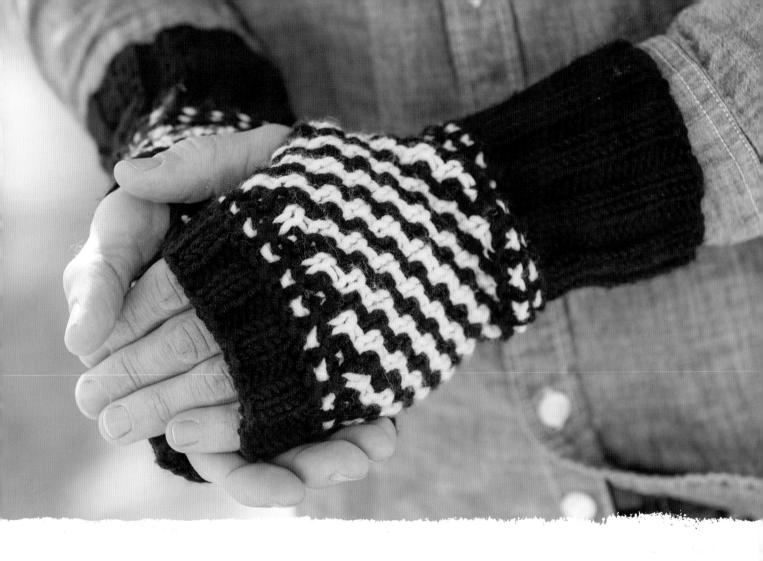

Row 2: (RS) With A, k1, *k1, sl 1 wyf, k1, sl 1 wyb; rep from * to last st, k1.

Row 3: With B, k1, *p1, sl 1 wyb, p1, sl 1 wyf; rep from * to last st, k1.

Row 4: With B, k1, *sl 1 wyb, k1, sl 1 wyf, k1; rep from * to last st, k1.

Row 5: With A, k1, *sl 1 wyb, p1, sl 1 wyf, p1; rep from * to last st, k1.

Row 6: With A, k1, *k1, sl 1 wyb, k1, sl 1 wyf; rep from * to last st, k1.

Row 7: With B, k1, *p1, sl 1 wyf, p1, sl 1 wyb; rep from * to last st, k1.

Row 8: With B, k1, *sl 1 wyf, k1, sl 1 wyb, k1; rep from * to last st, k1.

Rep Rows 1–7 once more, then work Row 8 and *at the same time* dec 1 st at the end of the row—41 sts rem.

Next row: With RS facing, rejoin for working in rnds, k2tog, *sl 1 wyf, k1, sl 1 wyb, k1; rep from * to last 3 sts, sl 1 wyf, k1, sl 1 wyb—40 sts rem.

Cont in patt from Rnd 1 as established until piece measures 8" (20.5 cm) from CO or 1½" (3.8 cm) less than desired finished length, ending with an even-numbered rnd.

Cut B; cont with A only.

Change to smaller needles.

Knit 1 rnd and *at the same time* dec 4 sts evenly spaced—36 sts rem.

Work Rnds 1–4 of check patt.

Purl 1 rnd, then knit 1 rnd.

Work in k2, p2 rib for 5 rnds.

Loosely BO all sts in patt.

finishing

Weave in loose ends.

Block as desired.

THUMB EDGING

With A and crochet hook, work 1 rnd of single crochet (see Glossary) around thumb openings of mitts.

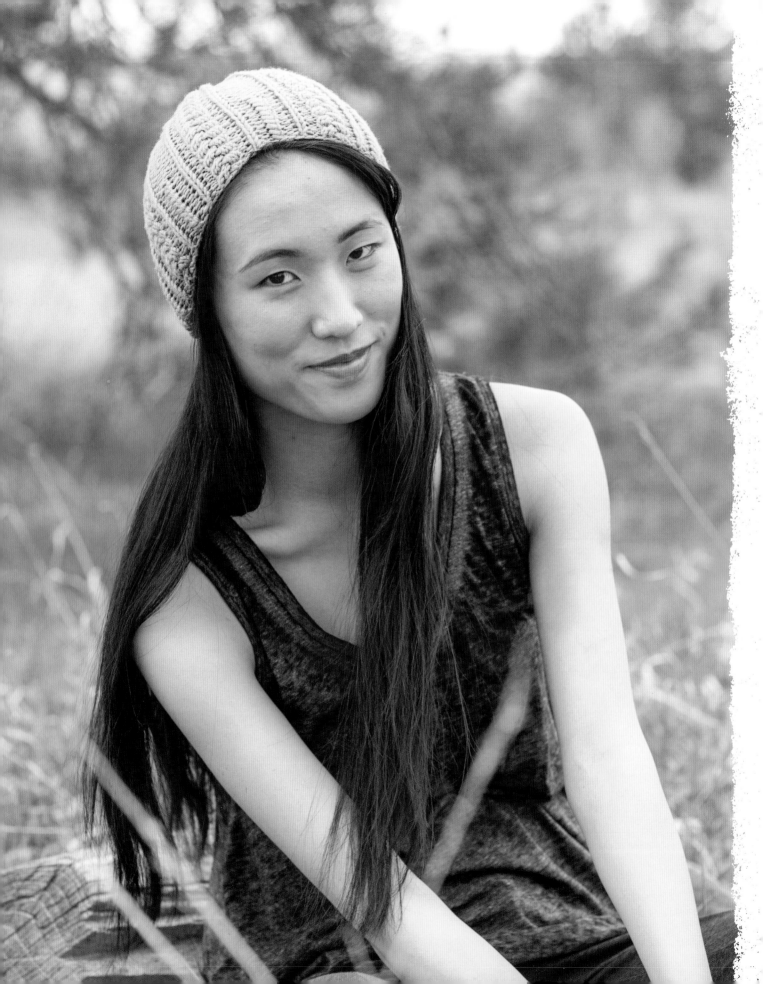

blizzard
HAT + SCARF

designed by PAULINA POPIOLEK

Dense cables add insulating texture to this hat and scarf set. Panels of braided cables interspaced with two-stitch twists give both pieces a classic look that is both warm and stylish. Not only is this set lovely to look at, but it's also interesting and fun to knit. The soft merino is sure to make you cozy and keep you warm, no matter how low the temperature drops.

FINISHED SIZE

Hat: About 17" (43 cm) in circumference and 8½" (21.5 cm) tall.

Hat will stretch to fit 23" (58.5 cm) circumference.

Scarf: About 7¼" (18.5 cm) wide and 74" (188 cm) long.

YARN

Worsted weight (#4 Medium).

Shown here: Cascade Yarns Longwood (100% superwash extrafine merino wool; 191 yd [175 m]/100 g): #22 Sky Blue, 4 balls for both hat and scarf.

NEEDLES

Hat edging: size U.S. 7 (4.5 mm): 16" (40 cm) circular (cir).

Hat body: size U.S. 8 (5 mm): 16" (40 cm) cir and set of 5 double-pointed (dpn).

Scarf: size U.S. 8 (5 mm): straight or cir.

Adjust needle size if necessary to obtain the correct gauge.

NOTIONS

Marker (m); cable needle (cn); tapestry needle; size E/4 (3.5 mm) crochet hook for scarf.

GAUGE

Hat: 23 sts and 30 rnds = 4" (10 cm) in cable patt worked in rnds on larger needles, after blocking.

Scarf: 24 sts and 28 rows = 4" (10 cm) in cable patt, after blocking.

STITCH GUIDE

k1b: Insert right needle tip from front to back into the st below the next st on left needle tip, wrap the yarn and knit this loop, then slip the st above off the left needle.

1/1LC: Slip 1 st onto cn and hold in front of work, k1, then k1 from cn.

2/2LC: Slip 2 sts onto cn and hold in front of work, k2, then k2 from cn.

2/2RC: Slip 2 sts onto cn and hold in back of work, k2, then k2 from cn.

2/2RCdec: Slip 2 sts onto cn and hold in back of work, k2, then k2tog from cn—1 st dec'd.

2/2LCdec: Slip 2 sts onto cn and hold in front of work, k2tog, then k2 from cn—1 st dec'd.

NOTES:
The hat is worked in rounds; the scarf is worked in rows.

A chain cast-on is used for the scarf so that both tails look the same.

hat

With larger cir needle, CO 84 sts. Place marker (pm) and join for working in rnds, being careful not to twist sts.

BRIM

Change to smaller cir needle.

Set-up rnd: *P1, k2, p1, k1, p1, [k1, k1f&b (see Glossary)] 2 times, p1, k1; rep from *—98 sts.

Work Rnds 1–4 of Chart A 4 times, then work Rnds 1–3 once more—piece measures 2¼" (5.5 cm) from CO.

CROWN

Change to the larger needle.

Work Rnd 1 of Chart B once, then work Rnds 2–5 eight times—piece measures 6¾" (17 cm) from CO.

TOP

Work Rnds 1–15 of Chart C—7 sts rem.

finishing

Cut yarn, leaving a 10" (25.5 cm) tail. Thread tail on tapestry needle, draw through rem sts, pull tight to close hole, and secure on WS.

Weave in loose ends.

Wet-block lightly.

scarf

With crochet hook, use the chain method (see Glossary) to CO 38 sts.

Set-up row: (WS) K3, p1, k1, *p1, M1 (see Glossary), p2, M1, [p1, k1] 2 times, p2, k1, p1, k1; rep from * once, p1, M1, p2, M1, p1, k1, p1, k3—44 sts.

Work Rows 1–4 of Chart D a total of 128 times, rep the 14-st patt twice on each row. Work Rows 1 and 2 once more—piece measures about 73½" (186.5 cm) from CO.

Dec row: (RS) K3, k1b (see Stitch Guide), p1, [sl 1, k1, psso, 2/2 RCdec (see Stitch Guide), p1, k1b, p1, 1/1LC (see Stitch Guide), p1, k1b, p1] 2 times, 2/2 RCdec, k2tog, p1, k1b, k3—38 sts rem.

With WS facing, BO all sts in patt.

finishing

Weave in loose ends.

Block to measurements.

	k on RS, p on WS
•	p on RS, k on WS
∩	k1b (see Stitch Guide)
/	k2tog
\	ssk
⅀	p2tog
⅄	p2tog tbl
ʌ	s2kp
⋈	1/1LC (see Stitch Guide)
⋈	2/2RC (see Stitch Guide)
⋈	2/2LC (see Stitch Guide)
▨	no stitch
☐	pattern repeat

CHART A

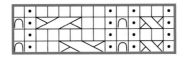

14-st repeat

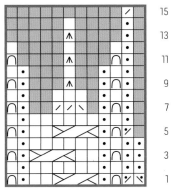

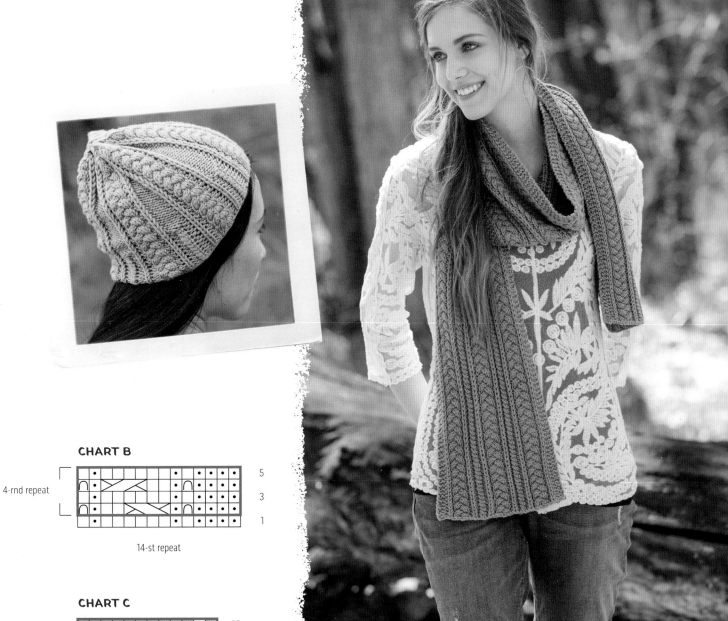

CHART B

4-rnd repeat

5

3

1

14-st repeat

CHART C

15

13

11

9

7

5

3

1

12-st repeat

CHART D

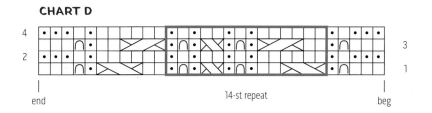

4

2

3

1

end

14-st repeat

beg

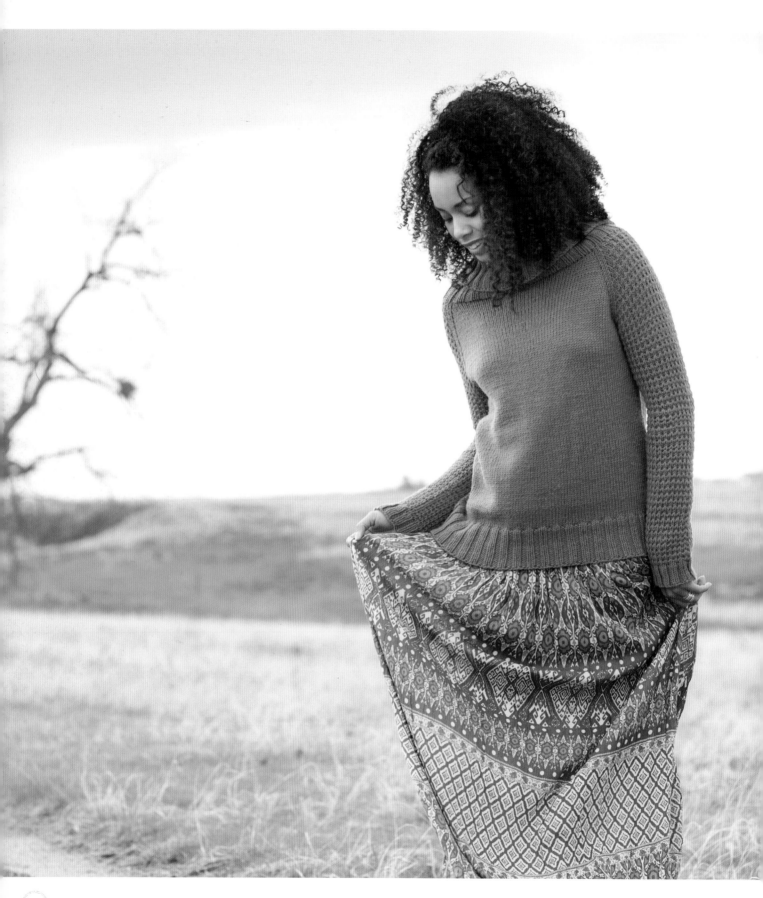

sweaters

[FOR THE BODY]

Find delight in the details with a new sweater, knitted just for you. Interesting necklines, both long- and short-sleeved options, classic cardigans, zippered jackets, and feminine lace will allow you to wrap yourself in warmth all year round.

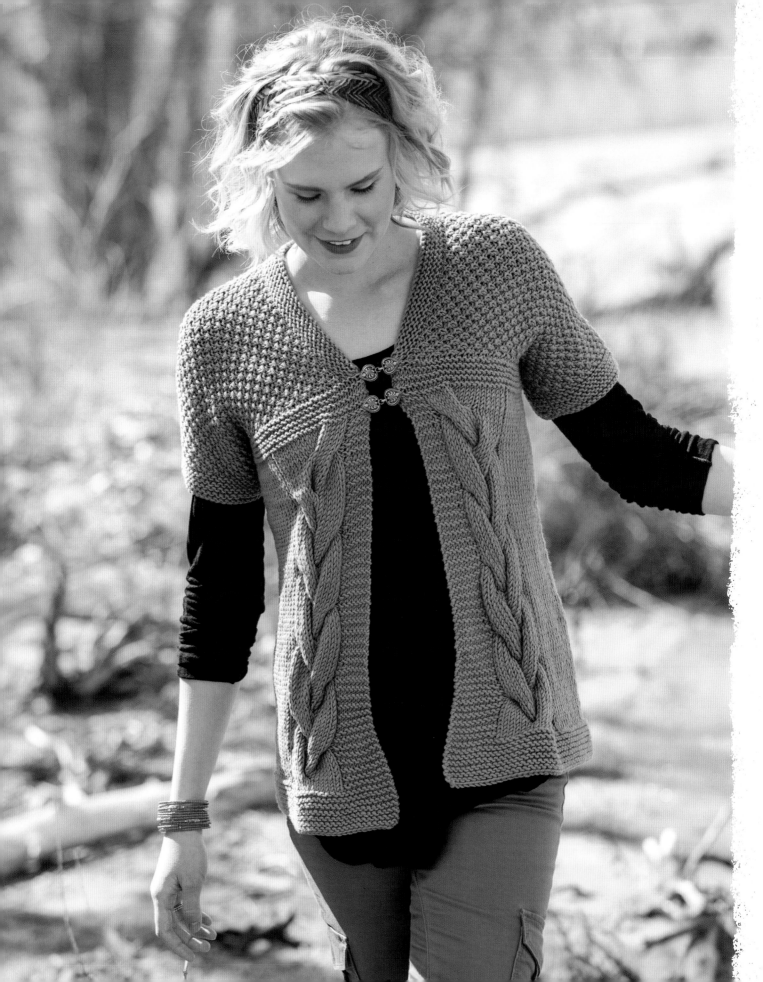

penelope
CARDIGAN

designed by ELENA NODEL

This top-down cardigan has unusual construction. The seed-stitch bodice has raglan shaping on the back but not on the front. The lower body is worked in stockinette with striking cable panels that provide interest for knitters of all levels. Stitches for the sleeves are picked up and worked in rounds to the garter cuffs. Two pewter clasps substitute for buttons and buttonholes.

FINISHED SIZE
About 32¾ (34¾, 37¼, 39¼, 41¼, 43¼, 45¾, 47¾)" (83 [88.5, 94.5, 99.5, 105, 110, 116, 121.5] cm) bust circumference.

Cardigan shown measures 34¾" (88.5 cm).

YARN
Worsted weight (#4 Medium).

Shown here: Cascade Yarns Longwood (100% superwash extrafine merino wool; 191 yd [175 m]/100 g): #02 Gray Forest, 5 (5, 5, 6, 6, 6, 6, 7) balls.

NEEDLES
Main body and upper sleeves: size U.S. 8 (5 mm): 16" and 32" (40 and 80 cm) circular (cir).

Neckline, hemline, and sleeve cuffs: size U.S. 7 (4.5 mm): 24" or 32" (60 or 80 cm) cir.

Adjust needle size if necessary to obtain the correct gauge.

NOTIONS
Markers (m); cable needle (cn); stitch holders or waste yarn; two 2" (5 cm) metal clasps; tapestry needle.

GAUGE
16 sts and 23 rows/rnds = 4" (10 cm) in double seed st worked on larger needles.

16 sts and 20 rows = 4" (10 cm) in St st worked on larger needles.

DOUBLE SEED STITCH WORKED IN ROUNDS
(mult of 2 sts)

Rnd 1: *K1, p1; rep from *.

Rnd 2: Knit the knits and purl the purls.

Rnd 3: *P1, k1; rep from *.

Rnd 4: Rep Rnd 2.

Rep Rnds 1–4 for patt.

DOUBLE SEED STITCH WORKED IN ROWS
(mult of 2 sts + 1)

Row 1: (RS) *K1, p1; rep from * to last st, k1.

Row 2: (WS) Knit the knits and purl the purls.

Row 3: (RS) *P1, k1; rep from * to last st, p1.

Row 4: Rep Row 2.

Rep Rows 1–4 for patt.

6/6LC: Sl 6 sts onto cable needle (cn) and hold in front of work, k6, then k6 from cn.

6/6RC: Sl 6 sts onto cable needle (cn) and hold in back of work, k6, then k6 from cn.

NOTES:
The back of the bodice and part of the sleeves have raglan shaping. While working raglan increases, there will always be a "seam" stitch on each side of the raglan marker; knit the seam stitches on right-side (RS) rows and purl them on wrong-side (WS) rows.

Once the armhole reaches sufficient depth, sleeve stitches will be placed on a holder to be worked later. The front bodice stitches will be picked up and the lower body will be worked next.

The bodice and lower body are worked back and forth in rows; the sleeves are worked in rounds.

bodice

With smaller cir needle and using the long-tail method (see Glossary), CO 75 (81, 87, 89, 93, 99, 101, 107) sts. Do not join.

[Knit 1 row, purl 1 row] 3 times, then knit 1 row.

Change to larger cir needle.

Set-up Row 1: (RS) [K1, p1] 12 (13, 14, 14, 15, 16, 16, 17) times, k1, place marker (pm), [k1, p1] 12 (13, 14, 15, 15, 16, 17, 18) times, k1, pm, [k1, p1] 12 (13, 14, 14, 15, 16, 16, 17) times, k1.

Set-up Row 2: (WS) Knit the knits and purl the purls, slipping markers (sl m) when you come to them.

Shape bodice as foll.

Row 1: (RS) [Work (p1, k1) to 3 sts before m, p1, k1f&b (see Glossary), k1, sl m, k1, M1P (see Glossary), k1] 2 times, work (p1, k1) to last st, p1—4 sts inc'd.

Row 2: (WS) [Knit the knits and purl the purls to 2 sts before m, k1, p1, sl m, p1, k1] 2 times, knit the knits and purl the purls to the end.

Row 3: (RS) [Work (k1, p1) to 2 sts before m, k1f&b, k1, sl m, k1, M1P] 2 times, work (k1, p1) to last st, k1—4 sts inc'd.

Row 4: Rep Row 2.

Rep these 4 rows 8 (9, 9, 10, 10, 10, 11, 11) more times, then rep Rows 1 and 2 again 1 (0, 1, 0, 1, 1, 0, 1) time, ending with a WS row—151 (161, 171, 177, 185, 191, 197, 207) sts; 44 (47, 50, 51, 54, 56, 57, 60) sts for each sleeve, 63 (67, 71, 75, 77, 79, 83, 87) sts for back.

DIVIDE FOR BODY AND SLEEVES

With RS facing, k1, sl next 43 (46, 49, 50, 53, 55, 56, 59) sts onto waste yarn or holder for sleeve, use the backward-loop method (see Glossary) to CO 2 (3, 5, 5, 7, 8, 9, 10) sts over gap, remove m, k1f&b (first st of back), work in patt to 1 st

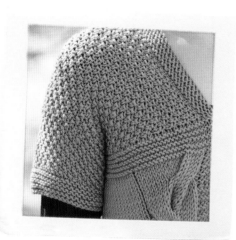

before next m, k1f&b, remove m, sl next 43 (46, 49, 50, 53, 55, 56, 59) sts onto waste yarn or holder for other sleeve, use the backward-loop method to CO 2 (3, 5, 5, 7, 8, 9, 10) sts, k1—71 (77, 85, 89, 95, 99, 105, 111) sts rem.

Cut yarn.

lower body

Holding the bodice upside down with RS facing, join yarn to left bodice edge.

With larger cir needle, pick up and knit 5 sts along garter-st band and 31 (32, 33, 35, 36, 38, 40, 41) sts evenly spaced along left bodice edge, k71 (77, 85, 89, 95, 99, 105, 111) live sts, then pick up and knit 31 (32, 33, 35, 36, 38, 40, 41) sts evenly spaced along right bodice edge and 5 sts along garter-st band—143 (151, 161, 169, 177, 185, 195, 203) sts total.

Knit 9 rows—4 garter ridges on RS.

Set up for cable panels as foll.

Set-up Row 1: (RS) K5, p1, k18, p1, knit to last 25 sts, p1, k18, p1, k5.

Set-up Row 2: (WS) K6, p18, k1, purl to last 25 sts, k1, p18, k6.

Rep these 2 set-up rows 2 more times.

Work cable charts (see pages 136 and 137) as foll.

Row 1: (RS) K5, p1, work Row 1 of Left Cable chart, p1, knit to last 25 sts, p1, work Row 1 of Right Cable chart, p1, k5.

Row 2: (WS) K6, work Row 2 of Right Cable chart, k1, purl to last 25 sts, k1, work Row 2 of Left Cable chart, k6.

Cont in this manner, working through Row 16 of charts, then rep Rows 1–16 and *at the same time* when piece measures about 3" (7.5 cm) from dividing row, ending with a WS row, inc 1 st in each garter band as foll.

Inc Row 1: (RS) K4, k1f&b, p1, work chart as established, p1, knit to last 25 sts, p1, work chart as established, p1, k1f&b, k4—145 (153, 163, 171, 179, 187, 197, 205) sts.

Working inc'd sts in garter st, cont even in patt until piece measures about 6"

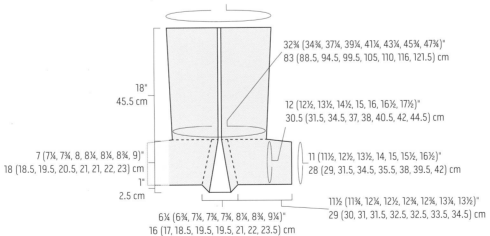

34¾ (36¾, 39¼, 41¼, 43¼, 45¼, 47¾, 49¾)"
88.5 (93.5, 99.5, 105, 110, 115, 121.5, 126.5) cm

32¾ (34¾, 37¼, 39¼, 41¼, 43¼, 45¾, 47¾)"
83 (88.5, 94.5, 99.5, 105, 110, 116, 121.5) cm

18"
45.5 cm

12 (12½, 13½, 14½, 15, 16, 16½, 17½)"
30.5 (31.5, 34.5, 37, 38, 40.5, 42, 44.5) cm

7 (7¼, 7¾, 8, 8¼, 8¼, 8¾, 9)"
18 (18.5, 19.5, 20.5, 21, 21, 22, 23) cm

1"
2.5 cm

11 (11½, 12½, 13½, 14, 15, 15½, 16½)"
28 (29, 31.5, 34.5, 35.5, 38, 39.5, 42) cm

11½ (11¾, 12¼, 12½, 12¾, 12¾, 13¼, 13½)"
29 (30, 31, 31.5, 32.5, 32.5, 33.5, 34.5) cm

6¼ (6¾, 7¼, 7¾, 7¾, 8¼, 8¾, 9¼)"
16 (17, 18.5, 19.5, 19.5, 21, 22, 23.5) cm

(15 cm) from dividing row, ending with a WS row.

Inc Row 2: (RS) K5, k1f&b, p1, work chart as established, p1, knit to last 26 sts, p1, work chart as established, p1, k1f&b, k5—147 (155, 165, 173, 181, 189, 199, 207) sts.

Working inc'd sts in garter st, cont even until piece measures about 9" (23 cm) from dividing row, ending with a WS row.

Inc Row 3: (RS) K6, k1f&b, p1, work chart as established, p1, knit to last 27 sts, p1, work chart as established, p1, k1f&b, k6—149 (157, 167, 175, 183, 191, 201, 209) sts.

Working inc'd sts in garter st, cont even until piece measures about 12" (30.5 cm) from dividing row, ending with a WS row.

Inc Row 4: (RS) K7, k1f&b, p1, work chart as established, p1, knit to last 28 sts, p1, work chart as established, p1, k1f&b, k7—151 (159, 169, 177, 185, 193, 203, 211) sts.

Working inc'd sts in garter st, cont even until piece measures about 16" (40.5 cm) from dividing row, or about 2" (5 cm) less than desired total length, ending with a RS row.

LOWER EDGING

Change to smaller needles and knit 12 rows—6 garter ridges on RS.

BO all sts knitwise.

sleeves

Return 43 (46, 49, 50, 53, 55, 56, 59) held sleeve sts onto shorter, larger cir needle.

With RS facing and beg at base of underarm, join yarn and pick up and knit 3 (2, 2, 4, 3, 5, 5, 6) sts, pm, then pick up and knit 2 (2, 3, 4, 4, 4, 5, 5) more sts—48 (50, 54, 58, 60, 64, 66, 70) sts total.

Cont in patt as established for 6 rnds.

Dec Rnd 1: Work in patt to 3 sts before m, k3tog or p3tog as necessary to maintain patt—2 sts dec'd.

Work 6 rnds even in patt.

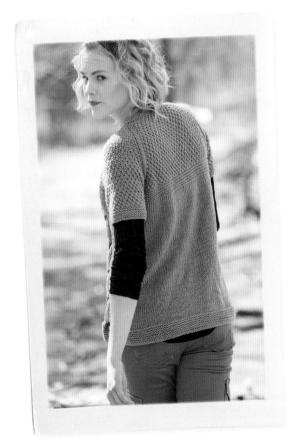

LEFT CABLE

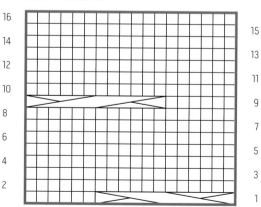

Dec Rnd 2: K3tog or p3tog as necessary to maintain patt, work in patt to end of rnd—2 sts dec'd; 44 (46, 50, 54, 56, 60, 62, 66) sts rem.

Work even in patt for 1 to 3 rnds as necessary to end with Rnd 1 or 3 of patt.

CUFFS

Change to shorter, smaller cir needle.

[Knit 1 rnd, purl 1 rnd] 4 times, then knit 1 rnd.

BO all sts purlwise.

finishing

Weave in loose ends.

Block to measurements.

With sewing needle and matching thread, sew metal clasps to correspond to top and bottom of garter-stitch band.

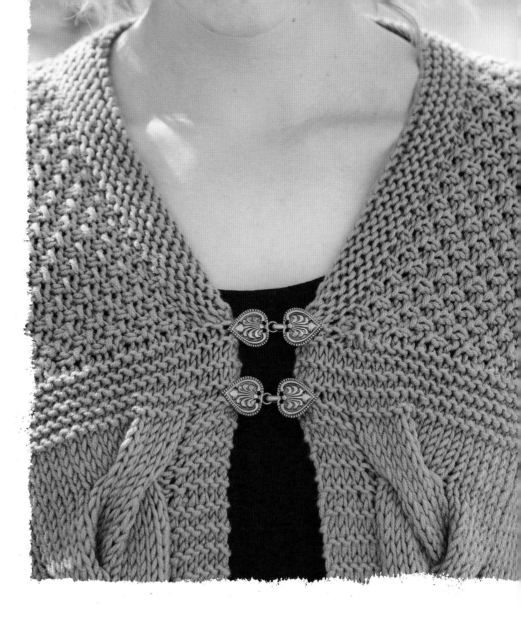

RIGHT CABLE

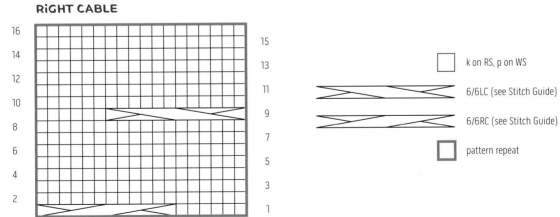

☐	k on RS, p on WS
⤬	6/6LC (see Stitch Guide)
⤬	6/6RC (see Stitch Guide)
☐	pattern repeat

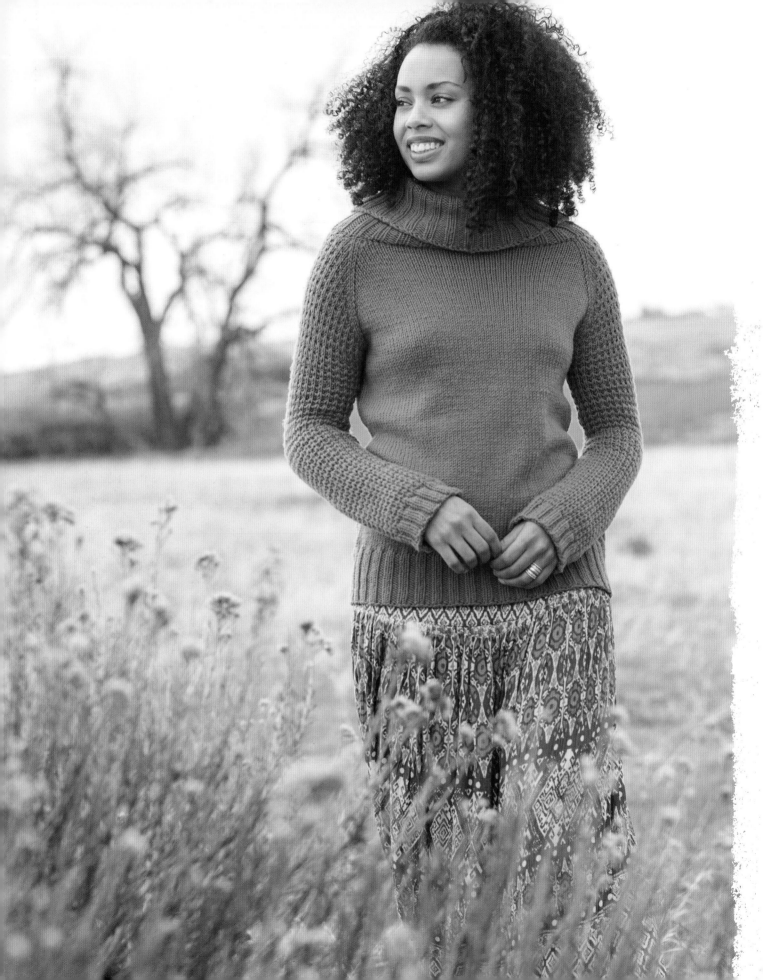

cowl-neck
RAGLAN

designed by ISABELL KRAEMER

Inspired by the colors and texture of autumn fields, this oversized sweater is all about fast and easy knitting. Knitted from the top down, there are no seams, and the length can be customized for a perfect fit. The slip-stitch pattern adds interest and cozy texture to the sleeves; the generous cowl will keep you covered when the temperatures plunge.

FINISHED SIZE

About 33¾ (36½, 41, 45¼, 49¾)" (85.5 [92.5, 104, 115, 126.5] cm) bust circumference.

Sweater shown measures 36½" (92.5 cm).

YARN

Worsted weight (#4 Medium).

Shown here: Cascade Yarns Longwood (100% superwash extrafine merino wool; 191 yd [175 m]/100 g): #09 Mustard, 7 (7, 8, 9, 9) balls.

NEEDLES

Size U.S. 8 (5 mm): 24" (60 cm) circular (cir) and set of 4 or 5 double-pointed (dpn).

Adjust needle size if necessary to obtain the correct gauge.

NOTIONS

5 markers (m); stitch holders or waste yarn; tapestry needle.

GAUGE

18 sts and 24 rnds = 4" (10 cm) in St st worked in rnds.

22 sts and 36 rnds = 4" (10 cm) in slip-stitch patt worked in rnds.

STITCH GUIDE

SLIP-STITCH PATTERN 1
(mult of 2 sts + 1)

Row 1: (RS) *K1, sl 1 purlwise with yarn in back (pwise wyb); rep from * to last st, k1.

Row 2: (WS) *K1, sl 1 purlwise with yarn in front (pwise wyf); rep from * to last st, k1.

Row 3: (RS) Knit.

Row 4: (WS) Purl.

Rep Rows 1–4 for patt.

SLIP-STITCH PATTERN 2
(mult of 2 sts + 1)

Rnd 1: *K1, sl 1 purlwise with yarn in back (pwise wyb); rep from * to last st, k1.

Rnd 2: *P1, sl 1 pwise wyb; rep from * to last st, p1.

Rnds 3 and 4: Knit.

Rep Rnds 1–4 for patt.

SLIP-STITCH PATTERN 3
(mult of 2 sts)

Rnd 1: *K1, sl 1 purlwise with yarn in back (pwise wyb); rep from *.

Rnd 2: *P1, sl 1 pwise wyb; rep from *.

Rnds 3 and 4: Knit.

Rep Rnds 1–4 for patt.

bodice

With cir needle and using the long-tail method (see Glossary), CO 65 (67, 71, 73, 75) sts.

Row 1: (WS) P2, place marker (pm), p13 (13, 15, 15, 15), pm, p35 (37, 37, 39, 41), pm, p13 (13, 15, 15, 15), pm, p2.

Row 2: (RS) [Knit to 1 st before m, M1R (see Glossary), k1, sl m, k1, M1L (see Glossary), work Row 1 of slip-st patt 1 (see Stitch Guide) to next m, M1R, k1, sl m, k1, M1L] 2 times, knit to end—8 sts inc'd.

Row 3 and all rem WS rows: [Purl to m, sl m, p2, work Row 2 of slip-st patt 1 to 2 sts before next m, p2, sl m] 2 times, purl to end.

Row 4: [Knit to 1 st before m, M1R, k1, sl m, k1, M1L, work Row 3 of slip-st pattern 1 to 1 st before next m, M1R, k1, sl m, k1, M1L] 2 times, knit to end—8 sts inc'd.

Rows 6 and 8: Rep Row 4—97 (99, 103, 105, 107) sts.

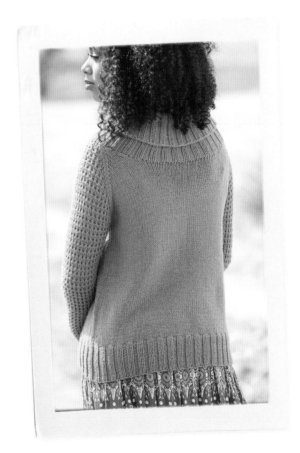

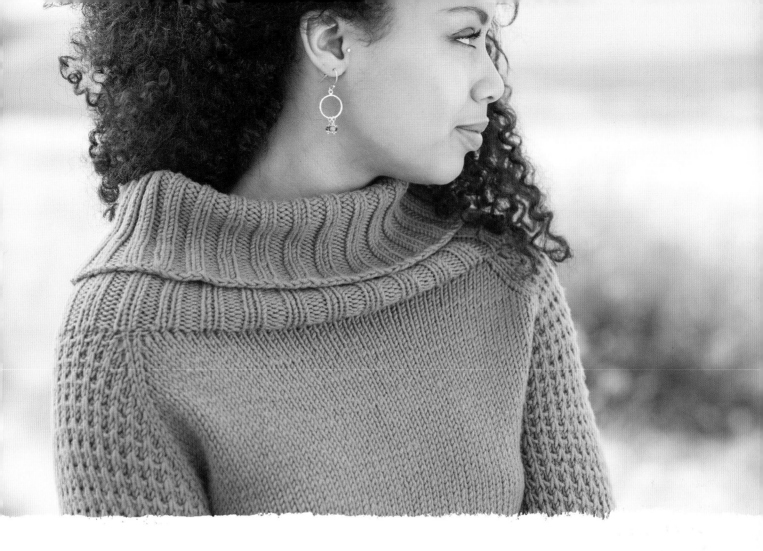

SHAPE NECK

Inc row: (RS) K2, M1L, [knit to 1 st before m, M1R, k1, sl m, k1, M1L, work slip-st patt 1 to 1 st before next m, M1R, k1, sl m, k1, M1L] 2 times, knit to 2 sts before end, M1R, k2—10 sts inc'd: 8 raglan incs and 2 neck incs.

Next row: (WS) [Purl to m, sl m, p2, work slip-st patt 1 to 2 sts before next m, p2, sl m] 2 times, purl to end.

Rep the last 2 rows once more—117 (119, 123, 125, 127) sts.

Next row: With RS facing, use the backward-loop method (see Glossary) to CO 2 (3, 3, 3, 3) sts onto left needle tip, knit these newly CO sts, then [knit to 1 st before next m, M1R, k1, sl m, k1, M1L, work slip-st patt 1 to 1 st before m, M1R, k1, sl m, k1 M1L] 2 times, knit

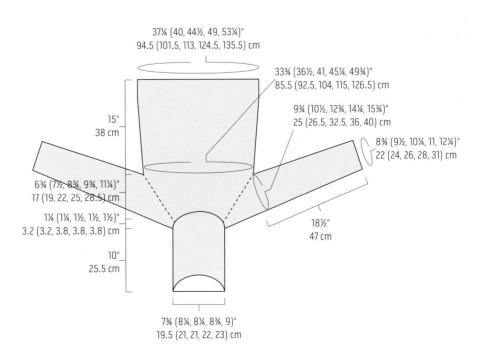

37¼ (40, 44½, 49, 53¼)"
94.5 (101.5, 113, 124.5, 135.5) cm

33¾ (36½, 41, 45¼, 49¾)"
85.5 (92.5, 104, 115, 126.5) cm

9¾ (10½, 12¾, 14¼, 15¾)"
25 (26.5, 32.5, 36, 40) cm

8¾ (9½, 10¼, 11, 12¼)"
22 (24, 26, 28, 31) cm

15"
38 cm

6¾ (7½, 8¾, 9¾, 11¼)"
17 (19, 22, 25, 28.5) cm

1¼ (1¼, 1½, 1½, 1½)"
3.2 (3.2, 3.8, 3.8, 3.8) cm

18½"
47 cm

10"
25.5 cm

7¾ (8¼, 8¼, 8¾, 9)"
19.5 (21, 21, 22, 23) cm

to end, use the backward-loop method to CO 2 (3, 3, 3, 3) sts onto right needle tip—12 (14, 14, 14, 14) sts inc'd.

Next row: (WS) [Purl to m, sl m, p2, work slip-st patt 1 to 2 sts before next m, p2, sl m] 2 times, purl to end.

Rep the last 2 rows once more—141 (147, 151, 153, 155) sts.

Joining row: With RS facing, use the backward-loop method to CO 19 (17, 17, 19, 21) sts onto left needle tip, knit these newly CO sts, [knit to 1 st before next m, M1R, k1, sl m, k1, M1L, work slip-st patt 1 to 1 st before next m, M1R, k1, sl m, k1, M1L] 2 times, knit to end, pm for beg of rnd (use a unique marker)—168 (172, 176, 180, 184) sts.

Cont working in rnds as foll.

Rnd 1: [Knit to next m, sl m, k2, work Rnd 2 of slip-st patt 2 to 2 sts before next m, k2, sl m] 2 times, knit to end.

Rnd 2: [Knit to 1 st before next m, M1R, k1, sl m, k1, M1L, work slip-st patt 2 to 1 st before next m, M1R, k1, sl m, k1, M1L] 2 times, knit to end—8 sts inc'd.

Rnd 3: [Knit to next m, sl m, k2, work slip-st patt 2 to 2 sts before next m, k2, sl m] 2 times, knit to end.

Rep the last 2 rnds 8 (10, 12, 15, 19) more times—240 (260, 280, 308, 344) sts.

Cont for your size as foll.

Sizes 41 (45¼ 49¾)" only

Next rnd: [Knit to 1 st before next m, M1R, k1, sl m, k1, work slip-st patt 2 to 1 st before next m, k1, sl m, k1, M1L] 2 times, knit to end—8 sts inc'd.

Next rnd: [Knit to next m, sl m, k1, work slip-st patt 2 to 1 st before next m, k1, sl m] 2 times, knit to end.

Rep the last 2 rnds 1 (2, 2) more time(s)—296 (332, 368) sts.

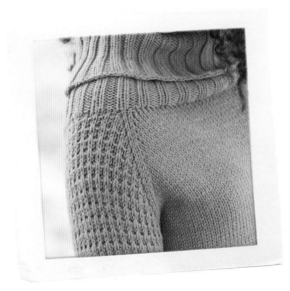

All Sizes

Next rnd: [Knit to next m, sl m, k1, work slip-st patt 2 to 1 st before next m, k1, sl m] 2 times, knit to end.

Rep last rnd 3 (3, 3, 1, 1) more time(s).

DIVIDE FOR BODY + SLEEVES

Knit to m, remove m, place next 49 (53, 63, 71, 79) sts onto holder for sleeve, remove m, use the backward-loop method to CO 2 (2, 3, 3, 3) sts, pm, CO 3 (3, 4, 4, 4) more sts as before, knit to next m, remove m, place next 49 (53, 63, 71, 79) sts onto holder for sleeve, remove m, use the backward-loop method to CO 2 (2, 3, 3, 3) sts, pm, CO 3 (3, 4, 4, 4) more sts as before, knit to end, remove m, knit to next m—152 (164, 184, 204, 224) sts rem.

lower body

Next rnd: [P1, knit to next m, sl m] 2 times.

Rep the last rnd until piece measures 2" (5 cm) from dividing rnd.

Inc rnd: [P1, k1, M1L, knit to 1 st before next m, M1R, k1, sl m] 2 times, knit to end—4 sts inc'd.

Work 3" (7.5 cm) even.

Rep inc rnd on next rnd, then every 3" (7.5 cm) 2 more times—168 (180, 200, 220, 240) sts.

Cont even until piece measures 12" (30.5 cm) from dividing rnd.

RIBBING

Work in k2, p2 rib until piece measures 15" (38 cm) from dividing rnd.

Loosely BO all sts in patt.

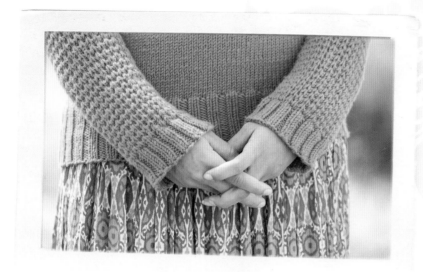

sleeves

Place 49 (53, 63, 71, 79) held sleeve sts onto dpn.

With RS facing and beg at the center of underarm, pick up and knit 3 sts, work 49 (53, 63, 71, 79) sleeve sts as foll: K1, work 47 (51, 61, 69, 77) sts in slip-st patt 2 as established, k1, pick up and knit 2 (2, 4, 4, 4) sts, pm, and join for working in rnds—54 (58, 70, 78, 86) sts total.

Work Rnds 1–4 of slip-st patt 3 (see Stitch Guide) until piece measures 3" (7.5 cm) from pick-up rnd.

Dec rnd: K2tog, work slip-st patt 3 as established to 2 sts before m, ssk—2 sts dec'd.

Work 29 (29, 15, 11, 11) rnds even.

Rep the last 30 (30, 16, 12, 12) rnds 2 (2, 6, 8, 8) more times—48 (52, 56, 60, 68) sts rem.

Work even in patt until piece measures 17" (43 cm) from pick-up rnd.

CUFF

Work in p2, k2 rib until piece measures 18½" (47 cm) from pick-up rnd.

Loosely BO all sts in patt.

finishing

COWL

With cir needle, RS facing, and beg at the left back raglan, pick up and knit 116 (120, 120, 124, 124) sts evenly spaced around neck opening. Pm and join for working in rnds.

Work in k2, p2 rib until piece measures 10" (25.5 cm) from pick-up rnd.

Loosely BO all sts in patt.

Weave in loose ends.

Block to measurements.

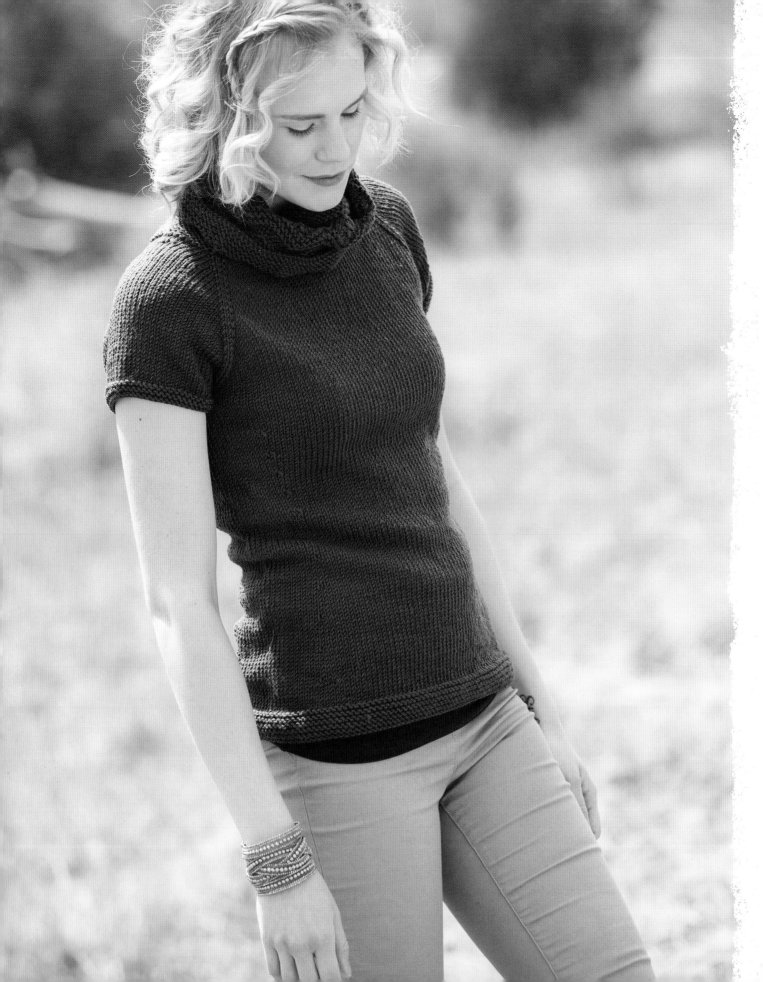

blue rock
TOP

designed by DANI SUNSHINE

This cute collared top is worked in the round from the top down, starting with the collar. The neckline is shaped with short-rows. The short sleeves and body are worked in the round and finished with garter stitch. Subtle waist shaping gives the body a feminine silhouette.

FINISHED SIZE

About 33¾ (38¾, 41, 45, 49)" (85.5 [98.5, 104, 114.5, 124.5] cm) bust circumference.

Top shown measures 38¾" (98.5 cm).

YARN

Worsted weight (#4 Medium).

Shown here: Cascade Yarns Longwood (100% superwash extrafine merino wool; 191 yd [175 m]/100 g): #24 Midnight Blue, 5 (5, 5, 6, 6) balls.

NEEDLES

Main body and collar: size U.S. 8 (5 mm): 16" and 24" or 32" (40 and 60 or 80 cm) circular (cir) and set of 4 or 5 double-pointed (dpn).

Garter hems: size U.S. 7 (4.5 mm): 24" or 32" (60 or 80 cm) cir and size U.S. 8 (5 mm) 24" or 32" (60 or 80 cm) cir and set of 4 or 5 dpn.

Adjust needle size if necessary to obtain the correct gauge.

NOTIONS

Markers (m), one of which is a unique color to mark beg of rnd; stitch holders or waste yarn; tapestry needle.

GAUGE

18 sts and 26 rnds = 4" (10 cm) in St st worked in rnds on larger needles.

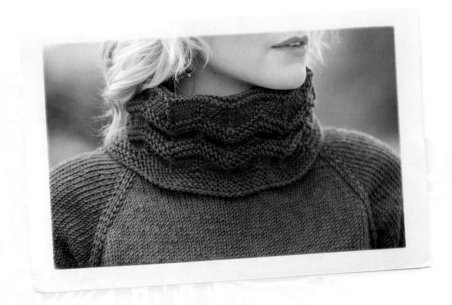

body

COLLAR

With smaller needles, CO 96 (108, 108, 120, 120) sts. Place marker (pm) of unique color and join for working in rnds, being careful not to twist sts.

[Knit 1 rnd, purl 1 rnd] 4 times.

Work chevron wave patt as follows.

Rnds 1, 3, 5, and 7: *K1, M1L (see Glossary), k4, sl 1, k2tog, psso, k4, M1R (see Glossary); rep from *.

Rnds 2, 4, and 6: Knit.

Rnds 8 and 10: Purl.

Rnds 9 and 11: Knit.

Rnd 12: Purl.

Rep Rnds 1–12 two more times—3 reps total; piece measures about 6" (15 cm) from CO.

[Knit 1 rnd, purl 1 rnd] 2 times.

Dec rnd: *K4 (4, 4, 4, 8), k2tog; rep from *—80 (90, 90, 100, 108) sts rem.

Cont alternating 1 rnd each of knit and purl (garter st) until piece measures about 10" (25.5 cm) from CO, ending with a purl rnd.

Next rnd: Knit and *at the same time* dec 4 (8, 6, 2, 0) sts evenly spaced—76 (82, 84, 98, 108) sts rem.

Purl 1 rnd.

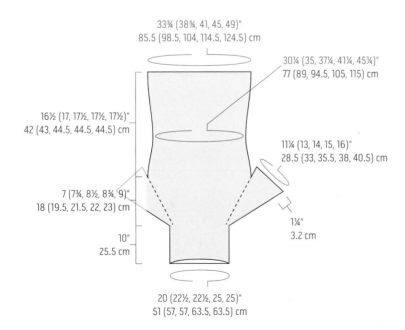

33¾ (38¾, 41, 45, 49)"
85.5 (98.5, 104, 114.5, 124.5) cm

30¼ (35, 37¼, 41¼, 45¼)"
77 (89, 94.5, 105, 115) cm

16½ (17, 17½, 17½, 17½)"
42 (43, 44.5, 44.5, 44.5) cm

11¼ (13, 14, 15, 16)"
28.5 (33, 35.5, 38, 40.5) cm

7 (7¾, 8½, 8¾, 9)"
18 (19.5, 21.5, 22, 23) cm

1¼"
3.2 cm

10"
25.5 cm

20 (22½, 22½, 25, 25)"
51 (57, 57, 63.5, 63.5) cm

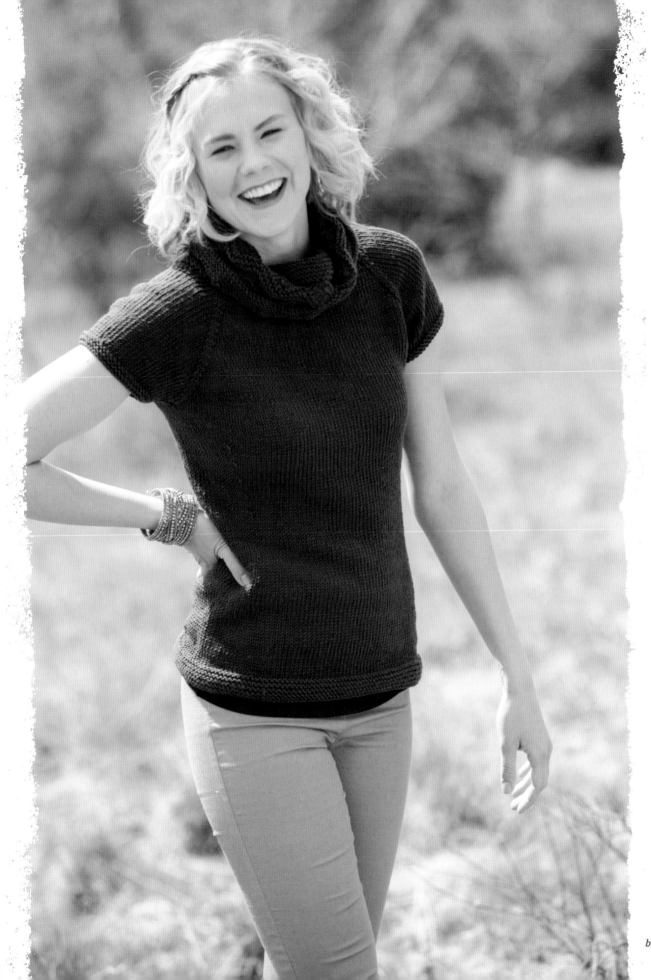

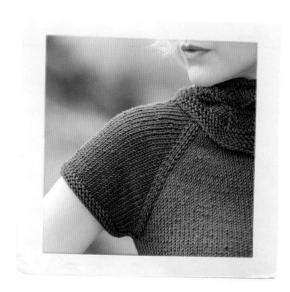

Inc rnd: *K1, sl m, M1L, knit to next m, M1R, sl m; rep from *—8 sts inc'd.

Next rnd: Knit, slipping markers when you come to them.

Rep the last 2 rnds 18 (21, 23, 24, 26) times—248 (278, 296, 318, 344) sts total; 50 (56, 60, 64, 68) sts for each sleeve, 72 (81, 86, 93, 102) sts each for front and back, and 1 st at each raglan.

DIVIDE FOR BODY AND SLEEVES

Removing raglan markers when you come to them, *place the first 52 (58, 62, 66, 70) sts on waste yarn for sleeve, use the backward-loop method (see Glossary) to CO 4 (6, 6, 8, 8) sts, k72 (81, 86, 93, 102) for back; rep from * for front—152 (174, 184, 202, 220) sts total.

lower Body

Place markers for waist shaping as follows.

K12 (13, 13, 14, 14), pm, k56 (67, 72, 81, 90), pm, k20, pm, k56 (67, 72, 81, 90), pm, knit to end.

Note: Beg of rnd marker is not centered at underarm; center of underarm is 10 sts from each waist-shaping marker.

Work even until piece measures 1" (2.5 cm) from dividing rnd.

Optional Waist Shaping

Dec rnd: Knit to next m, sl m, k2tog, knit to 2 sts before next m, ssk, sl m; rep from * once, knit to end of rnd—4 sts dec'd.

SHAPE RAGLAN

Set-up rnd: K1, pm, k7 (7, 7, 9, 9), pm, k1, pm, k28 (31, 32, 37, 42) for back, pm, k1, pm, k7 (7, 7, 9, 9), pm, k1, pm, k30 (33, 34, 39, 44) for front.

Inc Rnd 1: *K1, slip marker (sl m), M1L, knit to next m, M1R, sl m; rep from *—8 sts inc'd.

Work short-rows (see Glossary) to shape neck as foll.

Short-Row 1: With RS facing, k1, sl m, M1L, knit to next m, M1R, sl m, k1, sl m, M1L, knit to 3 sts before next m, wrap next st and turn work (w&t)—3 sts inc'd.

Short-Row 2: With WS facing, purl to 3 st before raglan m, w&t.

Short-Row 3: With RS facing, knit to wrapped st, knit wrap tog with wrapped st, knit to next m, M1R, sl m, k1 sl m, M1L, k6, w&t—2 sts inc'd.

Short-Row 4: With WS facing, purl to m, sl m, p1, sl m, purl to wrapped st, purl wrap tog with wrapped st, purl to next m, sl m, p1, sl m, p7, w&t.

Next row: Working wraps tog with wrapped sts when you come to them, knit to m, *M1R, sl m, k1, sl m, M1L, knit to next m, sl m; rep from *—96 (102, 104, 118, 128) sts total; 12 (12, 12, 14, 14) sts for each sleeve, 34 (37, 38, 43, 48) sts each for front and back, and 1 st at each raglan.

Cont working in rnds.

Work 5 rnds even. Rep the last 6 rnds 3 more times—136 (158, 168, 186, 204) sts rem.

Work even until piece measures 7" (18 cm) from dividing rnd.

Inc rnd: Knit to next m, sl m, M1L, knit to next m, M1R, sl m; rep from * once, knit to end of rnd—4 sts inc'd.

Work 7 rnds even. Rep the last 8 rnds 3 more times—152 (174, 184, 202, 220) sts.

Work even until piece measures 15 (15½, 16, 16, 16)" (38 [39.5, 40.5, 40.5, 40.5] cm) from dividing rnd or 1½" (3.8 cm) less than desired total length.

Change to smaller needles.

Work even in garter st (knit 1 rnd, then purl 1 rnd) for 1½" (3.8 cm).

Loosley BO all sts knitwise.

sleeves (make 2)

Place 52 (58, 62, 66, 70) held sleeve sts onto short cir needle or dpns.

Beg at center of underarm, pick up and knit 2 (3, 3, 4, 4) sts, k52 (58, 62, 66, 70) sleeve sts, pick up and knit 2 (3, 3, 4, 4) sts to end at center of underarm—56 (64, 68, 74, 78) sts total.

Pm and join for working in rnds.

Knit even until piece measures 1" (2.5 cm) from joining rnd.

Dec rnd: K3 (7, 9, 6, 8), k2tog, *k10, k2tog; rep from * 3 (3, 3, 4, 4) more times, knit to end—51 (59, 63, 68, 72) sts rem.

Change to smaller needles.

[Purl 1 rnd, knit 1 rnd] 2 times—4 rnds of garter st total.

Loosely BO all sts purlwise.

finishing

Weave in loose ends.

Block to measurements.

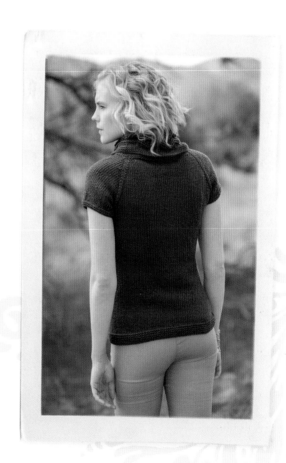

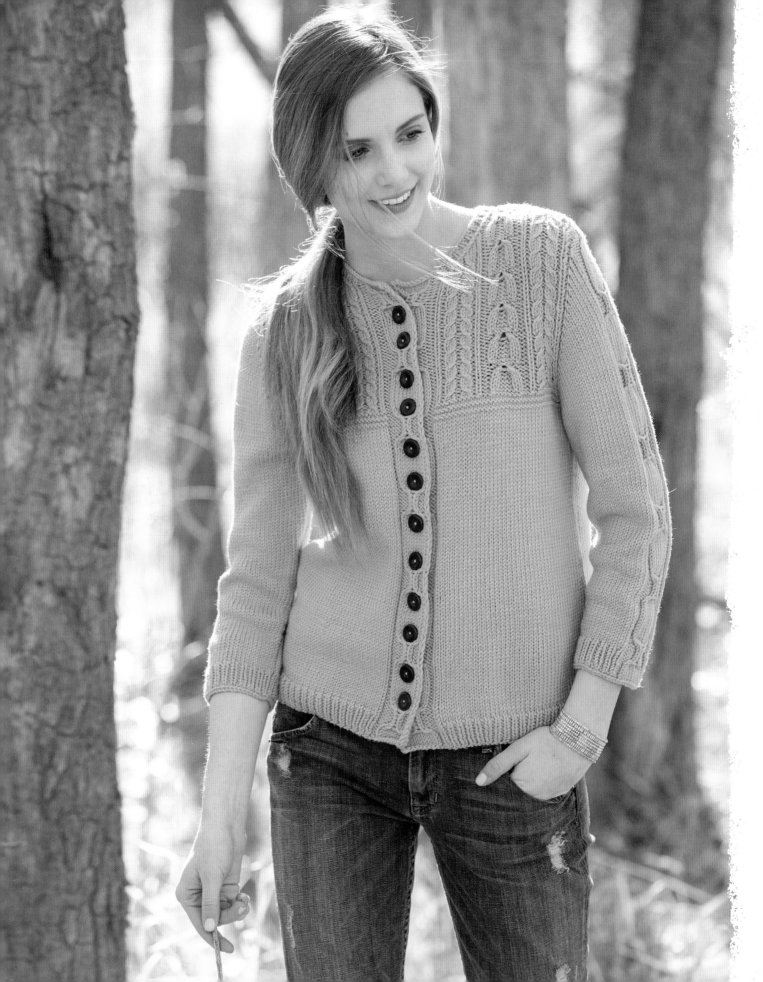

lady gansey

designed by ANN WEAVER

This sweater was modeled after traditional men's ganseys, which have stockinette-stitch bodies and a mix of cabled patterns at the shoulders. To add feminine versatility, this version is a cardigan. Knitted in one piece from the bottom up, it's quick to knit and has minimal finishing. The yarn shows off the cables beautifully!

FINISHED SIZE

About 32 (36¼, 39¾, 44, 47½, 51¾)" (81.5 [92, 101, 112, 120.5, 131.5] cm) bust circumference, buttoned with 1½" (3.8 cm) overlap.

Sweater shown measures 36¼" (92 cm).

YARN

Worsted weight (#4 Medium).

Shown here: Cascade Yarns Longwood (100% superwash extrafine merino wool; 191 yd [175 m]/100 g): #08 Artisan Gold, 5 (6, 6, 7, 8, 8) balls.

NEEDLES

Body: size U.S. 7 (4.5 mm): 24" or 32" (60 or 80 cm) circular (cir).

Sleeves: size U.S. 7 (4.5 mm): 16" (40 cm) circular and set of 4 or 5 double-pointed (dpn).

Adjust needle size if necessary to obtain the correct gauge.

NOTIONS

Six stitch markers (m); cable needle (cn); two stitch holders or waste yarn; tapestry needle; twelve (twelve, thirteen, thirteen, thirteen, thirteen) ⁵⁄₈" (16 mm) buttons; sewing needle and matching thread for attaching buttons.

GAUGE

20½ sts and 26 rows = 4" (10 cm) in St st.

STITCH GUIDE

1/3RC: Sl 3 sts onto cn and hold in back of work, k1, then k3 from cn.

1/3LC: Sl 1 st onto cn and hold in front of work, k3, then k1 from cn.

4/4CC: Sl 2 sts onto cn and hold in front of work, p2, yo, then work k2tog through back loop (tbl) from cn, sl next 2 sts onto cn and hold in back of work, k2tog, yo, then p2 from cn.

1/2LC: Sl 1 st onto cn and hold to front of work, k2, then k1 from cn.

1/2RC: Sl 2 sts onto cn and hold to back of work, k1, then k2 from cn.

TWO-STITCH ONE-ROW BUTTONHOLE: Sl 1 pwise, bring yarn to back between the needles and let it drop. [Sl 1 pwise, then pass st on right needle over slipped st and off the needle] 2 times—2 sts BO. Return first st from right needle onto left needle, then turn work—working yarn is now in front. Bring working yarn to back between needles and use it to use the cable method (see Glossary) to CO 3 sts. Turn work. Sl first st from left needle to right needle, then pass the first st on right needle (the last CO st) over it and off the needle.

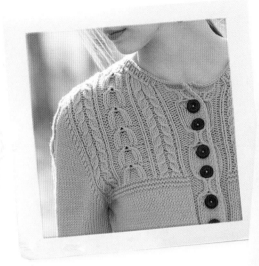

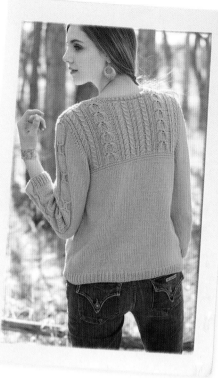

lower body

With longer cir needle, CO 12 sts, place marker (pm; Marker 1), CO 37 (43, 47, 53, 57, 63) more sts, pm (Marker 2), CO 1 st, pm (Marker 3), CO 80 (90, 100, 110, 120, 130) more sts, pm (Marker 4), CO 1 st, pm (Marker 5), CO 37 (43, 47, 53, 57, 63) more sts, pm (Marker 6), CO 12 more sts—180 (202, 220, 242, 260, 282) sts total.

Row 1: (RS) Work Row 1 of Chart A (see page 155), slip marker (sl m), *work [k1, p1] to 1 st before next m, k1, sl m, p1, sl m; rep from * once, work [k1, p1] to 1 st before next m, k1, sl m, work Row 1 of Chart B to end.

Row 2: (WS) Work Row 2 of Chart B, sl m, *work [p1, k1] to 1 st before next m, p1, sl m, k1, sl m; rep from * once, [p1, k1] to 1 st before next m, p1, sl m, work Row 2 of Chart A.

Working chart patts as established, rep these 2 rows 3 more times—8 rows total.

Next row: (RS) Cont in patt, work Chart A, sl m, *knit to next m, sl m, p1, sl m; rep from * once, knit to next m, sl m, work Chart B.

Next row: (WS) Work Chart B, sl m, *purl to next m, sl m, k1, sl m; rep from * 1 time, purl to next m, sl m, work Chart A.

Rep the last 2 rows until piece measures 14" (35.5 cm) from CO, ending with a WS row.

DIVIDE FOR FRONTS AND BACK

With RS facing and keeping in patt as established, work to 2 (3, 4, 4, 5, 5) sts before Marker 2, BO next 5 (7, 9, 9, 11, 11) sts (removing Markers 2 and 3), work to 2 (3, 4, 4, 5, 5) sts before Marker 4, BO next 5 (7, 9, 9, 11, 11) sts (removing Markers 4 and 5), work to end—170 (188, 202, 224, 238, 260) sts rem; 47 (52, 55, 61, 64, 70) sts for each front, 76 (84, 92, 102, 110, 120) sts for back.

left front

Rows 1, 3, and 5: (WS) Work Chart B, sl m, knit to end.

Row 2: (RS) K1, ssk, knit to m, work Chart B—1 st dec'd.

Row 4: Rep Row 2—45 (50, 53, 59, 62, 68) sts rem.

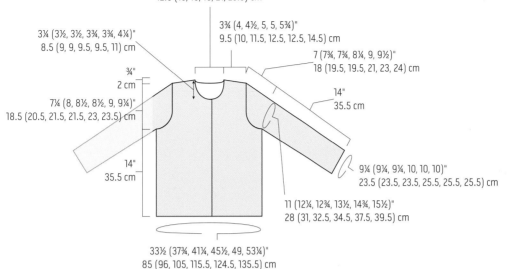

5 (6, 6, 7½, 8¼, 9¼)"
12.5 (15, 15, 19, 21, 23.5) cm

3¾ (4, 4½, 5, 5, 5¾)"
9.5 (10, 11.5, 12.5, 12.5, 14.5) cm

3¼ (3½, 3½, 3¾, 3¾, 4¼)"
8.5 (9, 9, 9.5, 9.5, 11) cm

7 (7¾, 7¾, 8¼, 9, 9½)"
18 (19.5, 19.5, 21, 23, 24) cm

¾"
2 cm

14"
35.5 cm

7¼ (8, 8½, 8½, 9, 9¼)"
18.5 (20.5, 21.5, 21.5, 23, 23.5) cm

14"
35.5 cm

9¼ (9¼, 9¼, 10, 10, 10)"
23.5 (23.5, 23.5, 25.5, 25.5, 25.5) cm

11 (12¼, 12¾, 13½, 14¾, 15½)"
28 (31, 32.5, 34.5, 37.5, 39.5) cm

33½ (37¾, 41¼, 45½, 49, 53¼)"
85 (96, 105, 115.5, 124.5, 135.5) cm

Row 6: K1, ssk, k1 (1, 4, 4, 2, 2), work sts 6–11 of Chart D 1 (0, 0, 1, 0, 1) time, work 11 sts of Chart D 0 (1, 1, 1, 2, 2) time(s), work Chart C, pm, work 11 sts of Chart D, sl m, work Chart B—44 (49, 52, 58, 61, 67) sts rem.

Cont as established until piece measures 4 (4½, 5, 4¾, 5¼, 5)" (10 [11.5, 12.5, 12, 13.5, 12.5] cm) from dividing row, ending with a RS row.

SHAPE NECK

Note: As you decrease, work remaining sts according to charts as established.

Row 1: (WS) Work Chart B, then place these 12 sts onto holder or waste yarn, remove m, BO 0 (0, 0, 2, 4, 5) sts, work in patt to end—32 (37, 40, 44, 45, 50) sts rem.

Row 2: (RS) Work in patt to last 3 sts, ssk, k1—1 st dec'd.

Row 3: P1, p2tog through back loop (tbl), work in patt to end—1 st dec'd.

Rep the last 2 rows 6 (7, 7, 8, 8, 9) more times, then rep Row 2 again 0 (1, 1, 1, 1, 1) more time—18 (20, 23, 25, 26, 29) sts rem.

Size 32" only
Work 1 WS row even as established.

SHAPE SHOULDER

Row 1: (RS) BO 6 (6, 7, 8, 8, 9) sts, work in patt to end—12 (14, 16, 17, 18, 20) sts rem.

Rows 2 and 4: (WS) Work even in patt.

Row 3: BO 6 (7, 8, 8, 9, 10) sts—6 (7, 8, 9, 9, 10) sts rem.

With RS facing, BO rem sts.

back

Rejoin yarn to 76 (84, 92, 102, 110, 120) back sts in preparation to work a WS row.

Row 1: (WS) Knit.

Row 2: (RS) K1, ssk, knit to last 4 sts, k3tog, k1—3 sts dec'd; 73 (81, 89, 99, 107, 117) sts rem.

Rows 3 and 5: Knit.

Row 4: K1, ssk, knit to last 3 sts, ssk, k1—2 sts dec'd; 71 (79, 87, 97, 105, 115) sts rem.

Row 6: K1, ssk, k4 (3, 7, 6, 5, 4), work sts 6–11 of Chart D 1 (0, 0, 1, 0, 1) time(s), work 11 sts of Chart D 0 (1, 1, 1, 2, 2) time(s), work Chart C, work Chart D, work sts 2–11 of Chart D, work Chart C, work 11 sts of Chart D 0 (1, 1, 1, 2, 2) time(s), work sts 6–11 of Chart D 1 (0, 0, 1, 0, 1) time, knit to last 3 sts, k2tog, k1—69 (77, 85, 95, 103, 113) sts rem.

Rows 7, 9, and 11: Work even in patt.

Row 8: K1, ssk, k3 (2, 6, 5, 4, 3), work in patt to last 3 sts, k2tog, k1—2 sts dec'd.

Row 10: K1, ssk, k2 (1, 5, 4, 3, 2), work in patt to last 3 sts, k2tog, k1—2 sts dec'd; 65 (73, 81, 91, 99, 109) sts rem.

Cont for your size as foll.

Sizes 32 (39¾, 47½)" only
Row 12: K1, ssk, k1 (4, 2), work in patt to last 3 sts, k2tog, k1—63 (79, 97) sts rem.

Sizes 36¼ (44¼, 51¾)" only
Row 12: Work even in patt—73 (91, 109) sts rem.

All sizes

Work even in patt until piece measures 7¼ (8, 8½, 8½, 9, 9¼)" (18.5 [20.5, 21.5, 21.5, 23, 23.5] cm) from dividing row, ending with a WS row.

SHAPE NECK AND SHOULDERS

Note: As you decrease, work remaining sts according to charts as established.

With RS facing, work 20 (22, 25, 27, 28, 31) sts in patt, BO 23 (29, 29, 37, 41, 47) sts, work in patt to end—20 (22, 25, 27, 28, 31) sts rem each side.

Next row: (WS) Work in patt to gap, join a second ball of yarn to sts after gap, work in patt to end.

Work the two sides simultaneously as foll.

Row 1: (RS) BO 6 (6, 7, 8, 8, 9) sts, work in patt to 3 sts before gap, k2tog, k1; k1, ssk, work in patt to end.

Row 2: BO 6 (6, 7, 8, 8, 9) sts, work in patt to gap; work in patt to end—13 (15, 17, 18, 19, 21) sts rem for each shoulder.

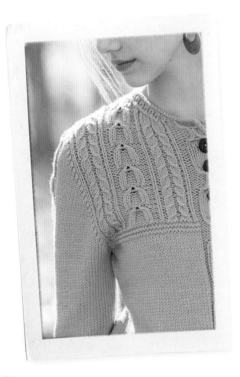

Row 3: BO 6 (7, 8, 8, 9, 10) sts, work in patt to 3 sts before gap, k2tog, k1; k1, ssk, work in patt to end.

Row 4: BO 6 (7, 8, 8, 9, 10) sts, work in patt to gap; work in patt to end—6 (7, 8, 9, 9, 10) sts rem for each shoulder.

With RS facing, BO both sets of shoulder sts.

right front

Rejoin yarn to 47 (52, 55, 61, 64, 70) right front sts in preparation to work a WS row.

Rows 1, 3, and 5: (WS) Knit to m, sl m, work Chart A to end of row.

Rows 2 and 4: (RS) Work Chart A, sl m, knit to last 3 sts, k2tog, k1—1 st dec'd.

Row 6: Work Chart A, sl m, work Chart D, work Chart C, work Chart D 0 (1, 1, 1, 2, 2) time(s), work sts 6–11 of Chart D 1 (0, 0, 1, 0, 1) time, knit to last 3 sts, k2tog, k1—44 (49, 52, 58, 61, 67) sts rem.

Work even in patt until piece measures 4 (4½, 5, 4¾, 5¼, 5)" (10 [11.5, 12.5, 12, 13.5, 12.5] cm) from dividing row, ending with a WS row.

SHAPE NECK

Note: As you decrease, work remaining sts according to charts as established.

Row 1: (RS) Work Chart A, then place these 12 sts onto holder or waste yarn, remove m, BO 0 (0, 0, 2, 4, 5) sts, work in patt to end—32 (37, 40, 44, 45, 50) sts rem.

Row 2: (WS) Work in patt to last 3 sts, p2tog, p1—1 st dec'd.

Row 3: K1, k2tog, work in patt to end—1 st dec'd.

Rep the last 2 rows 6 (7, 7, 8, 8, 9) more times, then rep Row 2 again 0 (1, 1, 1, 1, 1) more time—18 (20, 23, 25, 26, 29) sts rem.

Size 32" only

Work 1 RS row even in patt.

SHAPE SHOULDER

Row 1: (WS) BO 6 (6, 7, 8, 8, 9) sts, work in patt to end—12 (14, 16, 17, 18, 20) sts rem.

Rows 2 and 4: (RS) Work even in patt.

Row 3: BO 6 (7, 8, 8, 9, 10) sts—6 (7, 8, 9, 9, 10) sts rem.

With WS facing, BO rem sts.

With yarn threaded on a tapestry needle, sew shoulder seams.

sleeves

With RS facing, shorter cir needle, and beg at center of underarm, pick up and knit 30 (33, 34, 36, 39, 41) sts evenly spaced to shoulder seam, pm, pick up and knit 31 (34, 35, 37, 40, 42) sts evenly spaced back to center of underarm, pm (Marker 1) for beg of rnd—61 (67, 69, 73, 79, 83) sts total.

Work short-rows (see Glossary) to shape cap as foll.

Row 1: (RS) Knit to 6 sts before m, pm (Marker 2), work Chart B over next 12 sts (remove m), pm (Marker 3), wrap next st and turn work (w&t).

Row 2: (WS) Work Chart B between markers as established, w&t.

Row 3: Work in patt to 1 st past wrapped st, knitting wrap tog with wrapped st, w&t.

Row 4: Purl to m, work Chart B, sl m, purl to 1 st past wrapped st, purling wrap tog with wrapped st, w&t.

Rep Rows 3 and 4 until 3 (4, 5, 5, 6, 6) sts rem on each side of beg-of-rnd marker, ending with a WS row.

Joining rnd: (RS) Work in patt, working wraps tog with wrapped sts, to last st, pm (Marker 4), p1, sl m.

From here on, work sleeve in rnds, working Chart B between Markers 2 and 3 and purling sts between Markers 4 and 1, until piece measures 1½" (3.8 cm) from joining rnd.

Dec rnd: Ssk, work in patt to 2 sts before Marker 4, k2tog, sl m, p1—2 sts dec'd.

Work 13 (7, 6, 6, 4, 3) rnds even in patt.

Rep the last 14 (8, 7, 7, 5, 4) rnds 4 (7, 8, 8, 11, 13) more times, changing to dpns when sts can no longer fit comfortably on cir needle—51 (51, 51, 55, 55, 55) sts rem.

Work even in patt until piece measures 12½" (31.5 cm) from joining rnd.

Next rnd: Work [k1, p1] to 1 st before Marker 2, k1, sl m, work to Marker 3 as established, work [k1, p1] to 1 st before Marker 4, k1, sl m, p1.

Rep the last rnd 7 more times—8 rnds total.

BO all sts knitwise.

finishing

NECKBAND

With RS facing and cir needle, work 12 held right front band sts in patt, pick up and knit 17 (17, 17, 21, 23, 26) sts along right front neck, pm, 27 (33, 33, 41, 45, 51) sts across back neck, and 17 (17, 17, 21, 23, 26) sts along left front neck, pm, then work 12 held left band sts in patt—85 (91, 91, 107, 115, 127) sts total.

Row 1: (WS) Keeping in patt as established, work band sts, sl m, work [p1, k1] to 1 st before next m, p1, sl m, work band sts.

Row 2: (RS) Work band sts, sl m, work [k1, p1] to 1 st before next m, k1, sl m, work band sts.

Rep Row 1 once more.

BO all sts knitwise.

BUTTONS

Mark positions for buttons on left front band, opposite buttonholes on right front band.

With matching thread, sew buttons in place.

Weave in loose ends.

Block to measurements.

CHART A

CHART B

	k on RS, p on WS
	p on RS, k on WS
	1/2RC (see Stitch Guide)
	1/2LC (see Stitch Guide)
	3/1RC (see Stitch Guide)
	1/3LC (see Stitch Guide)
	3/1PRC (see Stitch Guide)
	1/3PLC (see Stitch Guide)
	4/4CC (see Stitch Guide)
	one-row buttonhole (see Stitch Guide)
	pattern repeat

CHART C

CHART D

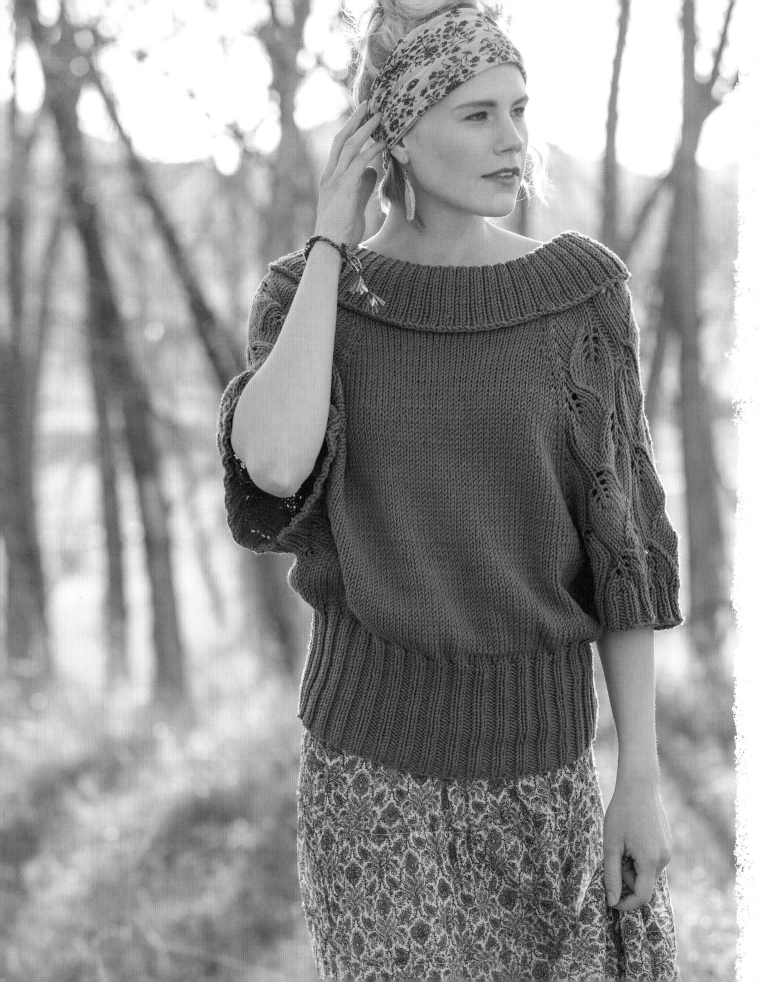

falling leaves
PULLOVER

designed by ELENA NODEL

This cozy and comfy poncho-sweater is perfect for layering. Worked from the top down, it's completely seamless. The back and front are worked simply in stockinette while the sleeves are worked in a lace pattern. The sleeves and lower body end with k2, p2 ribbing; the collar is worked in a combination of k1, p1 and k1, p2 ribbing.

FINISHED SIZE
About 39 (41½, 45¼, 47¾, 52½)" (99 [105.5, 115, 121.5, 133.5] cm) bust circumference.

Sweater shown measures 41½" (105.5 cm).

YARN
Worsted weight (#4 Medium).

Shown here: Cascade Yarns Longwood (100% superwash extrafine merino wool; 191 yd [175 m]/100 g): #11 Walnut, 5 (5, 6, 6, 7) balls.

NEEDLES
Main body and upper sleeves: size U.S. 8 (5 mm): 16" and 32" (40 and 80 cm) circular (cir).

Neckline, hemline, and sleeve cuffs: size U.S. 7 (4.5 mm): 24" or 32" (60 or 80 cm) cir.

Adjust needle size if necessary to obtain the correct gauge.

NOTIONS
Markers (m); stitch holders or waste yarn; tapestry needle.

GAUGE
15½ sts and 22 rnds = 4" (10 cm) in St st worked in rnds on larger needles.

18 sts and 19 rows = 4" (10 cm) in trailing leaves motif worked in rnds on larger needles.

STITCH GUIDE

TRAILING LEAVES MOTIF WORKED BACK AND FORTH
(panel of 15 sts)

Row 1: (RS) P2, k13.

Row 2: (WS) P13, k2.

Row 3: P2, k10, k2tog, yo, k1.

Row 4: Yo, p2, p2tog, p9, k2.

Row 5: P2, k8, k2tog, k1, yo, k2.

Row 6: P1, yo, p3, p2tog, p7, k2.

Row 7: P2, k6, k2tog, k2, yo, k3.

Row 8: P2, yo, p4, p2tog, p5, k2.

Row 9: P2, k4, k2tog, k3, yo, k4.

Row 10: P3, yo, p5, p2tog, p3, k2.

Row 11: P2, k13.

Row 12: P13, k2.

Row 13: P2, k1, yo, ssk, k10.

Row 14: P9, p2tog through back loops (tbl), p2, yo, k2.

Row 15: P2, k2, yo, k1, ssk, k8.

Row 16: P7, p2tog tbl, p3, yo, p1, k2.

Row 17: P2, k3, yo, k2, ssk, k6.

Row 18: P5, p2tog tbl, p4, yo, p2, k2.

Row 19: P2, k4, yo, k3, ssk, k4.

Row 20: P3, p2tog tbl, p5, yo, p3, k2.

Rep Rows 1–20 for patt.

TRAILING LEAVES MOTIF WORKED IN ROUNDS
(panel of 15 sts)

Rnds 1 and 2: P2, k13.

Rnd 3: P2, k10, k2tog, yo, k1.

Rnd 4: P2, k9, k2tog, k2, yo.

Rnd 5: P2, k8, k2tog, k1, yo, k2.

Rnd 6: P2, k7, k2tog, k3, yo, k1.

Rnd 7: P2, k6, k2tog, k2, yo, k3.

Rnd 8: P2, k5, k2tog, k4, yo, k2.

Rnd 9: P2, k4, k2tog, k3, yo, k4.

Rnd 10: P2, k3, k2tog, k5, yo, k3.

Rnds 11 and 12: P2, k13.

Rnd 13: P2, k1, yo, ssk, k10.

Rnd 14: P2, yo, k2, ssk, k9.

Rnd 15: P2, k2, yo, k1, ssk, k8.

Rnd 16: P2, k1, yo, k3, ssk, k7.

Rnd 17: P2, k3, yo, k2, ssk, k6.

Rnd 18: P2, k2, yo, k4, ssk, k5.

Rnd 19: P2, k4, yo, k3, ssk, k4.

Rnd 20: P2, k3, yo, k5, ssk, k3.

Rep Rnds 1–20 for patt.

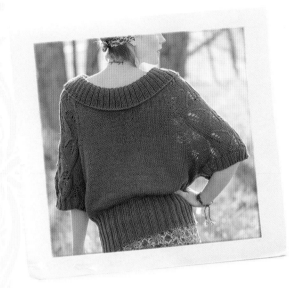

bodice

With larger cir needle and using the long-tail method (see Glossary), CO 79 (81, 83, 85, 87) sts. Do not join.

Set-up row: (WS) P2, place marker (pm), p25, pm, p25 (27, 29, 31, 33), pm, p25, pm, p2.

Row 1: (RS) [K1f&b (see Glossary)] 2 times, slip marker (sl m), work Row 1 of Left Sleeve chart (see page 161), sl m, k1f&b, knit to 2 sts before next m, k1f&b, k1, sl m, work Row 1 of Right Sleeve chart (see page 160), sl m, [k1f&b] 2 times—10 sts inc'd.

Row 2: Purl to m, sl m, work Row 2 of Right Sleeve chart, sl m, purl to next m, sl m, work Row 2 of Left Sleeve chart, sl m, purl to end.

Row 3: K1f&b, k3, sl m, work Row 3 of Left Sleeve chart, sl m, knit to m, sl m, work Row 3 of Right Sleeve chart, sl m, k2, k1f&b, k1—6 sts inc'd.

Rows 4, 6, and 8: Rep Row 3, working next row of both sleeve charts—2 sts inc'd each row.

Row 5: K1f&b, k3, k1f&b, sl m, work Row 5 of Left Sleeve chart, sl m, k1f&b, knit to 2 sts before next m, k1f&b, k1, sl m, work Row 5 of Right Sleeve chart, sl m, k1f&b, k2, k1f&b, k1—10 sts inc'd.

Row 7: K1f&b, k6, sl m, work Row 7 of Left Sleeve chart, sl m, knit to next m, sl m, work Row 7 of Right Sleeve chart, sl m, k5, k1f&b, k1—6 sts inc'd.

Row 9: K7, k1f&b, sl m, work Row 9 of Left Sleeve chart, sl m, k1f&b, knit to 2 sts before next m, k1f&b, sl m, work Row 9 of Right Sleeve chart, sl m, k1f&b, k6—8 sts inc'd; 125 (127, 129, 131, 133) sts total.

Joining row: With RS still facing, use the backward-loop method (see Glossary) to CO 10 (12, 12, 12, 12) sts onto right needle tip, then k1f&b (first st on left needle), knit to m—141 (145, 149, 155, 159) sts.

This m will now denote beg of rnd; make it a unique color if you wish.

Work in rnds from this point forward, maintaining chart patts as established and inc for raglan shaping every 3rd rnd as foll.

Rnd 1: Work Left Sleeve chart, sl m, knit to next m, work Right Sleeve chart, sl m, knit to end.

Rnd 2: Work Left Sleeve chart, sl m, k1f&b, knit to 2 sts before next m, k1f&b, k1, sl m, work Right Sleeve chart, sl m, k1f&b, knit to 2 sts before next m, k1f&b, k1—4 sts inc'd.

Rnd 3: Work Left Sleeve chart, sl m, knit to next m, sl m, work Right Sleeve chart, sl m, knit to end—4 sts inc'd.

Rep Rnds 1–3 through Row 66 (71, 75, 81, 84) of charts—287 (303, 317, 335, 345) sts total; 73 (75, 79, 83, 85) sts for each sleeve; 69 (75, 79, 85, 89) sts for back; 72 (78, 80, 84, 86) sts for front.

DIVIDE FOR BODY AND SLEEVES

Remove beg-of-rnd m, place first 73 (75, 79, 83, 85) sts onto holder for sleeve, remove m, use the backward-loop method to CO 2 (2, 4, 4, 7) sts over gap, pm for beg of rnd, CO 3 (2, 4, 4, 7) sts as before, k69 (75, 79, 85, 89) back sts, remove m,

place next 73 (75, 79, 83, 85) sts onto holder for other sleeve, remove m, CO 3 (2, 4, 4, 7) sts as before, CO 2 (2, 4, 4, 7) sts as before, knit to end—151 (161, 175, 185, 203) sts rem.

lower body

Knit 3 rnds.

Cont for your size as foll.

Sizes 39 (41½, 45¼)" only
Dec rnd: K1, k2tog, knit to 3 sts before m, ssk, k1, sl m, k1, k2tog, knit to 3 sts before m, ssk, k1—4 sts dec'd.

Sizes 47¾ (52½)" only
Next rnd: Knit.

All sizes
Rep the last 4 rnds 1 (2, 1, 1, 1) more time(s)—143 (149, 167, 185, 203) sts rem.

Knit 1 rnd and *at the same time* adjust sts to a multiple of 4 for your size as follows.

Sizes 39 (45¼, 52½)" only
K1, M1, knit to end—1 st inc'd; 144 (168, 204) sts.

Sizes 41½ (47¾)" only
Work k2tog at beg of rnd—1 st dec'd; 148 (184) sts rem.

LOWER EDGING
Change to smaller cir needle and work in k2, p2 rib until piece measures 6 (6, 7, 7, 7)" (15 [15, 18, 18, 18] cm) from beg of ribbing.

Loosely BO all sts in patt.

sleeves

Return 73 (75, 79, 83, 85) held sleeve sts onto shorter, smaller cir needle.

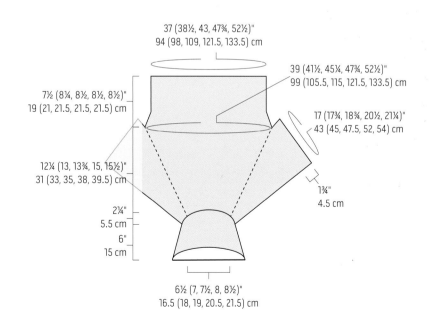

37 (38½, 43, 47¾, 52½)"
94 (98, 109, 121.5, 133.5) cm

39 (41½, 45¼, 47¾, 52½)"
99 (105.5, 115, 121.5, 133.5) cm

7½ (8¼, 8½, 8½, 8½)"
19 (21, 21.5, 21.5, 21.5) cm

17 (17¾, 18¾, 20½, 21¼)"
43 (45, 47.5, 52, 54) cm

12¼ (13, 13¾, 15, 15½)"
31 (33, 35, 38, 39.5) cm

1¾"
4.5 cm

2¼"
5.5 cm

6"
15 cm

6½ (7, 7½, 8, 8½)"
16.5 (18, 19, 20.5, 21.5) cm

With RS facing and beg at underarm gap, pick up and knit 2 (3, 2, 4, 5) sts, pm, then pick up and knit 1 (2, 3, 5, 6) more st(s)—76 (80, 84, 92, 96) sts total.

Pm and join for working in rnds.

Work in k2, p2 rib for 9 rnds.

BO all sts in patt.

finishing
COLLAR
With RS facing and beg at back right shoulder, pick up and knit 104 (108,

RIGHT SLEEVE LACE

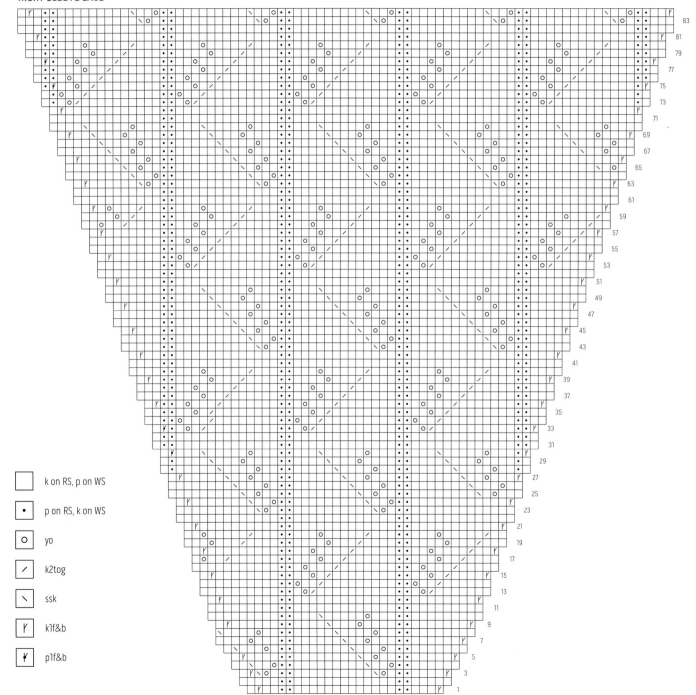

	k on RS, p on WS
	p on RS, k on WS
o	yo
╱	k2tog
╲	ssk
⅄	k1f&b
⅄	p1f&b

112, 118, 124) sts evenly space around neck opening (about 1 st for every CO st and 2 sts for every 3 rows along sloped edges).

Pm and join for working in rnds.

Work in k1, p1 rib until piece measures between 2" (5 cm) and 2½" (6.5 cm).

Inc rnd: *LLI (see Glossary), k1, p1; rep from * to end—156 (162, 168, 177, 186) sts.

Next rnd: *K2, p1; rep from * to end.

Work in k2, p1 rib as established until piece measures about 6" (15 cm) or desired length.

Loosely BO all sts in patt.

Weave in loose ends.

Block lightly to measurements.

LEFT SLEEVE LACE

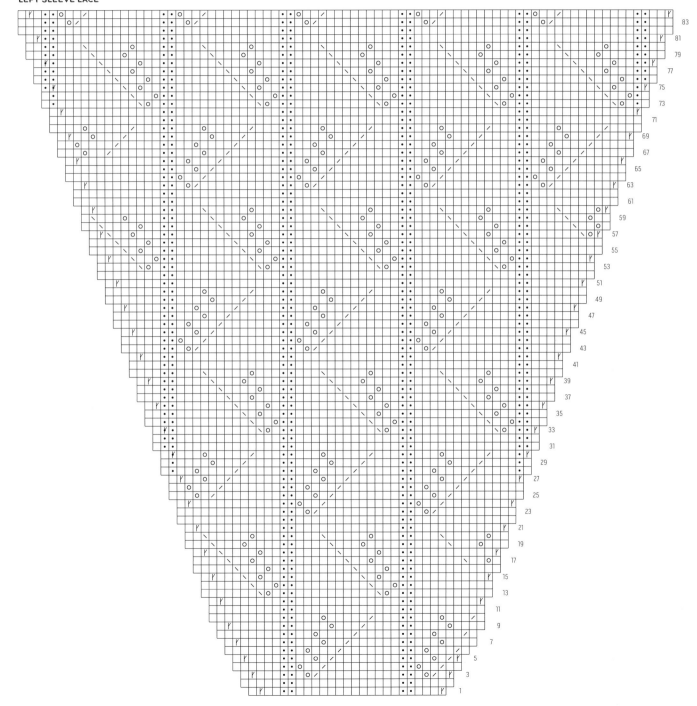

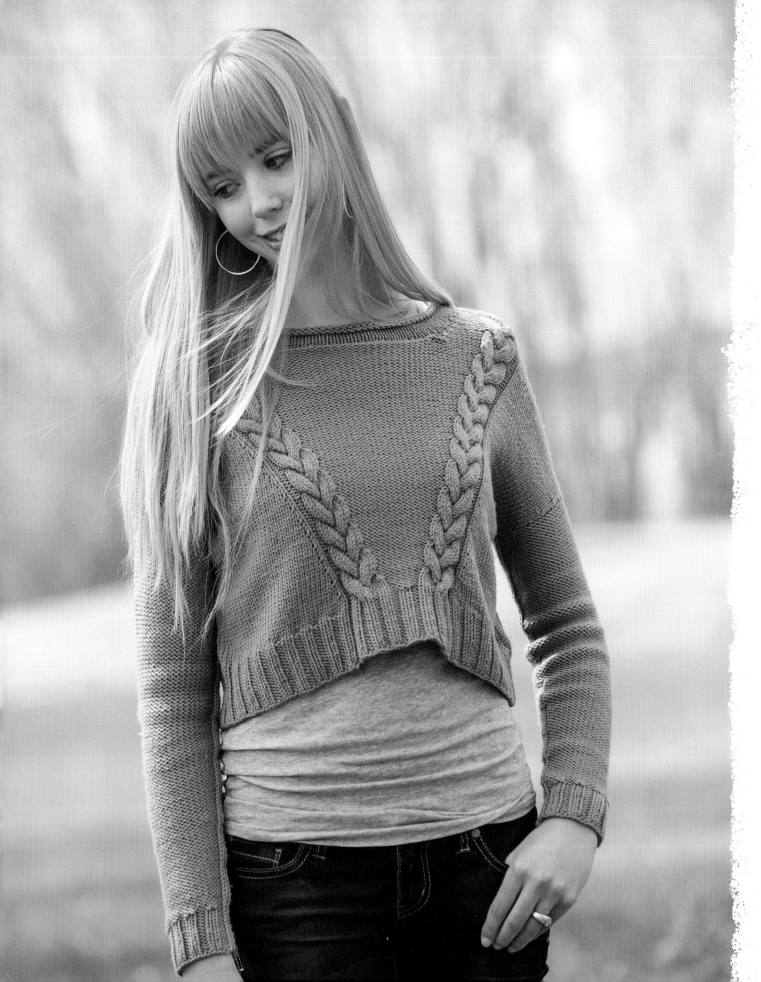

shifting cables
PULLOVER

designed by SUVI SIMOLA

This modern oversized sweater is worked from the top down with shifting cables and reverse stockinette-stitch details. The front and back are worked separately to the armholes, then joined, and the body is worked in rounds to the hem. Stitches for the sleeves are then picked up at the armholes and worked in rounds to the cuffs for minimal seaming. The sides are slightly shaped for a flattering fit.

FINISHED SIZE
About 44¼ (47¾, 52, 55½, 59¾)" (112.5 [121.5, 132, 141, 152] cm) bust circumference.

Sweater shown measures 44¼" (112.5 cm).

YARN
Worsted weight (#4 Medium).

Shown here: Cascade Yarns Longwood (100% superwash extrafine merino wool; 191 yd [175 m]/100 g): #26 Lavender, 5 (5, 6, 6, 7) balls.

NEEDLES
Body and sleeves: size U.S. 8 (5 mm): two 32" (80 cm) circular (cir).

Ribbing: size U.S. 7 (4.5 mm): 32" (80 cm) and 24" (60 cm) cir and set of 4 or 5 double-pointed (dpn).

Adjust needle size if necessary to obtain the correct gauge.

NOTIONS
Waste yarn and size H/8 (5 mm) crochet hook for provisional cast-on; markers (m); cable needle (cn); spare size 8 (5 mm) needle for three-needle bind-off; tapestry needle.

GAUGE
18½ sts and 28 rows/rnds = 4" (10 cm) in St st worked in rows and rnds on larger needles.

STITCH GUIDE

4/4LC: Slip 4 sts onto cn and hold in front of work, k4, k4 from cn.

4/4RC: Slip 4 sts onto cn and hold in back of work, k4, k4 from cn.

NOTES:
The right and left fronts are worked separately as increases are worked to shape the neck, then they're joined together.

Short-rows are used to shape the shoulder slope.

front

RIGHT FRONT

With crochet hook and waste yarn, make a crochet chain (see Glossary) 38 (40, 44, 47, 51) sts long. Flip the chain over so you can see the "bumps" on WS. With working yarn and larger cir needle, pick up and knit 1 st in each "bump"—38 (40, 44, 47, 51) sts total.

Set-up row: (WS) K4 (4, 5, 6, 7), place marker (pm), p12, k2, pm, p20 (22, 25, 27, 30).

Next row: (RS) Knit to m, slip marker (sl m), work Row 1 of Chart A (see page 167) over next 14 sts, sl m, purl to end.

Next row: (WS) Knit to m, sl m, work Row 2 of Chart A, sl m, purl to end.

Shape Neck and Shoulder

Working in patts as established, inc along front neck edge and work short-rows (see Glossary) to shape shoulder as foll.

Rows 1, 3, 5, and 7: (RS) Work to last 2 sts, M1P (see Glossary), p2—1 st inc'd.

Row 2: (WS) Work to last 4 (5, 5, 6, 7) sts, then wrap next st and turn work (w&t).

Row 4: Work to 4 (5, 6, 6, 7) sts before previously wrapped st, w&t.

Row 6: Work to 5 (5, 6, 6, 7) sts before previously wrapped st, w&t.

Row 8: Work to 5 (5, 6, 7, 7) sts before previously wrapped st, w&t.

Row 9: Work to last 2 sts, M1P, p2—1 st inc'd.

Row 10: Work as established, purling the wraps tog with the wrapped sts as you come to them.

Cont as established, inc 1 st every RS row 2 more times and 8-row cable patt from Chart A has been worked twice, working inc'd sts in Rev St st and ending with a WS row—45 (47, 51, 54, 58) sts.

Do not cut yarn.

LEFT FRONT

Provisionally CO 38 (40, 44, 47, 51) sts as for right front.

Set-up row: (WS) P20 (22, 25, 27, 30), pm, k2, p12, pm, k4 (4, 5, 6, 7).

Next row: (RS) Purl to m, sl m, work Row 1 of Chart B over next 14 sts, sl m, knit to end.

Next row: (WS) Purl to m, sl m, work Row 2 of Chart B, sl m, knit to end.

Shape Neck and Shoulder

Working in patts as established, inc along front neck edge and work short-rows to shape shoulder as foll.

Row 1: (RS) P2, M1P, work to last 4 (5, 5, 6, 7) sts, w&t—1 st inc'd.

Rows 2, 4, 6, and 8: (WS) Work as established.

Row 3: (RS) P2, M1P, work to 4 (5, 6, 6, 7) sts before previously wrapped st, w&t—1 st inc'd.

Row 5: (RS) P2, M1P, work to 5 (5, 6, 6, 7) sts before previously wrapped st, w&t—1 st inc'd.

Row 7: (RS) P2, M1P, work to 5 (5, 6, 7, 7) sts before previously wrapped st, w&t—1 st inc'd.

Row 9: P2, M1P, work as established, knitting the wraps tog with the wrapped sts as you come to them—1 st inc'd.

Cont as established, inc 1 st every RS row 2 more times and 8-row patt from Chart B has been worked twice, working inc'd sts in Rev St st and ending with a WS row—45 (47, 51, 54, 58) sts.

Cut yarn.

JOIN FRONTS AND SHIFT CABLES

Set-up row: (RS) With cir needle, working yarn attached to right front, and working Row 1 of charts, knit to 1 st before m, M1R (see Glossary), k1, sl m, p2, k11, ssk (removing m between sts), p10 (10, 11, 12, 13), use the backward-loop method (see Glossary) to CO 24 (28, 30, 32, 34) sts for center front, then work left front sts as: p10 (10, 11, 12, 13), k2tog (removing m between sts), k11, p2, sl m, k1, M1L (See Glossary), knit to end—114 (122, 132, 140, 150) sts total.

Working newly CO sts in Rev St st and shifting cable panels 1 st to the center on every rep of chart Rows 1 and 5, cont as foll.

Rows 1, 3, 5, and 7: (WS) Work even as established.

Row 2: (RS) Work even as established, working Row 3 of charts.

Row 4: (Row 5 of charts; patt shift) Knit to 1 st before m, M1R, k1, sl m, p2, k11, ssk, purl to 1 st before Chart B, k2tog, k11, p2, slip m, k1, M1L, knit to end.

Row 6: Work even as established, working Row 7 of charts.

Row 8: (Row 1 of charts; patt shift): Knit to 1 st before m, M1R, k1, sl m, p2, k11, ssk, purl to 1 st before Chart B, k2tog, k11, p2, sl m, k1, M1L, knit to end.

Cont in patt as established until piece measures 6 (6½, 7¼, 7¾, 8½)" (15 [16.5, 18.5, 19.5, 21.5] cm) from provisional CO along side edge, ending with a WS row.

Do not cut yarn. Set aside.

back

With crochet hook and waste yarn, make a crochet chain 114 (122, 132, 140, 150) sts long. Flip the chain over so you can see the "bumps" on WS. With new ball of working yarn and other larger cir needle, pick up and knit 1 st in each "bump"— 114 (122, 132, 140, 150) sts total.

Set-up row: (WS) P20 (22, 25, 27, 30), pm, k2, p12, pm, k46 (50, 54, 58, 62), pm, p12, k2, pm, p20 (22, 25, 27, 30).

Next row: (RS) Knit to m, sl m, work Row 1 of Chart B1 over next 14 sts, sl m, purl to next m, sl m, work Row 1 of Chart A1 over next 14 sts, sl m, knit to end.

Next row: Purl to m, sl m, work Row 2 of Chart A1, sl m, knit to next m, sl m, work Row 2 of Chart B1, sl m, purl to end.

SHAPE SHOULDERS

Cont in patts as established, work short-rows to shape shoulders as foll.

Short-Rows 1 and 2: Work to last 4 (5, 5, 6, 7) sts, w&t.

Short-Rows 3 and 4: Work to 4 (5, 6, 6, 7) sts before previously wrapped st, w&t.

Short-Rows 5 and 6: Work to 5 (5, 6, 6, 7) sts before previously wrapped st, w&t.

Short-rows 7 and 8: Work to 5 (5, 6, 7, 7) sts before previously wrapped st, w&t.

Next row: (RS) Work in patts to end of row, knitting the wraps tog with their wrapped sts.

Next row: (WS) Work in patts, purling rem wraps tog with their wrapped sts.

Work 4 more rows as established to end with Rnd 8 of cable patts.

SHIFT CABLES

Set-up row: (RS) Knit to 1 st before marker, M1R, k1, slip m, p2, k11, ssk (removing m between sts), purl to 1 st before next m, k2tog (removing m between sts), k11, p2, sl m, k1, M1L, knit to end.

Shifting cable panels 1 st to the center every rep of chart Rows 1 and 5, cont as foll.

Rows 1, 3, 5, and 7: (WS) Work even as established.

Row 2: (RS) Work even as established, working Row 3 of charts.

Row 4: (Row 5 of charts; patt shift) Knit to 1 st before m, M1R, k1, sl m, p2, k11, ssk, purl to 1 st before Chart A1, k2tog, k11, p2, sl m, k1, M1L, knit to end.

Row 6: Work even as established, working Row 7 of charts.

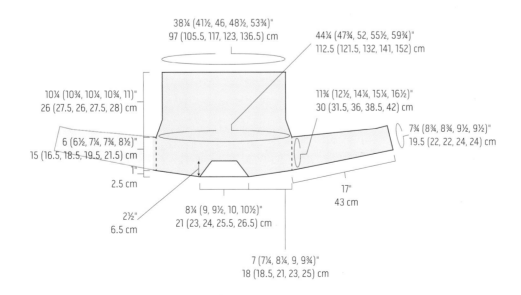

38¼ (41½, 46, 48½, 53¾)"
97 (105.5, 117, 123, 136.5) cm

44¼ (47¾, 52, 55½, 59¾)"
112.5 (121.5, 132, 141, 152) cm

10¼ (10¾, 10¼, 10¾, 11)"
26 (27.5, 26, 27.5, 28) cm

11¾ (12½, 14¼, 15¼, 16½)"
30 (31.5, 36, 38.5, 42) cm

6 (6½, 7¼, 7¾, 8½)"
15 (16.5, 18.5, 19.5, 21.5) cm

7¾ (8¾, 8¾, 9½, 9½)"
19.5 (22, 22, 24, 24) cm

1"
2.5 cm

2½"
6.5 cm

8¼ (9, 9½, 10, 10½)"
21 (23, 24, 25.5, 26.5) cm

17"
43 cm

7 (7¼, 8¼, 9, 9¾)"
18 (18.5, 21, 23, 25) cm

Row 8: (Row 1 of charts; patt shift) Knit to 1 st before m, M1R, k1, sl m, p2, k11, ssk, purl to 1 st before Chart A1, k2tog, k11, p2, sl m, k1, M1L, knit to end.

Cont in patt as established until piece measures same length as the front, ending with a WS row.

Cut yarn.

lower body

Joining rnd: With RS facing and using the cir needle and working yarn attached to front sts, work front sts as established, pm for side "seam," work back sts as established, pm for other side "seam" and beg of rnd—228 (244, 264, 280, 300) sts total.

SHAPE UNDERARMS

Maintaining patts and shifting cables every 4 rnds, cont as foll.

Dec rnd: K1, ssk, work to 3 sts before side m, k2tog, k1, sl m, k1, ssk, work to last 3 sts k2tog, k1—4 sts dec'd.

Work 3 rnds even in patt. Rep the last 4 rnds 4 more times—208 (224, 244, 260, 280) sts rem.

JOIN SHOULDERS

Note: Shoulders are joined at this point so the sweater can be tried on for fit.

Carefully remove waste yarn from provisional CO at each front shoulder and place 38 (40, 44, 47, 51) live sts onto separate dpns. Remove waste yarn from provisional CO on back and place 114 (122, 132, 140, 150) live sts onto a spare cir needle.

Hold pieces with RS facing tog and use the three-needle method (see Glossary) to BO the first 38 (40, 44, 47, 51) shoulder sts tog, p38 (42, 44, 46, 48) back neck sts, then BO rem 38 (40, 44, 47, 51) shoulder sts tog.

Cut yarn, leaving back neck sts on spare cir needle to work later.

Removing side m when you come to it, cont in patts as established until the cable patts have been worked a total of 12 (13, 13, 14, 15) times—6 (6, 10, 10, 10) purl sts rem between cables on front and back.

Next rnd: Remove beg-of-rnd m, then work to first cable m on front—this m will denote the beg of rnd for the remainder of the body.

RIBBING

Sizes 52" and 55½" only

Dec rnd: Work in patt to second cable m on front, sl m, ssk, knit to 2 sts before first cable m on back, k2tog, sl m, work to next m, sl m, ssk, knit to last 2 sts, k2tog—4 sts dec'd.

All sizes

Change to smaller cir needle.

Set-up rnd: *P2, k2, p2, ssk, k2tog, p2, [k2, p2] 3 (3, 4, 4, 4) times, ssk, k2tog, p2, k2, p2, sl m, work (k2, p2) to 2 sts before next m, k2, sl m; rep from * once more—200 (216, 236, 248, 272) sts rem.

Cont in rib as established until rib measures 2½" (6.5 cm).

Loosely BO all sts in patt.

sleeves

With RS facing, larger cir needle (for magic-loop technique; see Glossary) or dpns, and beg at center of underarm, pick up and knit 54 (58, 66, 70, 76) sts evenly spaced (about 2 sts for every 3 rows) around armhole. Pm and join for working in rnds.

Set-up rnd: K1, purl to last st, k1.

Cont as established until piece measures 1½" (3.8 cm) from pick-up rnd.

Dec rnd: Ssk, purl to last 2 sts, k2tog—2 sts dec'd.

Work 10 (10, 6, 6, 5) rnds even. Rep the last 11 (11, 7, 7, 6) rnds 7 (7, 9, 9, 7) more times—38 (42, 46, 50, 60) sts rem.

Rep dec rnd, then work 0 (0, 6, 6, 4) rnds even. Rep the last 0 (0, 7, 7, 5) rnds 0 (0, 2, 2, 7) more times—36 (40, 40, 44, 44) sts rem.

Work even until sleeve measures 15" (38 cm) from pick-up rnd, or 2" (5 cm) less than desired total length.

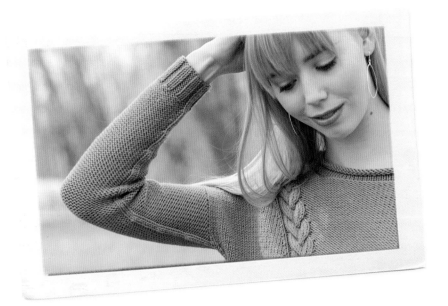

RIBBING

Change to smaller cir (for magic-loop technique) or smaller dpns.

Set-up rnd: K1, p2, *k2, p2; rep from * to last st, k1.

Cont in rib as established for 2" (5 cm).

Loosely BO all sts in patt.

finishing

NECKBAND

With smaller, shorter cir needle and RS facing, k38 (42, 44, 46, 48) back neck sts, then pick up and knit 11 sts (about 2 sts for every 3 rows) along front neck slope, 24 (28, 30, 32, 34) sts across center front neck, and 11 sts along other neck slope—84 (92, 96, 100, 104) sts total.

Pm and join for working in rnds.

Work in St st (knit all rnds) for 9 rnds.

Loosely BO all sts knitwise.

Weave in loose ends.

Block to measurements.

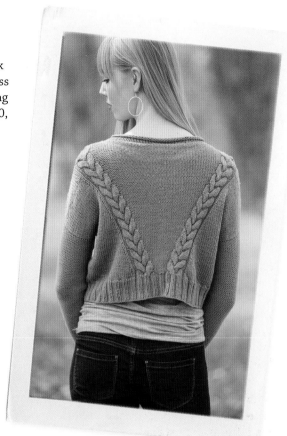

CHART A

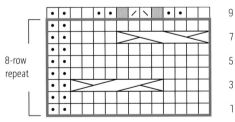

8-row repeat

CHART B

8-row repeat

CHART B1

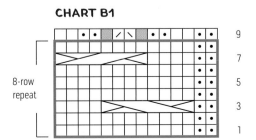

8-row repeat

CHART A1

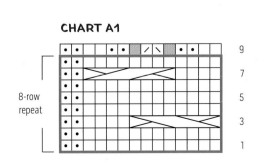

8-row repeat

☐	k on RS, p on WS
•	p on RS, k on WS
╱	k2tog
╲	ssk
▨	no stitch
⤬	4/4LC (see Stitch Guide)
⤬	4/4RC (see Stitch Guide)
☐	pattern repeat

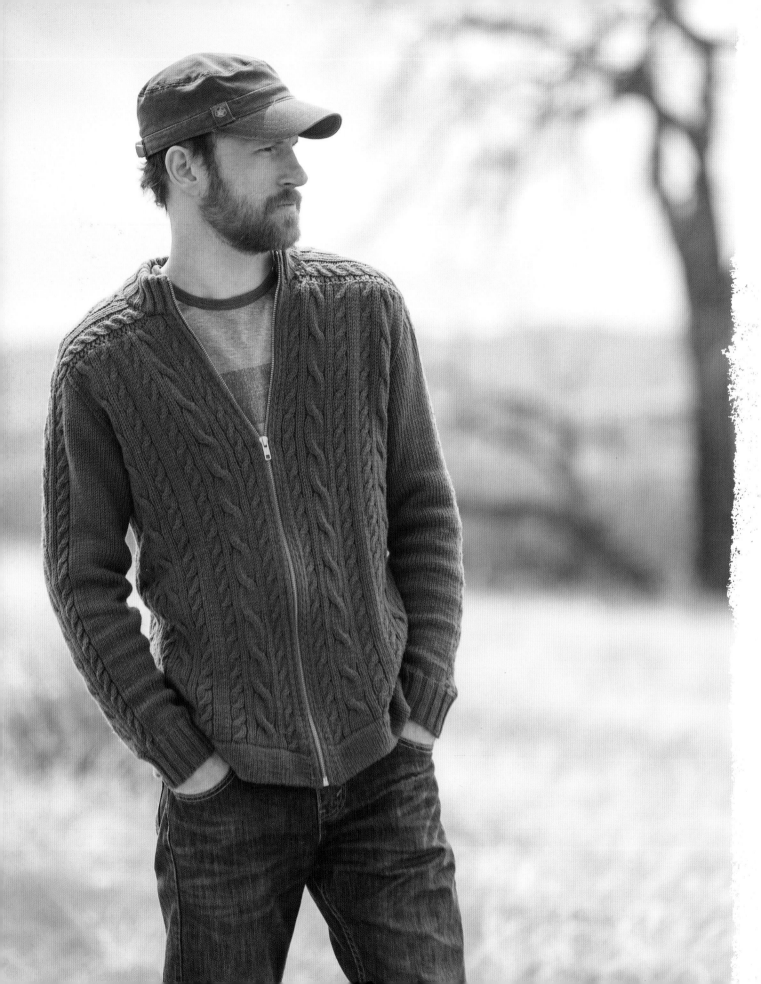

cabled JACKET

designed by TODD GOCKEN

Do you or someone you know have a fascination with lightweight outerwear? Knit up this chic, retro zippered jacket with cables. It features saddle shoulders, a folded hem, and a doubled collar to give it a casual, sporty feel. What's more, there's very little seaming involved!

FINISHED SIZE
34¾ (38¾, 43, 47, 51¼)" (88.5 [98.5, 109, 119.5, 130] cm) bust circumference.

Jacket shown measures 38¾" (98.5 cm).

YARN
Worsted weight (#4 Medium).

Shown here: Cascade Yarns Longwood (100% superwash superfine merino wool; 191 yd [175 m]/100 g): #15 Green Olive, 8 (9, 10, 11, 12) balls.

NEEDLES
Body and sleeves: size U.S. 7 (4.5 mm): 24" (60 cm) circular (cir) and set of 4 or 5 double-pointed (dpn).

Ribbing: size U.S. 5 (3.5 mm): 24" (60 cm) cir and set of 4 or 5 dpn.

Adjust needle size if necessary to obtain the correct gauge.

NOTIONS
Cable needle (cn); markers (m); stitch holders or waste yarn; waste yarn for provisional cast-on; tapestry needle; 24" to 26" (51 to 66 cm) long separating zipper.

GAUGE
20 sts and 28 rnds = 4" (10 cm) in St st worked in rnds on larger needles.

27 sts and 28 rows = 4" (10 cm) in cable patt worked back and forth on larger needles.

2/2RC: Slip 2 sts onto cn and hold in back of work, k2, k2 from cn.

3/3LC: Slip 3 sts onto cn and hold in front of work, k3, k3 from cn.

sleeves (make 2)

With smaller dpn, CO 44 (48, 52, 56, 60) sts. Place marker (pm) and join for working in rnds, being careful not to twist sts.

Work in k2, p2 rib for 2 (2½, 2½, 2½, 2½)" (5 [6.5, 6.5, 6.5, 6.5] cm).

Change to larger dpn.

Set-up rnd: K11 (13, 15, 17, 19), pm, work set up row of Cable chart from right edge of chart to left edge, pm, knit to end—50 (54, 58, 62, 66) sts.

Keeping in patt and slipping markers (sl m) when you come to them, work 3 rnds even.

Inc rnd: K1, M1L (see Glossary), work to last st, M1R (see Glossary), k1—2 sts inc'd.

Work 8 (7, 5, 5, 5) rnds even. Rep the last 9 (8, 6, 6, 6) rnds 11 (13, 16, 17, 18) more times—74 (82, 92, 98, 104) sts.

Cont even in patt until piece measures 18½ (19½, 20, 21, 21½)" (47 [49.5, 51, 53.5, 54.5] cm) from CO, ending 3 (4, 5, 6, 7) sts before end of last rnd.

Place next 6 (8, 10, 12, 14) sts onto holder—68 (74, 82, 86, 90) sts rem.

Set aside.

lower body

With smaller cir needle and waste yarn, use a provisional method (see Glossary) to CO 176 (198, 220, 242, 264) sts. Do not join.

Work even in St st (knit on RS; purl on WS) for 2 rows.

Use the backward-loop method (see Glossary) to CO 5 sts at the end of the next 2 rows—186 (208, 230, 252, 274) sts.

Establish I-cord edge as foll.

Row 1: (RS) Knit.

Row 2: (WS) Sl 4, purl to last 4 sts, sl 4.

Rep Rows 1 and 2 until piece measures 4" (10 cm) from CO, ending with a WS row.

Join hem: (RS) Carefully remove waste yarn from provisional CO and place exposed sts onto a spare cir needle. With larger cir needle, k5, *sl 1 st knitwise from working needle, sl 1 st knitwise from spare needle, knit these 2 sts tog through their back loops (tbl); rep from * to last 5 sts, k5—still 186 (208, 230, 252, 274) sts.

Set-up row: (WS) Sl 4, p1, work set-up row of Cable chart 8 (9, 10, 11, 12) times, p1, sl 4—234 (262, 290, 318, 346) sts.

Row 1: (RS) K5, work next row of chart to last 5 sts, k5.

Row 2: (WS) Sl 4, p1, work next row of chart to last 5 sts, p1, sl 4.

Rep Rows 1 and 2 until piece measures 17 (18, 18, 18, 18½)" (43 [45.5, 45.5, 45.5, 47] cm) from folded edge, ending with a WS row.

join sleeves to body

With RS facing, working yarn attached to body, and keeping in patt as established, work 56 (62, 68, 74, 80) body sts for right front, place next 6 (8, 10, 12, 14) sts onto holder, pm, work 68 (74, 82, 86, 90) right sleeve sts, pm, work 110 (122, 134, 146, 158) body sts for back, pm, place next 6 (8, 10, 12, 14) sts onto holder, pm, work 68 (74, 82, 86, 90) left sleeves sts, pm, work rem 56 (62, 68, 74, 80) body sts for left front—358 (394, 434, 466, 498) sts total.

yoke

Keeping in patt as established, shape the sleeve cap (and armholes) in four dec sequences as foll.

DEC SEQUENCE 1

Row 1: (RS) *Work to 2 sts before next m, k2tog, slip marker (sl m), ssk; rep from *—1 st dec'd each side of each m; 8 sts dec'd total.

Row 2: (WS) Work to next m, *sl m, p2tog, work to 2 sts before next m, ssp (see Glossary), sl m, work to next m; rep from *—1 st dec'd on sleeve side of each marker; 4 sts dec'd total.

Rep these 2 rows 0 (2, 3, 3, 4) more times—346 (358, 386, 418, 438) sts rem.

DEC SEQUENCE 2

Row 1: (RS) *Work to 2 sts before m, k2tog, sl m, ssk; rep from *—1 st dec'd on each side of each m; 8 sts dec'd total.

Row 2: (WS) Work even in patt.

Rep these 2 rows 4 (4, 5, 5, 6) more times—306 (318, 338, 370, 382) sts rem.

DEC SEQUENCE 3

Row 1: (RS) Work to m, *sl m, ssk, work to 2 sts before next m, k2tog, sl m, work to next m; rep from *—1 sts dec'd on sleeve side of each m; 4 sts dec'd total.

Row 2: (WS) Work even in patt.

Rep these 2 rows 10 (9, 6, 8, 7) more times—262 (278, 310, 334, 350) sts rem.

DEC SEQUENCE 4

Note: Short-rows shaping is introduced to raise the back neck while this decrease sequence is in progress; read all the way to the end of this section before proceeding.

Row 1: (RS) Work to m, *sl m, ssk, work to 2 sts before next m, k2tog, sl m, work to next m; rep from *—1 sts dec'd on sleeve side of each m; 4 sts dec'd total.

Row 2: (WS) Work to next m, *sl m, p2tog, work to 2 sts before next m, ssp, sl m, work to next m; rep from *—1 sts dec'd on sleeve side of each marker; 4 sts dec'd total.

Rep these 2 rows 1 (1, 3, 3, 3) more time(s).

At the same time on the last WS row, begin short-rows (see Glossary) on back sts as foll.

Short-Rows 1 and 2: With WS facing, work to next m, sl m, work sleeve sts, sl m, work back to 10 sts before next m, wrap next st and turn work (w&t) so RS is facing, work to 10 sts before m, w&t.

***Short-Rows 3 and 4:** With WS facing, work to 10 sts before previous wrapped st, w&t, with RS facing, work to 10 sts before previous wrapped sts, w&t.

Rep from * 1 (1, 1, 2, 2) more time(s), then work to end of row, working wraps tog with wrapped sts when you come to them—246 (262, 278, 302, 318) sts rem

after all decs and short-rows have been completed.

Next row: (RS) Work even in patt, working rem wraps tog with wrapped sts when you come to them—24 sts rem for each sleeve.

Next row: (WS) Keeping in patt as established, work 5 sts, BO rem 45 (49, 53, 59, 63) left front sts and remove m to BO last front st, work to next m, remove m, BO 98 (106, 114, 126, 134) back sts and remove m to BO last back st, work to next m, remove m, BO 45 (49, 53, 59, 63) right front sts, work to end of row—58 sts rem; 5 sts at each front edge and 24 sts for each sleeve.

Place first 5 and last 5 sts onto holders.

Do not cut yarn.

RIGHT SLEEVE SADDLE

With RS facing, join yarn and work rem 24 right sleeve sts as established and *at the same time* inc 1 st each end of first row—26 sts.

Cont in patt until saddle measures 4¾ (5¼, 5½, 6¼, 6½)" (12 [13.5, 14, 16, 16.5] cm), ending with a RS row.

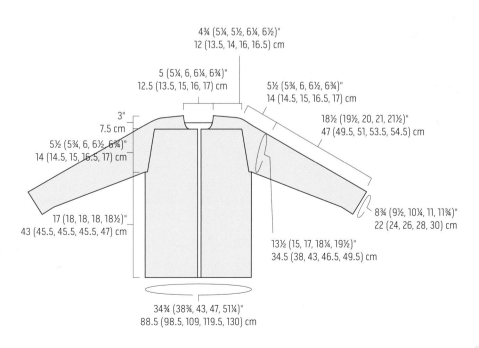

4¾ (5¼, 5½, 6¼, 6½)"
12 (13.5, 14, 16, 16.5) cm

5 (5¼, 6, 6¼, 6¾)"
12.5 (13.5, 15, 16, 17) cm

5½ (5¾, 6, 6½, 6¾)"
14 (14.5, 15, 16.5, 17) cm

3"
7.5 cm

18½ (19½, 20, 21, 21½)"
47 (49.5, 51, 53.5, 54.5) cm

5½ (5¾, 6, 6½, 6¾)"
14 (14.5, 15, 16.5, 17) cm

8¾ (9½, 10¼, 11, 11¾)"
22 (24, 26, 28, 30) cm

17 (18, 18, 18, 18½)"
43 (45.5, 45.5, 45.5, 47) cm

13½ (15, 17, 18¼, 19½)"
34.5 (38, 43, 46.5, 49.5) cm

34¾ (38¾, 43, 47, 51¼)"
88.5 (98.5, 109, 119.5, 130) cm

Keeping in patt, cont as foll.

Set-up row: (WS) BO 20 (20, 18, 18, 16) sts, work to end of row—6 (6, 8, 8, 10) sts rem.

Row 1: (RS) Work to last 3 sts, k2tog, k1—1 st dec'd.

Row 2: (WS) Ssk, work to end of row— 1 st dec'd.

Rep Rows 1 and 2 until 1 st rem.

BO rem st.

LEFT SLEEVE SADDLE

With RS facing, join yarn and work rem 24 left sleeve sts as established and *at the same time* inc 1 st each end of first row.

Cont in patt until saddle measures 4¾ (5¼, 5½, 6¼, 6½)" (12 [13.5, 14, 16, 16.5] cm), ending with a WS row.

Keeping in patt, cont as foll.

Set-up row: (RS) BO 20 (20, 18, 18, 16) sts, work to end of row—6 (6, 8, 8, 10) sts rem.

Row 1: (WS) Work to last 3 sts, p2tog, k1—1 st dec'd.

Row 2: (RS) Ssk, work to end of row— 1 st dec'd.

Rep Rows 1 and 2 until 1 st rem.

BO rem st.

finishing

With yarn threaded on a tapestry needle, sew saddles to upper back, then to upper front.

Place 6 (8, 10, 12, 14) held left sleeve sts onto one needle, place corresponding 6 (8, 10, 12, 14) held underarm sts onto another needle, and hold the two needles parallel with WS of fabric facing tog.

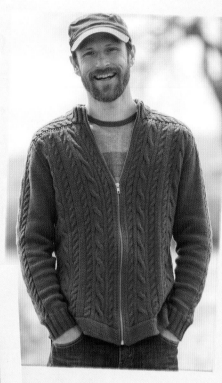

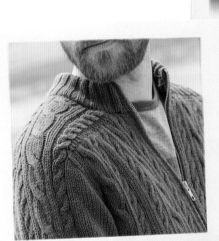

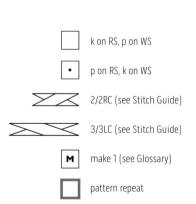

CABLE

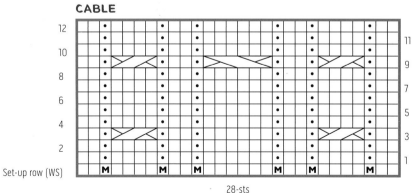

28-sts
repeat for body; work once for sleeve

Set-up row (WS)

	k on RS, p on WS
•	p on RS, k on WS
	2/2RC (see Stitch Guide)
	3/3LC (see Stitch Guide)
M	make 1 (see Glossary)
	pattern repeat

With yarn threaded on a tapestry needle, use the Kitchener st (see Glossary) or three-needle BO method (see Glossary) to join the two sets of sts tog.

Rep for right sleeve.

COLLAR

With smaller cir needle, RS facing, and working yarn attached to front, k5 held right front sts, pick up and knit 3 sts along right front neck edge, 24 sts across right saddle, 34 (34, 38, 42, 46) sts across back neck edge, 24 sts across left saddle, and 3 sts along left front neck edge, then k5 held left front sts—98 (98, 102, 106, 110) sts total.

Row 1: (WS) Sl 4, k2, *p2, k2; rep from * to last 4 sts, sl 4.

Row 2: (RS) K4, *p2, k2; rep from * to last 2 sts, k2.

Rep Rows 1 and 2 until collar measures 4" (10 cm) from pick-up row.

Loosely BO all sts in patt.

Fold BO edge to WS and, with yarn threaded on a tapestry needle, sew BO edge to pick-up rnd.

Weave in loose ends.

Block to measurements.

ZIPPER

Sew zipper in place (see Glossary).

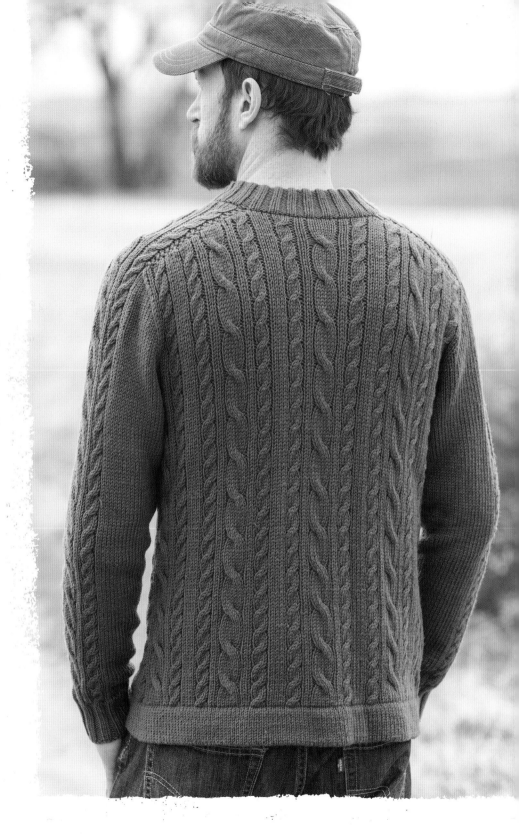

glossary

ABBREVIATIONS

BEG(S)	begin(s); beginning	**m**	marker	**sc**	single crochet
BO	bind off	**mm**	millimeter(s)	**sl**	slip
CC	contrast color	**M1**	make one (increase)	**ssk**	slip, slip, knit (decrease)
cir	circular	**M1L**	make one; left slant (increase)	**st(s)**	stitch(es)
cm	centimeter(s)			**St st**	stockinette stitch
cn	cable needle	**M1R**	make one; right slant (increase)	**tbl**	through back loop
CO	cast on	**oz**	ounce(s)	**tog**	together
cont	continue(s); continuing	**p**	purl	**w&t**	wrap and turn
dec(s)('d)	decrease(s); decreasing; decreased	**p1f&b**	purl into the front and back of the same stitch (increase)	**WS**	wrong side
				wyb	with yarn in back
dpn	double-pointed needles	**p2tog**	purl two stitches together (decrease)	**wyf**	with yarn in front
foll	follow(s); following	**patt(s)**	pattern(s)	**yd**	yard(s)
g	gram(s)	**pm**	place marker	**yo**	yarnover
inc(s)('d)	increase(s); increasing; increase(d)	**psso**	pass slipped stitch over	*****	repeat starting point
		pwise	purlwise; as if to purl	*** ***	repeat all instructions between asterisks
k	knit	**rem**	remain(s); remaining		
k1f&b	knit into the front and back of the same stitch (increase)	**rep**	repeat(s); repeating	**()**	alternate measurements and/or instructions
		Rev St st	reverse stockinette stitch		
k2tog	knit two stitches together (decrease)	**RLI**	right lifted increase (right leaning)	**[]**	work instructions as a group a specified number of times
kwise	knitwise, as if to knit	**rnd(s)**	round(s)		
LLI	left lifted increase (left leaning)	**RS**	right side		

BIND-OFFS

STANDARD BIND-OFF

Knit the first stitch, *knit the next stitch (two stitches on right needle), insert left needle tip into first stitch on right needle (**Figure 1**) and lift this stitch up and over the second stitch (**Figure 2**) and off the needle (**Figure 3**). Repeat from * until one stitch remains on the right needle. Cut the yarn, leaving a 6" (15 cm) tail, then pull on the loop of the last stitch until the tail comes free to secure the last stitch.

THREE-NEEDLE BIND-OFF

Place the stitches to be joined onto two separate needles and hold the needles parallel so that the right sides of knitting face together. Insert a third needle into the first stitch on each of two needles (**Figure 1**) and knit them together as one stitch (**Figure 2**), *knit the next stitch on each needle the same way, then use the left needle tip to lift the first stitch over the second and off the needle (**Figure 3**). Repeat from * until no stitches remain on first two needles. Cut the yarn, leaving a 6" (15 cm) tail, then pull on the loop of the last stitch until the tail comes free to secure the last stitch.

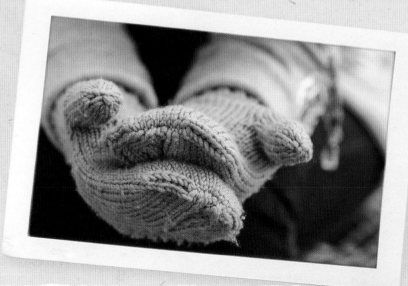

CAST-ONS

BACKWARD-LOOP CAST-ON

*Loop working yarn and place it on needle backward so that it doesn't unwind. Repeat from *.

CABLE CAST-ON

If there are no stitches on the needles, make a slipknot of working yarn and place it on the left needle, then use the knitted method (see page 177) to cast on one more stitch—two stitches on needle. When there are at least two stitches on the left needle, hold needle with working yarn in your left hand. *Insert right needle between the first two stitches on left needle (**Figure 1**), wrap yarn around needle as if to knit, draw yarn through (**Figure 2**), and place new loop on left needle (**Figure 3**) to form a new stitch. Repeat from * for the desired number of stitches, always working between the first two stitches on the left needle.

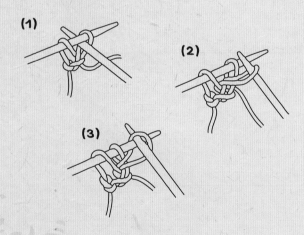

CHAIN CAST-ON

Make a slipknot on a crochet hook and hold it in your right hand. Hold a knitting needle and yarn in your left hand. Bring the yarn under the needle, then use the crochet hook to grab a loop of yarn over the top of the needle and pull it through the slipknot. *Bring the yarn back under the needle, use the crochet hook to grab a loop over the top of the needle, and pull it through the loop on the crochet hook. Repeat from * for one less than the desired number of sitches, then transfer the loop from the crochet hook onto the needle for the last stitch.

CROCHET PROVISIONAL CAST-ON

With waste yarn and crochet hook, make a loose crochet chain (see page 178) about four stitches more than you need to cast on. With knitting needle, working yarn, and beginning two stitches from end of chain, pick up and knit one stitch through the back loop of each crochet chain (**Figure 1**) for desired number of stitches. When you're ready to work in the opposite direction, pull out the crochet chain to expose live stitches (**Figure 2**).

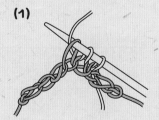 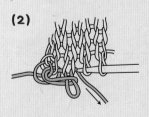

INVISIBLE PROVISIONAL CAST-ON

Make a loose slipknot of working yarn and place it on the right needle. Hold a length of contrasting waste yarn next to the slipknot (or tie it together with the slipknot) and around your left thumb; hold working yarn over your left index figer. *Bring the right needle forward under waste yarn, over working yarn, grab a loop of working yarn (**Figure 1**), then bring the needle back behind the working yarn and grab a second loop (**Figure 2**). Repeat from * for the desired number of stitches. When you're ready to work in the opposite direction, place the exposed loops onto a knitting needle as you pull out the waste yarn.

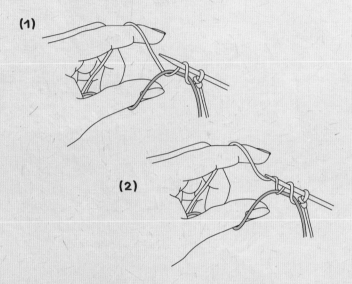

LONG-TAIL (CONTINENTAL) CAST-ON

Leaving a long tail (about ½" [1.3 cm] for each stitch to be cast on), make a slipknot and place on right needle. Place thumb and index finger of your left hand between the yarn ends so that working yarn is around your index finger and tail end is around your thumb and secure the yarn ends with your other fingers. Hold your palm upwards, making a V of yarn (**Figure 1**). *Bring needle up through loop on thumb (**Figure 2**), catch first strand around index finger, and go back down through loop on thumb (**Figure 3**). Drop loop off thumb and, placing thumb back in V configuration, tighten resulting stitch on needle (**Figure 4**). Repeat from * for the desired number of stitches.

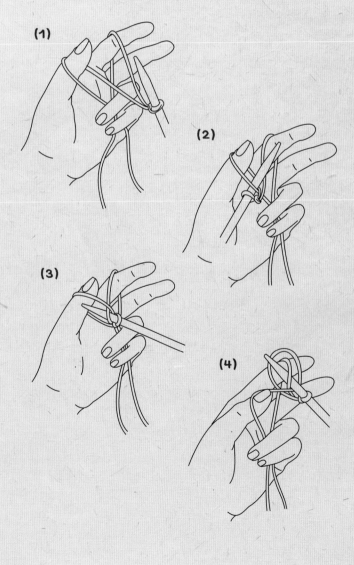

KNITTED CAST-ON

If there are no stitches on the needles, make a slipknot of working yarn and place it on the left needle. When there is at least one stitch on the left needle, *use the right needle to knit the first stitch (or slipknot) on left needle (**Figure 1**) and place new loop onto left needle to form a new stitch (**Figure 2**). Repeat from * for the desired number of stitches, always working into the last stitch made.

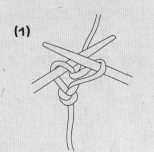
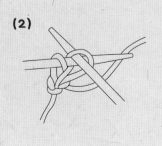

CROCHET

CROCHET CHAIN

Make a slipknot and place on crochet hook. *Yarn over hook and draw through a loop on the hook. Repeat from * for the desired number of stitches. To fasten off, cut yarn and draw end through last loop made.

SINGLE CROCHET (SC)

*Insert hook into the second chain from the hook (or the next stitch), yarn over hook and draw through a loop, yarn over hook (**Figure 1**), and draw it through both loops on hook (**Figure 2**). Repeat from * for the desired number of stitches.

(1) **(2)**

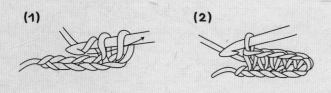

SLIP-STITCH CROCHET (SL ST)

*Insert hook into stitch, yarn over hook and draw a loop through both the stitch and loop already on the hook. Repeat from * for the desired number of stitches.

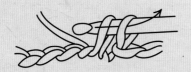

DECREASES

KNIT 2 TOGETHER (K2TOG)

Knit two stitches together as if they were a single stitch.

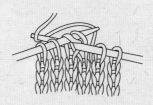

PURL 2 TOGETHER (P2TOG)

Purl two stitches together as if they were a single stitch.

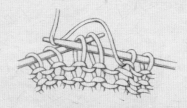

SLIP, SLIP, KNIT (SSK)

Slip two stitches individually knitwise (**Figure 1**), insert left needle tip into the front of these two slipped stitches, and use the right needle to knit them together through their back loops (**Figure 2**).

(1) **(2)**

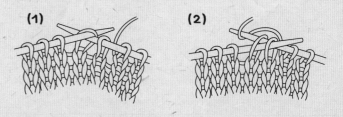

SLIP, SLIP, PURL (SSP)

Holding yarn in front, slip two stitches individually knitwise (**Figure 1**), then slip these two stitches back onto the left needle (they will be twisted on the needle) and purl them together through their back loops (**Figure 2**).

(1) **(2)**

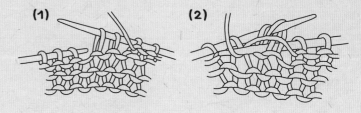

GRAFTING

KITCHENER STITCH

Arrange stitches on two needles so that there is the same number of stitches on each needle. Hold the needles parallel to each other with wrong sides of the knitting facing together. Allowing about ½" (1.3 cm) per stitch to be grafted, thread matching yarn on a tapestry needle. Work from right to left as follows:

Step 1. Bring tapestry needle through the first stitch on the front needle as if to purl and leave the stitch on the needle **(Figure 1)**.

Step 2. Bring tapestry needle through the first stitch on the back needle as if to knit and leave that stitch on the needle **(Figure 2)**.

Step 3. Bring tapestry needle through the first front stitch as if to knit and slip this stitch off the needle, then bring the tapestry needle through the next front stitch as if to purl and leave this stitch on the needle **(Figure 3)**.

Step 4. Bring tapestry needle through the first back stitch as if to purl and slip this stitch off the needle, then bring the tapestry needle through the next back stitch as if to knit and leave this stitch on the needle **(Figure 4)**.

Repeat Steps 3 and 4 until one stitch remains on each needle, adjusting the tension to match the rest of the knitting as you go. To finish, bring the tapestry needle through the front stitch as if to knit and slip this stitch off the needle, then bring the tapestry needle through the back stitch as if to purl and slip this stitch off the needle.

Insert the tapestry needle into the center of the last stitch worked, pull the yarn to the wrong side, and weave the tail into the purl bumps on the wrong side of the toe.

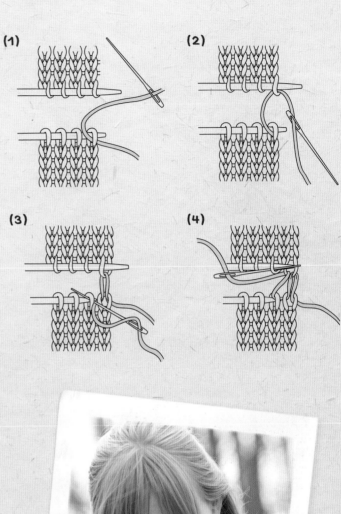

(1)

(2)

(3)

(4)

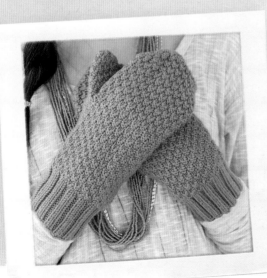

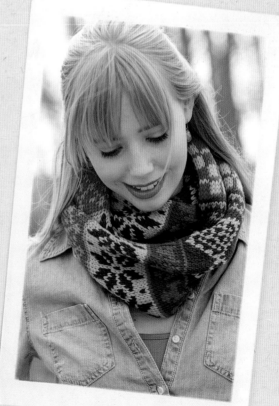

INCREASES

BAR INCREASES

Knitwise (k1f&b)

Knit into a stitch but leave the stitch on the left needle **(Figure 1)**, then knit through the back loop of the same stitch **(Figure 2)** and slip the original stitch off the needle **(Figure 3)**.

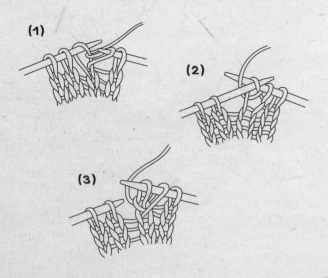

Purlwise (p1f&b)

Work as for a knitwise bar increase, but purl into the front and back of the same stitch.

3-STITCH I-CORD

Using double-pointed needles, cast on the desired number of stitches (usually three to five). *Without turning the needle, slide stitches to other end of needle, pull the yarn around the back, and knit the stitches as usual. Repeat from * for desired length.

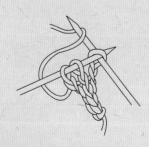

RAISED MAKE-ONE (M1) INCREASE

Note: Use the left slant (M1L) if no direction is specified.

Left Slant (M1L)

With left needle tip, lift the strand between the last knitted stitch and the first stitch on the left needle from front to back **(Figure 1)**, then knit the lifted loop through the back **(Figure 2)**.

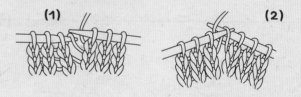

Right Slant (M1R)

With left needle tip, lift the strand between the needles from back to front **(Figure 1)**, then knit the lifted loop through the front **(Figure 2)**.

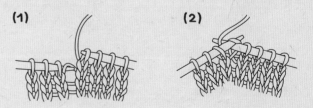

Purlwise (M1P)

Work as for knitwise make-one increase (with either a left or right slant), but purl the lifted loop.

LIFTED INCREASE

Left Lifted Increase (LLI)

Insert left needle tip into the back of the stitch (in the "purl bump") below the stitch just knitted (**Figure 1**), then knit this lifted stitch (**Figure 2**).

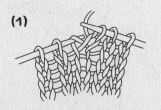

(1)

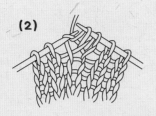

(2)

Right Lifted Increase (RL1)

Insert right needle tip into the back of the stitch (in the "purl bump") in the row directly below the first stitch on the left needle (**Figure 1**), knit this lifted stitch, then knit the first stitch on the left needle (**Figure 2**).

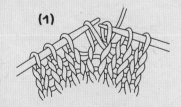

(1)

(2)

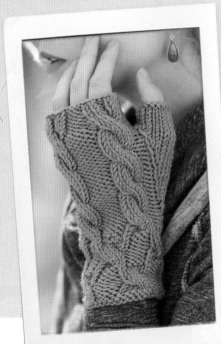

MAGIC-LOOP TECHNIQUE

Using a 32" or 40" (80 or 100 cm) circular needle, cast on the desired number of stitches. Slide the stitches to the center of the cable, then fold the cable and half of the stitches at the midpoint, then pull a loop of the cable between the stitches—half of the stitches will be on one needle tip and the other half will be on the other tip (**Figure 1**). Hold the needle tips parallel so that the working yarn comes out of the right-hand edge of the back needle. *Pull the back needle tip out to expose about 6" (15 cm) of cable and use that needle to knit the stitches on the front needle (**Figure 2**). At the end of those stitches, pull the cable so that the two sets of stitches are at the ends of their respective needle tips, turn the work around, and repeat from * to complete one round of knitting.

(1)

(2)

SHORT-ROWS

SHORT-ROWS KNIT SIDE

Work to turning point, slip next stitch purlwise (**Figure 1**), bring the yarn to the front, then slip the same stitch back to the left needle (**Figure 2**), turn the work around and bring the yarn in position for the next stitch—one stitch has been wrapped and the yarn is correctly positioned to work the next stitch. When you come to a wrapped stitch on a subsequent row, hide the wrap by working it together with the wrapped stitch as follows: insert right needle tip under the wrap (from the front if wrapped stitch is a knit stitch; from the back if wrapped stitch is a purl stitch; **Figure 3**), then into the stitch on the needle, and work the stitch and its wrap together as a single stitch.

SHORT-ROWS PURL SIDE

Work to the turning point, slip the next stitch purlwise to the right needle, bring the yarn to the back of the work (**Figure 1**), return the slipped stitch to the left needle, bring the yarn to the front between the needles (**Figure 2**), and turn the work so that the knit side is facing—one stitch has been wrapped and the yarn is correctly positioned to knit the next stitch. To hide the wrap on a subsequent purl row, work to the wrapped stitch, use the tip of the right needle to pick up the wrap from the back, place it on the left needle (**Figure 3**), then purl it together with the wrapped stitch.

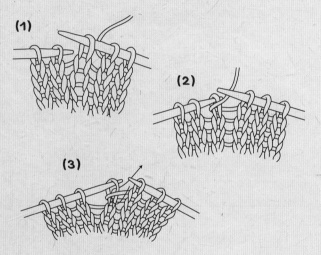

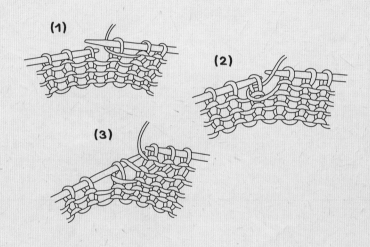

ZIPPER

With right side facing and zipper closed, pin zipper to the knitted pieces so edges meet at the zipper teeth. With contrasting thread and right side facing, baste zipper in place close to teeth (**Figure 1**). Turn work over and with matching sewing thread and needle, stitch outer edges of zipper to wrong side of knitting (**Figure 2**), being careful to follow a single column of stitches in the knitting to keep the zipper straight. Turn work back to right side facing, and with matching sewing thread, sew knitted fabric close to teeth (**Figure 3**). Remove basting.

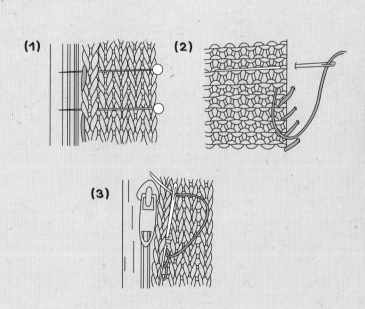

Index

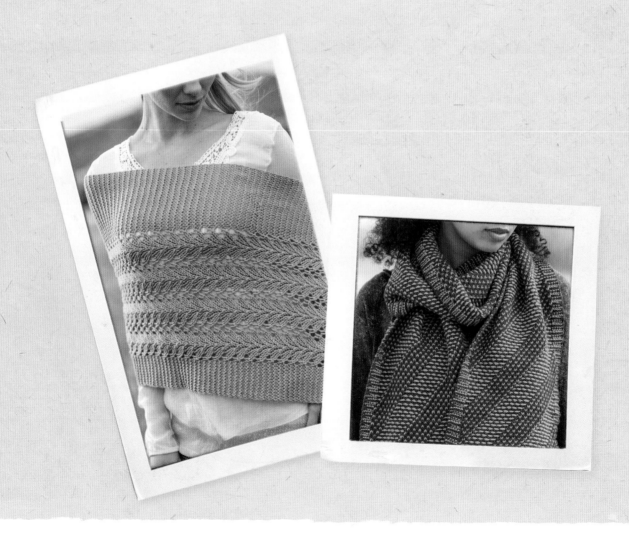